OVERLOOKING THE VISUAL

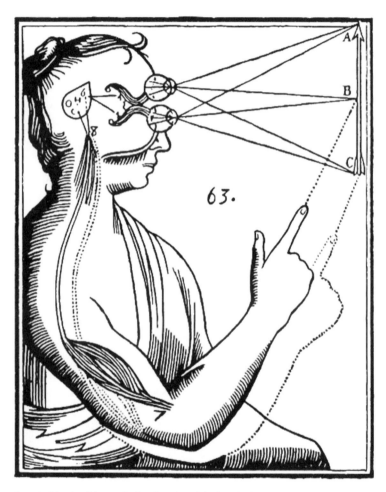

Descartes' drawing of the coordination of muscle and visual mechanisms
clarifying the distinction thought to exist between body and mind (c.1664).

Overlooking the visual

Demystifying the art of design

Kathryn Moore

Routledge
Taylor & Francis Group

First published 2010
by Routledge
2 Park Square, Milton Park, Abingdon, Oxon OX14 4RN

Simultaneously published in the USA and Canada
by Routledge
270 Madison Avenue, New York, NY 10016, USA

Routledge is an imprint of the Taylor & Francis Group, an informa business

Designed and typeset in Lucida Sans by Alex Lazarou
Printed and bound in Great Britain by Ashford Colour Press

British Library Cataloguing in Publication Data
A catalogue record for this book is available from the British Library

Library of Congress Cataloging in Publication Data
Moore, Kathryn (Kathryn J.)
Overlooking the visual : demystifying the art of design /
Kathryn Moore.
 p. cm.
 Includes bibliographical references and index.
 1. Design—Philosophy. I. Title.
NK1505.M66 2009
745.401—dc22

 2009018054

ISBN10: 0-415-30869-0 (hbk)
ISBN10: 0-415-30870-4 (pbk)
ISBN10: 0-203-16765-1 (ebk)

ISBN13: 978-0-415-30869-4 (hbk)
ISBN13: 978-0-415-30870-0 (pbk)
ISBN13: 978-0-203-16765-6 (ebk)

contents

When I first talked to Kathryn Moore about this book, she was in the middle of writing it. She was teaching at the university in Birmingham, and she was also at that time the president of the Landscape Institute, the professional body for British Landscape Architects – so she was pretty busy. In one snatched meeting at a cafe in Euston Station, she drew a line down the middle of a piece of paper and started listing idealisms on one side and the opposing materialisms on the other. At the bottom, under the line, she wrote the word *experience*. The oppositional dialectics of the philosophers are misleading, she was saying. Everything we do and know and think about the world comes from our experience of it.

Now everyone knows that the opposite of experience is innocence. I was at the time in the middle of writing my own book, a work I was calling *How to Like Everything*: and being mindful of my small son's wide-eyed appreciation of everything around him, which seemed to me some sort of key as to how to like everything, I said to her, but what about the little children? What about innocence?

'No, no, no', she said. 'Little children aren't innocent, that's metaphysical rubbish. Little children are ignorant.'

Ignorance! That's what the opposite of experience is. Not innocence. The remark was so startling it has stayed with me ever since. It echoed when I read Milan Kundera's joke about the Czech dictator who liked having photographs of himself with children – because children are the future. Of course they are, says Kundera, because the state keeps its people in such ignorance they might as well be children. It echoed again when I came across W. H. Auden's idea that childhood is a trap, and growing up is learning to spring the locks and escape. And again, a slightly different thought, my own this time, is that ignorance is another word for hope – we are all ignorant of our future, because if not, how would we continue to live?

But there I am straying into metaphysical territory again. This is not the place to do that. The substance of this book is a sustained reassessment of the conditions for creative activity. Moore's resource for her anti-metaphysical, anti-rationalist stance is the writings of the Pragmatists. William James, who coined the term in America at the beginning of the last century, was explicitly critical of both rationalism on one hand, and materialism on the other. Materialism then was not the subtle tracking of emergent structures it has become; it was the implacable logic of modern science, for which all things are atomistic. He called that approach Tough Minded. And rationalism was, as it still is, the idealist heritage of ancient Greece made transcendent by Christianity and hammered into the great dialectic of mind and body by Descartes. James called all that Tender Minded. And how is rationalism idealistic? How tender? Because, in my words again, rationalists believe in absolute truth, in the laws of nature. And for that absolute to prevail there must be a foundation. For which we have, and since nature went dynamic with the theory of evolution we only have, the very ancient concept of God.

I want to be clear about the words because pragmatism in the demotic sense means what politicians do; they compromise and self serve and horse trade in whatever way suits the problem at hand. So with rationalism – not tender at all, those are the guys who steamroller solutions through, who operate outside human emotion and passion, cold and clinical. And materialists? They only think about money and status. This is the common view. It sounds like the view of the inhabitants of a fallen world. But still, the gulf between these everyday perceptions of the terms and what philosophers mean by them is huge – as is the gulf of perception between the philosophers themselves. Especially in the case of the design philosophers, who write for an audience of each other so particular, so jumpy, that when you try to engage them you think you have fallen in with gladiators. On one side the growls of the philosophers of emergence and on the other the barbs of the critical theorists. From the gallery, the sigh of the phenomenologists. And in there still, as soothing as aspirin, the traditional idealists. 'When Nietzsche says there is no truth, he is asking you not to believe him', they say. 'So don't.' But Nietzsche was one of the engines of contemporary relational thought. He was not asking you to believe him. He was showing you how to believe yourself.

To step into the gymnasium emphasising plain speaking and personal interpretation as this book does is a big departure. The great thing is that Moore comes not with a broom to sweep the rubbish away, but with a floodlight that shows the complexities as fragments of one thing. She is not a fundamentalist, she is a radical. Again and again she insists; abandon the distinction between seeing and thinking, between reason and feeling, between form and function, and anything becomes possible. After a century of clashing dialectics, of difficulties and contradictions, and of the continual dismantling of failed utopias, this is good news. The Truth, Beauty and Goodness of the idealists are abstractions, immaterialities that don't exist. What does is action. You pursue truth, you find beauty and you do goodness. All of which is so nearly the subject of art and architecture pedagogy that it is surprising that Pragmatism should not have figured more strongly in that field. This alone would be enough to make *Overlooking the visual* significant; it is all the more so because it rescues design philosophy and aesthetics from the ivory tower and reintroduces them to everyday practice.

Pragmatism was constructed to explain the abyss between what we know and what we want. There is the mundane world, which contains all we have to work with. We are impelled by our frailties and desires to make changes to it, but can only do so on the ground of our experience, which is complex, fallible, mutable and difficult to communicate. How to proceed in these confusing circumstances is what this book is about. It is for all designers, all artists, but Moore is a landscape designer by profession, so I'll add one more thing. Pragmatism's fit with the subject of landscape is convincing. It was probably clear as a spring morning a hundred years ago when human relations with the land were so intimate; now, even though we take such enormous pleasure in abstractions and virtualities, landscape design is the nearest thing we have to the possibility of a comprehensive discipline, the best placed to anticipate the dire changes forecast for the world. It is a discipline of combination, of history and, geography, of space and time, dynamic, natured. *Overlooking the visual* is an invitation to take part.

Paul Shepheard
Architect and Author
London, June 2009

After studying art and design in Brighton, I gained degrees in geography and landscape architecture at Manchester University. When I started work at Salford City Council in the north west of England, working for the derelict land reclamation team, the area was a real mess. There was so much derelict land it was almost thought of as a job for life. After six years I became responsible for the council's large and busy landscape group. We had a range of projects, mainly urban regeneration and inner city land reclamation, including massive housing refurbishment schemes and large-scale visionary projects like Salford Quays and a 47 hectare woodland management scheme where burnt out cars were the problem rather than rabbits, deer and brambles. When I first took over the group I was determined to shift the priority away from spending the money by the end of the financial year and focus on design quality. It made a difference and this was one of the primary reasons I took the job at Birmingham City University (BCU) because it seemed to me that the only way to really address the issue of design quality was through education. At BCU I couldn't find any books on how to teach design and I was curious. We can teach maths and English, why not a spatial, perceptual visual skill? I got a research grant from the Leverhulme Trust and pestered all the leading practitioners and educators of design I knew. I then pestered their colleagues and friends and I'd like to thank them all for taking my calls and giving their time as well as their encouragement.

Recognising the need to radically redefine the relationship between the senses and intelligence was the outcome of the Leverhulme Trust grant. An initial paper questioning the existence of the concept of visual thinking was presented at the 1999 ECLAS (European Council of Landscape Architecture Schools) meeting in Berlin. It led to invitations to examine the implications of this premise for the role of drawing at the 'Art Materials' conference, Graduate College at the University of Arts, Berlin, February 2000, the studio as research for the New Zealand publication *Landscape*

Research in 2002, the role of aesthetics in design at the Academy of Architecture, Amsterdam and the House of Lords in 2005, and the role of aesthetics and nature in the city at the International Federation of Housing and Planning conference in Copenhagen 2007. In the meantime papers relating to these topics and more, addressing aspects such as the design process, the genius loci, design expertise and the art of design in academic, professional and educational contexts have been presented extensively in the UK and abroad, including at the National Congress on Urban Greenspace and Landscape on Kish Island, Iran, at the University of Virginia during my tenure as the Thomas Jefferson Visiting Professor and at the Graduate School of Design, Harvard as part of the Department Lecture Series during Fall 2008. As President of the Landscape Institute UK from 2004–06, I had the invaluable opportunity to present the ideas to a wide range of non-academic, professional and non-specialist audiences. Most significantly, all of this research informs and develops from my teaching and the design of courses on undergraduate, graduate and postgraduate degrees and diplomas in Landscape architecture at Birmingham City University, other workshops and courses taught in the UK and abroad.

acknowledgements

Thanks to the Leverhulme Trust, the Landscape Foundation and the Graham Foundation for Advanced Studies in the Fine Arts Chicago for funding periods of research to write this book. In addition there are many, many individuals who have played a part in making this happen. I'd like to thank Sir Geoffrey Jellicoe, Hilary Putnam and Richard Rorty for their words of encouragement and support.

Those involved in the initial research project included Glyn Thomas, Birmingham University, Ken Baynes, Loughborough University, Ian Richards, Aston University and Bryan Lawson, Sheffield University. Interviewees included Martha Schwartz, Gary Hilderbrand, Beth Meyer, George Hargreaves and Alistair McIntosh, all then at the Graduate School of Design, Harvard University, Harry Porter, Warren Byrd, Nancy Takahashi and Elissa Rosenberg from the University of Virginia, Charlottesville, James Corner and Anuradha Mathur, University of Philadelphia, Fernando Magallanes and Art Rice from North Carolina State University, Leonard Newcombe, Rhode Island School of Design, Doug Patterson and Moura Quayle, University of British Colombia, Chip Sullivan, University of California, Berkeley, Elias Torres (Martínez Lapeña-Torres Arquitectos), Enric Batlle (Battle y Roig), Enric Miralles (EMBT), Robert Camlin (Camlin Lonsdale), and Bridget Baines and Marcy Eaton (Edinburgh College of Art). Heartfelt thanks to those who have continued to play an active role in supporting me over the years and who have contributed to this book.

In addition, thanks to Atelier Carajoud, Claude Cormier, Hal Moggridge (Colvin Moggridge), Scott Dyde (GALA), Benedetta Tagliabue (EMBT), Beth Gali (BB + GG Arquitectes), Brian Goodey, Andrew Grant (Grant Associates), Bridget Baines and Elco Hooftman (Gross Max), Kathryn Gustafson (Gustafson Porter), Jeppe Aagard Andersen (JAA), Juul | Frost, Juurlink [+] Geluk, Andy Williams and James Harrison (Capita Lovejoy, Birmingham), James Hayter, Oxygen, Frits Palmboom, (Palmboom & van

den Bout Stedenbouwkundigen bv.), David Patten, Kim Wilkie (Kim Wilkie Associates), Beata Corcoran (Michael Vergason Landscape Architects) and Thijs Verburg (VHA). I have not been able to use all of the images and all the text, I have reduced and paraphrased as I thought necessary, so any mistakes are mine and mine alone. Thanks also to Malcolm Nugent, John Hawes and Nick Harrison for their photographs, to Dave Woodward at Adept Scientific, Norman Ashfield at BCU, and to Alex Lazarou.

Thanks to Martha Schwartz Inc, Capita Lovejoys, Birmingham and Carlos Jankilevich at the University of Costa Rica for the opportunities to investigate the consequences of these ideas in practice. Special thanks to Matilda Palmer, Ruth Morrow, Richard Weston and Paul Shepheard for their insights and friendship. At BCU I'd like to thank in particular David Tidmarsh, Peter Knight, Phil Walkling, Jim Low and Tom Jefferies for supporting my research and each and every one of the great students I've taught over the years. Particular thanks go to Alan Middleton for supporting me through thick and thin, to Jennifer Corcoran and to Birmingham City Council, especially Philip Singleton and Bharat Patel.

Thanks to my patient friends and family and finally to Lol. Without his scrutiny, patience and humour ... for everything. Couldn't have happened without you.

To Lol

OVERLOOKING THE VISUAL

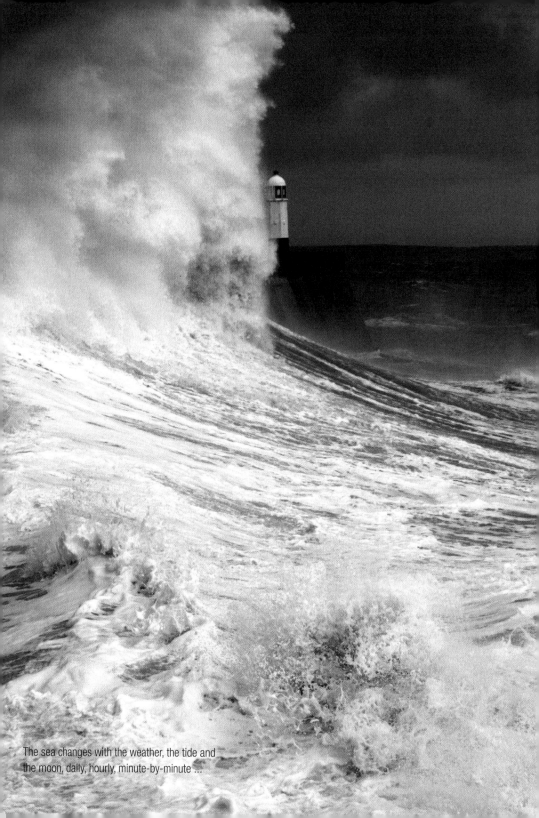

The sea changes with the weather, the tide and the moon, daily, hourly, minute-by-minute ...

Introduction

> Pragmatism, a termite 'undermining foundations, collapsing distinctions, and deflating abstractions'.
>
> (Menand 1997: pxxxi)

BORN OUT OF a passionate desire to improve design quality and a recognition that this can only happen through education, the main premise of this book is that a radical redefinition of the relationship between the senses and intelligence is long overdue. Written primarily from my perspective as an experienced teacher and practitioner of landscape architecture, the problems are not specific to this discipline alone, but are equally relevant to architecture, urban design and other art and design disciplines, as well as philosophy, aesthetics and education more generally. Deliberately crisscrossing the carefully demarcated boundaries and borders between philosophy, theory and practice, it aims to demonstrate the very real practical consequences of philosophical ideas and the philosophical lessons that can be learned from practice. The argument it puts forward helps clarify and resolve the great design riddle: why it is still largely considered to be unteachable and how we can dismantle this antiquated supposition, constructing in its place a means of dealing with spatial, visual information that is artistically and conceptually rigorous.

One of the main preoccupations of contemporary cultural discourse has been the argument for and against the existence of universal truth. By carrying this argument into the perceptual realm and adopting a pragmatic line of inquiry which questions the very nature of foundational belief, it becomes possible to offer an alternative, interpretative view of perception. With this one pivotal adjustment, the whole metaphysical edifice built on

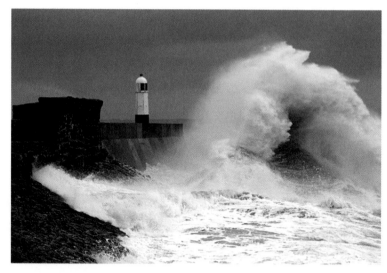

... the sun is a clock,
letting you know what time of day it is ...

the flawed conception of a sensory mode of thinking comes tumbling down. Constructed in its place is a means of dealing with spatial, visual information that is artistically and conceptually rigorous. This book examines some of the implications of this paradigm shift for design theory and education.

Although rarely articulated, the concept of the sensory interface is hugely pervasive, affecting almost every facet of Western culture. It lies at the heart of a common assumption that art involves a different conceptual framework from science, a different mode of thinking. It also underpins the idea that art is a pleasurable pastime whereas science is a serious endeavour, that it is possible, indeed preferable, to forget all you know in order to fully appreciate a piece of music, a painting or the landscape, embracing the sensuality of the experience with a clean slate, uncontaminated by knowledge or rationality. Why, despite so much evidence to the contrary, we still characterise scientists as cool, detached, unencumbered by emotion and artists as passionate, subjective and slightly deranged. Why we think decisions can be made on the one hand intuitively, without knowledge and on the other objectively, without value judgements. That language is linear and the emotions irrational and that

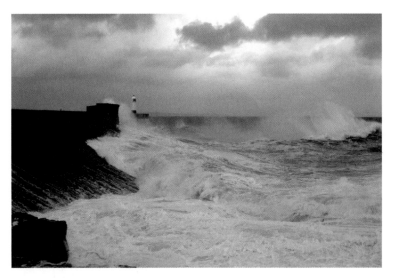

... and the force of the wind gives you
an unmistakable sense of exactly where you are ...

theory is separate from practice. At the centre of aesthetic experience, the sensory mode of thinking is what those learning to design are expected to reap the benefits of, if they are to be in any way successful. It distances nature from culture and makes it practically impossible to develop a holistic view or vision of the landscape.

Growing concern about the destruction of the environment in the name of development and the potentially dire consequences of climate change have at last pricked our collective consciousness. Cities across the world have strategies for sustainability, creativity and cultural identity. There is at last, a tangible recognition that the physical, cultural and social condition of our environment has a profound effect on the quality of life and is a vital component of sustainable economic growth. We know that good-looking quality places lift the spirit and have a dramatic effect on people's morale, confidence and self-worth. Dreary, unkempt, dysfunctional places make people feel unvalued and resentful. It's common sense really, a statement of the obvious. It's just a pity it's taken some of us so long to realise it. Now, it has become a political reality and we all have a responsibility.

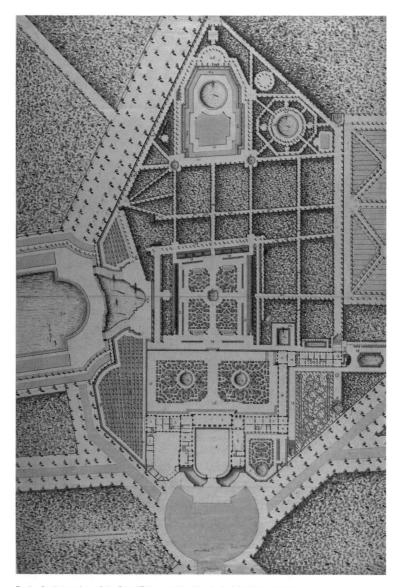

Design for the gardens of the Grand Trianon at Versailles by André le Notre (1694).

So what do we mean by the art of design? I first saw this remarkable design at an exhibition of landscape drawings from 1600–2000 currently on display at Het Loo in Appledoorn. I remarked to my colleagues that it would be wonderful if a student handed in a drawing like that. Wondering who had designed it we peered at the text and found it was by le Notre; it was his design for the gardens of the Grand Trianon at Versailles, accompanied by eight pages of manuscript connecting image and concept, ideas and form.

It is remarkable for many reasons. It exhibits astonishing skill and confidence in the expression of ideas in form, through technology, with elegance and panache. Far from being a slave to the geometry of the plan, the asymmetrical design is an imaginative manipulation of the spatial structure of the landscape, intensifying perspectives, foreshortening views, skewing natural crossfalls and creating vistas, connecting seamlessly with the landscape beyond. It is responsive to the topography and context, culture and time. Extraordinarily knowledgeable, skilfully exploiting the full range of the medium, this design is there to manipulate the emotions, express power and control movement. This is what the art of design is about. There is no mistaking its brilliance – if you know what to look for.

A powerful cultural force is currently undermining any serious attempt to develop the kind of expertise le Notre exhibits. It is, of course, possible to teach many aspects of design. There are books on design theory, criticism, history, its technology and modes of communication. There are guides on collaboration, team building and how to carry out design reviews. But large chunks of the actual design process, the real nitty-gritty of the discipline, are clouded by subjectivity and therefore thought to be beyond teaching. Design is often characterised as a highly personal, mysterious act, almost like alchemy, adding weight to the dangerous idea that it is possible, even preferable, to hide behind the supposed objective neutrality implied by more 'scientific', technology-based, problem-solving approaches. Talking about excellence is actually considered somehow undemocratic and elitist. It is this kind of dogmatism that impacts so negatively on our thinking about design.

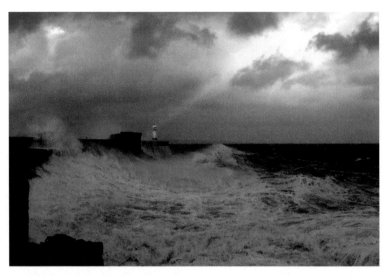

... as does the constant noise of the waves ...

The crux of the problem is that an intractable rationalist paradigm dominates our thinking to such a degree we no longer give it much thought. All manner of assumptions, suppositions and tall tales have moved beyond question and become self-evident, obvious and largely taken for granted. It is this philosophical tradition that actually prevents us from having informed discussions about the significance of the way things look, the material, physical qualities of what we see. Reinforced by a host of beliefs and suppositions it exiles materiality to a metaphysical wilderness where it languishes, separated from intelligence, safely hidden out of sight, out of mind.

This paradigm is manifested in the interface thought to exist between us 'in here', and the real world 'out there', apparently helping to correlate, crystallise, process or structure our sensory impressions to serve intelligence. It's called many things – a sensory modality, visual thinking, the aural or tactile modality, the experiential, the haptic – the latest I have come across is unfocused peripheral vision. Whatever it's called, however it's characterised, it is there to pick up the really important stuff. It sifts the wheat from the chaff, sorts out the things worth noticing. Discriminating on our behalf, it helps us understand the world. Dig deep enough however and all you find are value judgements masquerading as universal truth,

the 'real' truth that exists 'out' there if only we look hard enough, or are lucky enough to be clever enough, or sensitive enough to find it.

No one knows how all this really works. The actual mechanics of it remain a mystery, or as Jay puts it 'somewhat clouded' (Jay 1994: 7). From a pragmatic point of view, this perceptual whodunit is insoluble because the entire plot is based on a rationalist belief in different modes of thinking and pre-linguistic starting points of thought, a set of assumptions that have been with us so long they have become part of common sense. Ironically, despite all the post-modern rhetoric, concepts such as visual thinking, intuition, language, emotions, artistic sensibility and design expertise remain imbued with the fundamental Cartesian distinction between body and mind, between facts and values, real truth and mere opinions. It is a metaphysical duality that slips under the intellectual radar, disguised in visual and perceptual theories.

The consequences for those studying to become designers and ultimately for the places they create are potentially devastating. Nullifying any educational rationale for substantial areas of decision-making, within the arts there is instead a misguided dependence on concepts such as creativity, the genius loci, ideation or the mind's eye, delving into the subconscious or sharpening intuitive responses. This causes a good deal of confusion and bewilderment often reducing design education to an arbitrary second-guessing of what the tutor likes or otherwise leaving students either hoping they can somehow pick 'it' up as they go along, or left wondering what on earth 'it' is all about.

Whilst this makes what designers do seem rather mysterious and intriguing, it is, in fact, deeply questionable. The scant regard for materiality it engenders in design theory can only serve to obfuscate the understanding of any spatial, visual medium. But the implications of an imagined sensory interface are far more wide reaching. Responsible for the continuing distinction made between theory and practice, the separation of ideas from form, emotions and intelligence and a host of other misconceptions, it thwarts design pedagogy, fuelling the myth that anything other than the purely practical or neutrally functional is a bit iffy, too subjective, a matter of taste really and best avoided. Giving the impression that concepts such as artistic rationality, aesthetic sensibility and design expertise are

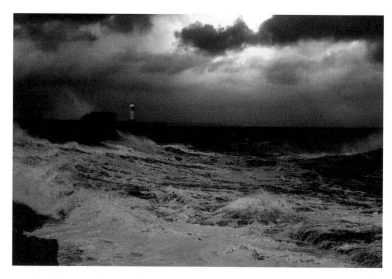

... the smell of the sea ...

contradictions in terms rather than credible educational objectives, it baulks any attempt to provide a convincing rationale for art education, still generally regarded as 'nice but not necessary' as Eisner reluctantly admits (Eisner 2002: xi). The prevalence of this dogma explains why a premium is out on reading or writing rather than drawing. We are not learning to be aware of our surroundings, to recognise our responses to place and space, and are rarely shown why things look like they do given the time, place or context. All things aesthetic remain firmly off limits. It is just not polite to use the 'A' word. More generally, it skews the way intelligence is defined or what counts as valid knowledge and gives a prejudicial and narrow view of the role of language. The same implacability militates against arguments for resources, space, time or money in competition with more so-called 'rational' disciplines. The upshot is that many theorists and those who are not practising designers can find it very difficult to imagine the effort, knowledge and skill it takes to work out the spatial qualities of a design. An eminent academic specialising in the role of drawing and design for example, asked why architects spend all that time drawing – why don't they just draw what they see in their heads and forget about all that sketching business? University administrators, struggling to understand why studios, expensive in terms of real estate, are necessary, ask why design can't be taught like mathematics or business studies with lecture

rooms crammed full of students, as well as asking why all that expensive tutorial time is wasted hunched over a drawing board. It plays havoc with the academic and research standing of art and design disciplines and makes it difficult to mount hard-nosed political arguments about the social and economic value of good quality environments. Pervasive and insidious, the rationalist paradigm disregards a rich and complex lost horizon of design. It really is that big a deal.

In order to ensure the education we offer is convincing and therefore sustainable, we need to up our game, rethink a good many presumptions we have about design, the bad habits, if you like, that we've gotten ourselves into. Addressing these issues also gives us the opportunity to have a sensible discussion about the art of design. This is not art in the landscape or art in front of or attached to the building, but artistic practice; the elegant, expressive and imaginative transformation of ideas in a particular medium. This is the only truly effective way to achieve design excellence.

It is not a question of rethinking how to design. There are plenty of brilliant designers around today who know how to do this only too well. It is more about re-evaluating the *way* we think about design. The conceptual void at the heart of the design process, the vast differences separating what it is that designers actually do from the way design is represented in both design and educational theory, how we talk and think of ourselves as designers when we reflect on our work, is fashioned by an almost inviolable mythology of innate skills, arcane traditions and deep-seated universal archetypes. To properly demystify the art of design we have to recognise that there is no choice but to engage with ideas at every stage of the design process and in order to develop artistic practice we need to express these ideas and feelings in space, words, shadow, light and form to manipulate and shape the quality of experience. The understanding that even the most intimate, seemingly magical elements of the design process are based on knowledge and knowledge alone, prepares the ground for a fresh artistic and conceptual approach to design, as well as establishing it as a holistic, critical endeavour. It has radical implications in the studio, setting a new agenda for tutors and students alike. It also offers an entirely different way of addressing design matters beyond the studio, providing a mechanism

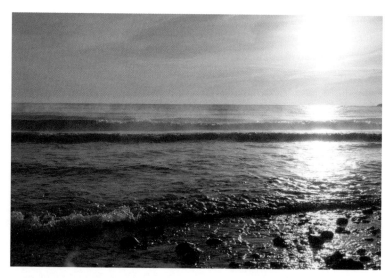

... and the taste of salt spray on your tongue ...

both to appreciate and work cohesively with the richness and significance of the social, physical and cultural context of our lives. More than anything else, it extends design right into the political/social arena, putting it at the heart of development and change as well as at the top of the quality of life agenda. A philosophical argument based on the recognition that consciousness, the landscape and the design process are not separate, fragmented issues, allows for the development of a more holistic approach. In turn, this challenges the deep-seated hostility towards design, excellence and expertise.

Any assault on the accepted order of things, the rationalist *status quo*, naturally attracts antipathy and criticism. Rorty, clearly no stranger to controversy, wearily explains that pragmatists are accused of being relativists or irrationalists, even 'enemies of reason and common sense' (Rorty 1999: xvii). To argue that the challenge is not directed at what might be seen as an obvious, universally accepted truth, but at 'antiquated, specifically philosophical dogmas' doesn't help much either, because he explains, 'what we call dogmas are exactly what our opponents call common sense. Adherence to these dogmas is what they call being rational' (Rorty 1999: xvii). James remarking on the cost of querying the metaphysical basis of disciplines, declares, 'A pragmatist turns his

back resolutely and once for all upon a lot of inveterate habits dear to professional philosophers' (James 1981: 28, first published in 1907).

The problem here is that the idea of a sensory resonance is so endemic it has practically become a fact of life. For some, it is impossible to consider that there may even *be* a problem. It is mightily difficult to think the unthinkable, to recognise that there may be something amiss with a statement of the blindingly obvious. I have been assured for example that visual thinking categorically does exist and that students are seen using it regularly. Just how I wonder? Does it arrive in kit form? Is it like a protractor or a compass? Is there really any evidence for it other than hearsay? It comes as a considerable shock to realise it is a philosophical construct rather than a foundational truth, just one version of events, one way of understanding the world.

It takes time, effort and planning to set the fuse that eventually leads to the explosion of a myth. To unpick swathes of conceptions and preconceptions, all the things that are taken as read. As one layer of interrelated beliefs is peeled away another is revealed. It is a complex and painstaking process. It requires reflective thinking, which Dewey says,

> is always more or less troublesome because it involves overcoming the inertia that inclines one to accept suggestions at face value; it involves a willingness to endure a condition of mental unrest and disturbance. Reflective thinking, in short, means judgment suspended during further inquiry; and suspense is likely to be somewhat painful.
>
> (Dewey 1991/1910: 13)

Letting go of the notion of a sensory mode of thinking does not, in any way, strip out the sensuous, ambiguous and exhilarating nature of art any more than that of mathematics or chemistry. Any discipline can be romantic, seductive and enticing, just as they may appear mundane and uninteresting. It is not to suggest that the design process is without values and intuition and no matter how hard we try, we cannot segregate emotion or imagination from any aspect of thought, discipline or practice, even though we may try to suppress our feelings. The senses are how we stay in contact with the world. But the view that the senses somehow tug at the

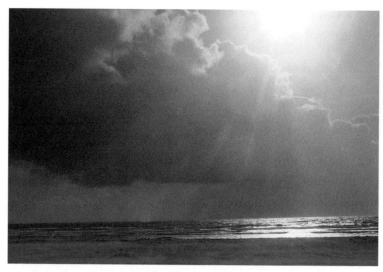

… the quality of light changes according to the wind, the pressure, the temperature and the humidity – the whole place is like a giant meteorological station.

subconscious to organise or filter information 'from out there' on our behalf, is at best unproven, at worst fanciful. The alternative is to consider the sensory qualities of design, but to do so intelligently, with knowledge, expression and technological prowess. Then we are more likely to create far better places that are responsive to the genuine needs and concerns of the people who live and work in them.

Calling off the search for universal archetypes, essences or the genius loci does not mean designers will inevitably become hard-nosed, scientific problem solvers. Dispensing with the idea that we all possess 'pure' vision or perception on to which culture and experience is added as a secondary gesture puts the onus on us to interpret and reinterpret our responses. Indeed it liberates emotions, intelligence and rationality from narrow, unrealistic and imaginary constraints. Most important of all, it suggests that what we see cannot be separated in any way from what we know. There is no need to look for anything hidden beyond or beneath what is already there in front of our eyes. Not that all disciplines or media are equivalent, a drawing is plainly different from an essay, mathematics is not the same as landscape architecture. However, distinctions between disciplines should not be made on the basis that some are more serious

or academic than others because they somehow get closer to universal truth. The differences between science and art are based on idiom, culture, tradition and means of expression rather than engaging different conceptual spheres of knowledge.

There are many different things that can engage and absorb us in different ways. Some of us may be highly skilled musicians, others expert draughtsmen, some able to work out the three-dimensional implications of a drawing with ease, whilst others struggle to read a map. The lack of spatial skill in this sense does not relate to an inability to engage a particular way of thinking. It is not about born talent or innate skill, but interest, inclination and practice. These factors are provoked or encouraged by experience, culture, personality and nurture. All these contribute to what we decide to spend our time thinking about, what we become interested in and what interests we pursue. It is fluency and familiarity within a particular medium of endeavour that has a bearing on the level of skill achieved, rather than the ability to switch on a different cognitive mode of thinking.

In design education, this kind of approach can certainly rattle some metaphysical cages and helps to democratise the design process. It empowers students so that they no longer need to rely on the poorly defined constructs that make them susceptible to the haphazard (and sometimes dubious) practices often encountered in the studio. Years of experience in that environment have shown me that this makes a real difference. Not only does it dispense with many of the intractable problems of design theory and philosophy but also from a student's point of view they can at last stand up and give a proper rationale for their work. They can lead the critic and, to a certain extent, take control. It shifts the balance of power a little. Outside the studio, it encourages a more rigorous debate. Closing the traditional divide between the theoretical and practical aspects of design it is an approach that has been used to re-conceptualise the way design is taught in undergraduate, graduate and postgraduate courses in landscape architecture at BCU Birmingham. Studios in BCU and exploring the design process have been developed in tandem with the research undertaken for this book, and are a reference point and source of many of the illustrations.

These images evoke strong memories of my childhood, growing up in Porthcawl, a seaside town in South Wales. I know this place; I have learnt over time to understand what it is I am looking at. There's nothing invisible or hidden beneath the surface. The landscape locates us by place, by time and day. And it is this understanding, knowledge of the visual particularity and the material qualities of the place that inspires and shapes my design ideas.

Dispensing with the metaphysical dimension of perception introduces a much-needed critical element to all of design education, not just certain parts of its theory or technology. Sensible discussions can emerge about the making of informed, imaginative and often difficult design decisions. It makes it clear that there is nothing magical or mysterious about all this, these decisions are the nuts and bolts of the process. An artistic rationale if you like. This above all, is what we need to learn if we are to get anywhere near the level of expertise evident in the work discussed at the beginning of this chapter. To help meet the responsibility and contribute to achieving design excellence, as educators, practitioners and advisors, we have to deal with the myths and fables that have obscured important aspects of design for too long. We have to claim the art of design, articulate it and encourage others to do likewise, weaving it into the fabric of the places we want to create. If we drive through rationalism's metaphysical fog we can rethink the design process and carve out a new discourse to teach design expertise, develop aesthetic and artistic sensibility and instil the confidence to make judgements in a spatial, conceptual medium. Finding a means to that end is what this book is all about.

There is a great range of tones, contrasts, colours and textures.
From soft, grey and muted …

The sensory interface and other myths and legends

> No theory is kind to us that cheats us of seeing.
>
> Henry James to Robert Louis Stephenson,
> on 12 January 1891 (Putnam 1999: 3)

LOOK MORE CLOSELY at the philosophical basis of theories of perception and the knot of complex, interrelated misconceptions and criticisms emanating from the idea of a sensory mode of thinking begin to unravel. It explains how the separation between the senses and intelligence happens in the first place and why rationalism has had such a devastating impact on our understanding of materiality. A quite different pragmatic and interpretative concept of perception creates a platform for a radical and far-reaching overhaul of design pedagogy.

It was Descartes in the seventeenth century who clarified the general thrust of what we understand to be the process of perception, giving us an enduring version of events that embodies the foundations of rationalist thought. The terminology used to describe the process today varies depending on the discipline, context and of course, fashion. We might for example, sense qualia, have sensations or hazy intuitions, we may perceive, intuit, or have direct awareness of experiences. However, in one way or another, it involves 'a "primal sketch", low level, depthless representation of the scene' (Costall 1995: 17) or momentary patchworks of colour expanses (Ryle 1990: 201) that are registered, translated and processed in some way to service intelligence in order to 'reconstruct a spatial and meaningful world' (Costall 1995: 17). Broadly this defines sense datum theories of perception.

... becoming bright, clear
and vibrant ...

... while the scudding
clouds tell you what's
passed ...

... and what's on its way.

Essentially it is thought that language is formulated to give expression to such sensory intuitions in order to communicate their meaning. In this way, conventional wisdom about perception and its relationship to intelligence puts the senses in a primitive, pre-linguistic place, creating a 'wordless consciousness' pre-dating language, which Eagleton ironically describes as an 'affair of consciousness, rather than of words' or a 'ghostly wordless mental act' (Eagleton 1983: 67). It is apparently what we call upon to access the genius loci, intuit essences or sense archetypes. These intuitions or impulses by definition exist independently of language. Together with other, similar structures of pre-linguistic consciousness, they are categorised by Rorty as 'natural starting points' of thought (Rorty 1982: xx). Their existence is one of the foundational assumptions of rationalism.

The premise of pre-linguistic starting points is dependent on the idea that there are universal truths external to our culture, another plank of rationalist thought. The thinking is that by stripping away preconceptions, we may be able to sense what is really out there just as much as we can sense in the mind's eye the true essence of things. The existence of timeless and unchanging truth is necessary, at least in part, to make sense of the infinite complexity of individual subjective worlds and to avoid the dangers of relativism. The identification of such truths, conceptually or in images, through aesthetic understanding, language, science, intuition or visual thinking, is crucial to the rationalist agenda.

All of this requires some pretty nifty mental gymnastics. Putnam describes it as the idea that 'the objects we perceive give rise to chains of events that include stimulations of our sense organs and finally to "sense data" in our minds' (Putnam 1999: 22), or to put it another way, that 'external things' are the *causes* of our 'inner experiences' or that the mind takes 'on the form' of the object perceived, 'without its matter' (Putnam 1999: 23–24). Ryle refers to this as 'Descartes' Myth' or 'the official theory', which he refers to with 'deliberate abusiveness' as 'the dogma of the Ghost in the Machine' (Ryle 1949: 17). What prompts a shift in our mode of thinking when we gaze at a picture compared to when we read the accompanying text, when we start drawing as opposed to writing, is unresolved, indeed, how the switch is achieved at all remains unclear. But the idea that there is a particular kind of mental processing going

on during a particular endeavour is a rationalist assumption that has persisted for so long it has practically become another given.

Naturally enough, the way in which perception is characterised reflects the preoccupations of the seventeenth century. In the face of significant advances in scientific observation, the spirit of rationalising, measuring and categorising nature for the first time is 'conceived of as the realm of mathematical law, of relations expressible ... by means of algebra and calculus' (Putnam 1999: 23). It became increasingly unacceptable to believe the evidence of one's own eyes; 'I couldn't believe my eyes', 'you can't trust first appearances' etc. The simple fact that a straight stick appears to be crooked when held partly submerged in water for example is cited so often it seems evidence enough to seal the reputation of the senses as being unreliable. Gradually perception becomes associated with intuition and the senses rather than hard knowledge. Along with feelings, emotions, intuition and all those other unreliable responses that don't fit comfortably into a rationalist framework, the senses are dismissed as mere 'subjective affectations of the mind' and as such, perception becomes little more than a primal response, epitomising what lies beyond measurable knowledge or behind the reality established by scientific methodology.

The foundations of this way of thinking actually have a far older provenance, emerging from the philosophical tradition of the 'peculiarly metaphysical dualisms' inherited from the Greeks, 'those between essence and accident, substance and property and appearance and reality' (Rorty 1999: 47). The basis of the common presupposition that a distinction can be made between mere opinion and genuine knowledge, objectivity and subjectivity, and a host of related and familiar concepts, these ancient beliefs also lie behind the idea that we can differentiate 'between elements in human knowledge contributed by the mind and those contributed by the world' (Rorty 1999: 47). However these are characterised, body and soul, body and mind, mind and matter, theories of perception are predicated on these divisions, culminating as Dewey remarks, 'in one between knowing and doing, theory and practice' (Dewey 1997a: 208). It is this fundamental split made between 'bodily sensation and mental representation' (Ingold 2000: 285), that establishes a rationale for the concept of a self-supporting realm of sensory experience. It introduces

the metaphysical dimension, a dependence on the unknown into the perceptual process, pervading epistemology, psychology and subsequently almost every other kind of cultural discource.

It is difficult to exaggerate how much the general understanding of intelligence is dominated by this divide and, in turn, the difficulties it creates. Reinforced by Cartesian theories of perception, it underpins all manner of positivist and subjectivist inquiry, explaining why contrary to expectations, what are usually taken to be distinctly opposite approaches are in fact dependent on each other, to all intents and purposes, two sides of the same coin. They have the same foundation. The visual is perhaps the most celebrated expression of a sensory mode of thinking. More has been written about it than any other, and its role in design and art theory and pedagogy is vital, if not conflicted. The following discussion concentrates on this nebulous concept to expose the flaws and problems of this sensory modality, although the analysis applies equally to other supposedly sensory ways of making sense of anything, in fact to any other kind of ontological way of knowing or being in the world.

There are contradictory views of the visual. The focus of considerable attention, on the one hand it is regarded as the holy grail of art education yet at the same time is derided and despised by many philosophers and design theorists. The most common view characterises the visual as an ancient more primitive mode of thinking, less sophisticated than verbal thinking, which is supposedly conceptual, intellectual and on a higher level (see Goldschmidt 1994; Koestler 1964). Each is thought to involve a different cognitive style. Visual thinking, it follows, having nothing to do with intelligence, is more likely to be subjective, intuitive and irrational, 'chaotic, instinctive and unpredictable' (Raney 1999), whereas verbal thinking, more usually associated with the cool rationality of language, is apparently linear, analytical and logical.

A raft of misconceptions directly related to this basic premise set the scene for a diminution of the visual, not only as a cognitive style, but also in the act of looking, the skill of seeing and the physical appearance of things. Partly it is a consequence of what James calls the 'psychologist's fallacy', the habit of slipping concepts across from one situation to explain another. Put simply, it is wrongheaded to assume that just because there

are objects in the world we are able to view them or talk about them objectively. It is an easy and casual borrowing of psychological principles and terms to explain concepts that have nothing to do with psychology (James 1884 #304: 65). Theories about different modes of thinking 'in here', that is to say a perceived cognitive mental style, pop up to explain what we think of things 'out there' in the real world.

The situation is made all the more complex by the presumption that the senses are discrete and function separately. This implies that not only do we use a sensory mode of thinking, but also experience the world selectively, one sense at a time, for example visually, orally or simply through touch. It informs the idea that things can be designed in a way that privileges one particular sense over another and even that landscapes or art can be appreciated from one sensory dimension, all of which is done viscerally, without thinking. But is it really possible to design for sound and touch, without considering the spatial or visual implications? Spatial dimensions, roughness, smoothness, materials, have visual, aural and tactile qualities. It is impossible to separate them. Is it reasonable to suppose that we can suppress our sense of smell, taste and touch? True, you can stick your fingers in your ears, to block out the passing traffic, but it is impossible to decide not to hear it, even though you may not always notice it. It is impossible to be in a landscape and decide not to feel the wind and the rain, not to sniff the air or hear sounds of life. You can protect yourself against them, you may well take them for granted, become casual about what notice you take of them, but you can't just decide them away.

The notion that the sensory inputs are separate, engendered by the penchant for dividing up consciousness, comes about, Dewey explains, because we presume that since we see a painting through our eyes and hear music through our ears, it is only too easy to think that such visual or auditory qualities are 'central if not exclusive' to the expression of the ideas, to the immediate nature of the work and to the way we experience the work (Dewey 1934: 123). Nothing he adds, 'could be further from the truth'. Suggesting that a painting or the smell of bread, 'are stimuli to which we respond with emotional, imaginative and intellectual values drawn from ourselves ...', he argues these are not to be seen as separate responses to be synthesised (no matter how quickly), but one response only (Dewey 1934: 123).

An added complication and contradictory scenario engendered by the distinctions made between vision and the other senses is fed by what Jay calls an 'essentially ocularphobic discourse' (Jay 1994: 15). Responsible for a vigorous denouncement of a so-called cultural over-emphasis on what is characterised as the dominant 'cool and distant realm of vision' (Pallasmaa 1994: 29), once again, the visual is singled out as a prime suspect, but this time from an entirely different perspective. Ingold summarises the list of trumped up charges brought against it,

> that sound penetrates, whereas vision isolates, that what we hear are sounds that fill the space around us whereas what we see are things abstracted or 'cut out' from the space before us, that the body responds to sound like a resonant cavity and to light like a reflecting screen, that the auditory world is dynamic and the visual world static, that to hear is to participate whereas to see is to observe from a distance, that hearing is social whereas vision is asocial or individual, that hearing is morally virtuous whereas vision is intrinsically untrustworthy, and finally, that hearing is sympathetic whereas vision is indifferent or even treacherous.
>
> (Ingold 2000: 251–252)

It's an impressive list of crimes and misdemeanours, prosecuted in particular by phenomenological discourse, with the visual as chief perpetrator and villain of the piece. Now installed as the primary instrument of objective knowledge it is held responsible for architecture having apparently turned 'into the retinal art of the eye' (Pallasmaa 1994: 29), creating a lack of sensuality or experience of being in the world, which is what Heidegger refers to as a loss of nearness.

The separation of the senses, one from another, together with the fallacy which James identifies, makes it almost inevitable that the perceived characteristics of a visual mode of thinking, either with all that irrational, subjective or cool and distant baggage attached, impacts on every aspect of the visual, physical world. Causing mischief and mayhem, it is, Ingold remarks, as if 'vision had been compelled to take on the mantle of a particular cognitive style and all the virtues and vices that go with it' (Ingold 2000: 286). The weight of prejudice against the visual distorts our conceptions of images and almost any other kind of so-called visual

information and the visual dimension of materiality, if considered at all, is regarded with suspicion. Reflexively we associate graphics for example, with 'illiteracy, delusion, shape shifting and colouring emotion' (Stafford 1997: 11). Images are seen as deceptive, seductive and notoriously unreliable, and questions of form, subjective and certainly not worthy of much attention. We are urged to 'avoid the gravitational pull of the object' (Borden and Rendell 2000: 5) and warned that focusing on what something looks like is an unnecessary indulgence, a 'retreat into form' used to 'justify inattention to function, construction, environment, and so on' (Schuman 1991: 4–5).

To counter these criticisms there are calls for a more socially responsible architecture, emphasising 'process and programmatic context' rather than 'formal expression' (Dutton 1991: 15). A stance usually adopted to criticise the ills of modernism, the mundane nature of many built environments is blamed on a priority given to the visual and formal qualities of design to the exclusion of acoustic, tactile or intuitive conceptions rather than acknowledging that these might simply have been badly designed. So-called 'visual' designs or stylistic objects are criticised because social practice is once again abandoned in favour of what are dismissively referred to as 'purely formal' investigations. To rectify things, Pallasmaa speaks of the need for a 're-sensualisation' of architecture to recharge the interaction of other senses with the world in order to deal with the problem. Translating into greater community liaison, participation with clients, user groups and the like, even though most appreciate that 'if poetry emerges all well and good', what something looks like is thought to be largely irrelevant, as though it were possible to design anything at all without some consideration of form.

The flagrant contradictions inherent in what is really no more or less than a rubbishing of the visual have, over time, seriously disabled design discourse. A good deal of highbrow psycho-babble has been written and talked about the visual, serving no real purpose except to heap further recrimination upon it. Long standing, but still unsubstantiated arguments from the 'cake and eat it' school of discourse appear to want it both ways. Whether sensory, earthy and intuitive or cool and calculating, distant and isolating, vision is the culprit, guilty as charged. Whilst idiomatically, seeing and understanding are almost synonymous, 'Do you see what I mean?'

or 'I can see your point of view' etc., it is clear, however, that as soon as we begin to theorise about the way we think, the urge to distinguish between seeing and thinking whilst at the same time becoming more and more metaphysical, becomes more and more irresistible. Ideas emerge that conflict as Ryle points out, 'with the whole body of what we know about minds when we are not speculating about them' (Ryle 1990: 13). The tortuous plot to 'separate out the discourse surrounding vision from the actual practices of looking, watching and seeing', is no longer convincing, it has become, as Ingold suggests, 'unsustainable' (Ingold 2000: 286). What we really need is a proper consideration of vision and seeing as it is experienced in everyday life, 'rather than as imagined by philosophers ... allowing the realities of experience to intrude on the hallowed turf of intellectual debate' (Ingold 2000: 286).

But that is not all. A further consequence of theories of perception is that in all of this, as intermediaries, whether it's the visual, haptic, or the experiential, it's the senses and the like that call the tune. It makes no difference if the agency is a belief in unconscious or subconscious archetypal structures in our minds or unchanging significant truths in the world, the process depends on the senses having a perceptive resonance or moment of clarity in order to recognise and filter information for us. To all intents and purposes therefore, we are passive. The self is not responsible, as Bryson observes, for 'constructing the content of its consciousness: it can do nothing to stem or modify the incoming stream of information stimuli; the visual field it experiences is there by virtue of anatomical and neurological structures that lie beyond its influence' (Bryson 2001: 29). Believing the senses give us the nod about the things worth knowing is in effect to subsume significant areas of decision making 'into the psychology of the perceiving subject' (Bryson 1983: xii). In other words, it lets us off the hook. The implication is that we don't see things on our own, that 'our cognitive powers cannot reach all the way to the objects themselves', a view Putnam argues, which is 'disastrous for just about every part of metaphysics and epistemology' (Putnam 1999: 10). The problem is that residing in the subconscious this mysterious sensory dimension is and will always be by definition beyond our understanding. How can you prove or disprove what you can never know? In thrall to the unconscious, deep-seated structures or archetypal resonances, we use the site, intuition, God, ecology, universal morality, whatever takes our metaphysical fancy, to justify our beliefs and

desires, rather than come clean and take responsibility for our own thoughts and actions in response to what we know. In doing so we are unwittingly building a safe-house for all kinds of hidden agendas.

One way to tackle the problem is by adopting a pragmatic approach. Since its emergence as an intellectual movement in the latter part of the nineteenth century, pragmatism's main thrust has been to question and debunk the metaphysical basis of disciplines. Cutting across the 'transcendental empiricist distinction by questioning the common presupposition that there is an invidious distinction to be drawn between kinds of truths' (Rorty 1982: xvi), pragmatism sets itself against the traditions of analytical philosophy, including those of language, evolutionary psychology, eco-psychology and phenomenology, which currently underpin much of design discourse. Analytical philosophy has many guises, but:

> from the point of view of the pragmatist, they all share the idea that there is a distinctively philosophical method of analysis that can be used to get to the bottom of problems about the mind, knowledge, meaning, truth and so on.
>
> (Menand 1997: xxxii)

It challenges evolutionary psychology with its 'central premise' that 'there is a universal human nature' and its belief that 'this universality exists primarily at the level of evolved psychological mechanisms, not of expressed cultural behaviours' (Barkow *et al.* 1995: 5). It questions the cognitive psychologists for whom the 'challenge lies in explicating the universal rules that govern perception' (Goldschmidt 1994: 159). Countering the argument that there is a collective subconscious or human memory, it suggests there are no predetermined end points and no universal truths to measure up to, even in vision and perception. In contrast, the aim of pragmatism, far from finding universal truths, Rorty explains, is:

> to undermine the reader's confidence in 'the mind' as something about which one should have a 'philosophical view', in 'knowledge' as something about which there ought to be a 'theory' and which has 'foundations' and in 'philosophy' as it has been conceived since Kant.
>
> (Rorty 1980: 7)

Scuttle the idea of an all-embracing truth that is the 'naked, rock-bottom, unmediated God's-eye view of reality' (Shusterman 2000: 115) and the controlling rationalist tradition in disciplines as varied as philosophy, sociology, history, law, cultural studies and education is holed below the water line. As Rorty advises, just because Platonic distinctions have become a part of Western common sense, is 'not a sufficient argument for retaining them' (Rorty 1999: xix). But it's hard to kick a bad habit. Despite a sustained onslaught, rationalism has, as Fish observes, proved 'remarkably resilient and resourceful' (Fish 1989: 345). If anything, it has become even more firmly entrenched.

James, Putnam notes, was criticising the basic dichotomy between seeing and knowing as far back as 1879, stating that in his opinion,

> the traditional claim that we must conceive of our sensory experiences as *intermediaries* between us and the world has no sound arguments to support it and, worse, makes it impossible to see how persons can be in genuine contact with a world at all.
>
> (Putnam 1999: 11)

But by the 1930s Putnam records that the traditional view of perception once again dominated and nearly 20 years later it was so well established that Ryle asks scathingly, 'How could one question the existence of sense impressions? Has it not been notorious, at least since the time of Descartes, that these are the original, the elementary and the constant contents of consciousness?' (Ryle 1990: 230). Calling the separation of the senses from intelligence a 'logical howler' caused by 'assimilating the concept of sensation', the physiological part of vision, 'to the concept of observation', the looking, 'cognitive' part of vision (Ryle 1990: 203), is a mistake which Ryle suggests not only 'makes nonsense simultaneously' of both concepts, but also contributes to the assumption that observation requires no attention or effort (Ryle 1990: 203). In other words, that it is possible to simply look, or glance at something without knowledge, just as we react unthinkingly to being prodded by a stick. Ryle argues that whilst observing involves having sensations, there is nothing 'mental' about these sensations. We observe (see, detect, perceive), on purpose, very often from inquisitiveness or obedience. When we observe, we may be 'careful or careless, cursory or sustained, methodical or haphazard,

accurate or inaccurate, expert or amateurish' (Ryle 1990: 194), but nonetheless, seeing is indivisible from thinking.

The dependence on this knot of rationalist beliefs continues to undermine serious attempts to learn more about the role and nature of vision. Ingold for example, traces the main positions ranging from the idea of vision as a mode of speculation (Jonas), to a mode of participation (Gibson), to a mode of 'being', as set out by Merleau-Ponty (Ingold 2000). In sequence, these move away from an absolute conception of the world and a 'defence of the idea of objective knowledge' towards the equally unsatisfactory suggestion that 'the world we know is to an indeterminate extent the product of our own minds' (Putnam 1999: 6). Even more recent discussions relating to the hermeneutical and interpretative nature of reasoning in design rely on the paraphernalia of image schemata, mental images, language structures, bodily experiences, tacit knowledge or pre-conceptual images. The fact that a firm adherence to the belief in different cognitive or sensory ways of thinking persists only serves to perpetuate the myth.

So why has this belief proved so resilient? Stafford suggests that it's because culturally we are 'mired in a deep logo centrism … a cultural bias convinced of the superiority of written or propositional language, that devalues sensory, affective and kinetic forms of communication precisely because they often baffle verbal resolution' (Stafford 1997: 23). Such chauvinism makes it almost inconceivable to think that anything drawn can have any intellectual basis. It may also be, as Putnam suggests, dismissed because mistakenly we think that too much time has already been wasted debating about the traditional problems in the philosophy of perception, 'as if we (are) were simply beyond them now' (Putnam 1999: 13).

The prejudices are deep-seated and resistant to change, so much so that the only real difference Putnam can see is in the 'nature of the arguments offered' to retain the original duality, which today he adds 'is defended more and more on metaphysical grounds' (Putnam 2002: 40). Remedies for the problem are generally variations on a theme, palliative rather than preventative, sticking plaster arguments about the interpretation of details within an established framework. None demand a systematic

Sharp, fine windy days arrive as a weather front moves across the sky, from the southwest …

… the contrasts become vivid and colours intense …

… and when the weather front has gone, there may be a temporary respite …

dismantling of the overall architecture of the paradigm necessary to deal with a doctrine that as Ryle puts it, 'is not merely an assemblage of particular mistakes. It is one big mistake and a mistake of a special kind', which he incisively calls the 'philosophers myth' (Ryle 1990: 17).

Without a fundamental shift in the argument, the idea of a sensory interface will remain unchallenged and intact. Replacing these old suppositions with a solid, pragmatic pedagogical framework then, is a matter of doing away with sense datum theories of perception. In this study, a pragmatic analysis is used to mount a further challenge to the metaphysical basis of perception in order to get what Bryson calls 'a firm grasp of the tangible world' (Bryson 2001: 31). This approach is not based on concepts of subjectivity or objectivity. It is interpretative, but not hermeneutical. Following the interpretative line a step or two further, it argues that not only is reasoning interpretative, as Best (1992) and Snodgrass and Coyne (2006) have suggested, but that perception also is interpretative. Rather than arguing as Arnheim and many others have done, that we should recognise the intelligence of perception, it is to argue that perception is intelligence.

The philosophical argument is surprisingly simple. From the early stages of this research, it was becoming increasingly clear that the initial proposal was flawed, actually not so much flawed, but part of the problem. The main issue it was trying to tackle, as in much of the research into the design process, was how to make a connection between visual and verbal thinking, creativity and rationality, intuition and intelligence, in other words between what are held to be different conceptual spheres of knowledge. Reading Rorty and other pragmatists, it became evident that it was a mistake to assume there is a difference to be made in the first place, wrong to think consciousness is fragmented into different kinds of knowing or intelligence. In addition, the characteristics of the subjective objective dichotomy that theorists and thinkers have been trying so hard to dispel over the last few decades, matches precisely that of the visual verbal duality. Both have the same foundational basis. If one dichotomy can be proved erroneous, then so can another. One simple move, take away the foundation stone, the very idea that there are different modes of thinking, and there is no need to worry about how the different realms can be reconciled. All those intractable problems melt away.

Disassemble the argument for different types of reasoning and the idea that there are different ways of thinking is similarly undone. From a pragmatic perspective, it follows that all thinking, whether in the arts or sciences is therefore interpretative and metaphorical; neither uses a special kind of reasoning. Essentially, this is to say that we think the same way no matter what we happen to be thinking about. In understanding emotions or equations, formulae or artistic responses we interpret, reinterpret, judge and try to make sense of our feelings because there is simply no other way to make sense of what we see, to make sense of the world.

Just because we are looking at a painting, does not mean we are thinking in pictures, or that when we are reading a book, we are thinking linguistically. Whatever grabs our attention or catches our eye; no matter what gets us thinking, we always get to think about it by the same route, through language. There are no exceptions, no special cases, ifs or buts. Language binds us, separates us, it quite literally defines us.

The implications of this analysis for the role of language are both surprising and profound. Rather than language being a 'medium in which we try to form pictures of reality', it is seen as 'part of the behaviour of human beings' (Rorty 1982: xviii), 'something that we *do*, as indissociably interwoven with our practical forms of life' (Eagleton 1983: 147). Pragmatism argues that even if we wanted to, it is impossible to move outside of the 'traditions, linguistic and others within which we do our thinking and self-criticism – and compare ourselves to something absolute' any more than we can 'step outside our skins' (Rorty 1982: xix). In this sense, language does not describe events 'out there' or seek to identify 'nature's own language', but is the context in which we operate. It is impossible 'to think about either the world or our purposes except by using our language' (Rorty 1982: xix). And it is not set in stone, absolute or definitive but transient and malleable, developed and stretched by our culture.

The significance of this kind of common-sense realism is that it enables us to avoid the rationalist polarity between an objective reality and subjective relativism that has caused many to oscillate, some might say vacillate, nervously between the two in a 'pattern of recoil'. Leaping 'from frying pan to fire, from fire to a different frying pan, from different frying pan to a different fire, and so on, apparently without end' (Putnam

. . . as the weather quietens down, the scale
of the sky is huge, overwhelming even —
these are big canvases.

1999: 1). This is something Putnam urges us to overcome by searching for 'a middle way between reactionary metaphysics and irresponsible relativism' (Putnam 1999: 5). It is precisely what this new interpretative definition of perception offers.

Redefining the relationship between the senses and intelligence means that essentially there is no need to choose one or the other. This releases us from the endless debate between positions that are natural or cultural, classical versus romantic, scientific or artistic, theoretical from practical, value laden from quantitative, or approaches that are personal or community based. This significant transformation comes about for the simple reason that we are no longer required to fathom out all those complicated interactions between 'sensations and the shaping or judging capacity of the mind' or quite how much 'participatory dimension' there is in the visual process between spectator and object (Jay 1994: 30). As a consequence, rather than trusting the world to pass messages to us through sense data, perfect forms or amenable spirits, we can rely on our reactions and responses being entirely dependent on the sense we make of what we see. We respond to the world through intelligence and that response is informed by education.

Concentrating on understanding the implications of this new perceptual perspective, this book demonstrates that there is almost no escape from the pervasive and hidden, the sensory interloper. No matter how much we might resist or even dislike the idea, most of us remain captivated by and dependent on rationalist ideals; no further proof is needed than the extent to which the metaphysical idea of a sensory mode of thinking continues to underpin epistemological theories. Clarifying the pedagogical crises this causes, indicating how it can be re-conceptualised, by focusing on particular facets of rationalism such as concepts of universal truth, objective neutrality and subjective irrationality, this book explores how new conceptions of the role of intelligence, language, the emotions, value judgements and objectivity can be used to demystify the art of design.

Teaching the unknowable

DEFINING ARTISTIC SENSIBILITY from a pragmatic point of view is actually relatively simple. A familiarity with and knowledge of artistic practice, the ability to recognise how ideas and emotions have been or could be, as Dewey puts it, worked 'over in terms of some definite medium' (Dewey 1934: 75) and having the skill and confidence to appreciate how effectively, appropriately and imaginatively this has been done; these are the essentials. It involves artistic judgement, aesthetic expertise and technological know-how. The kind of expertise we rely on when judging whether to follow one particular line of investigation or another, it informs decisions about the interpretation and transformation of form. Ultimately, we depend on it to determine what things look like and why and it is as much a part of designing as it is a part of criticism. At the moment, however, the concept of a sensory modality seriously undermines the teaching of these important skills. Exposing how the many manifestations of visual thinking actually thwart learning rather than encourage it, explaining how an alternative, interpretative view of perception can be used to develop an educational rationale for teaching visual skill as a critical endeavour, is the first stage in developing a new pedagogical strategy.

Championed by many as the very antithesis of intelligence, it is in the arts where the influence of a sensory mode of thinking is most telling. Here the metaphysical fog obscuring materiality and rigorous artistic discourse is at its thickest.

Making matters worse is the fact that this obfuscation is a cause for celebration rather than concern. Understanding Dewey's perspective

requires dispensing with every trace of a dependence on sensory intuitions and the associated paraphernalia of a psychological undertow that is so integral to the nomenclature and reference points of art and design education.

Get curious about art education or delve into the mechanism of the design process and sooner or later you come across the idea of the visual. Dig deeper and its significance becomes all the more apparent. By its nature indefinable and arcane, the mystique of the visual remains as powerful today as it was in Athens two and a half millennia ago. There is a presumption that it is self-evident, hence the lack of hard evidence. There is little point in proving the existence of something you already know to be there. It may not be referred to explicitly, but the concept of visual thinking lies beneath most assumptions about art and design education, creativity and aesthetics.

Extraordinary power is ascribed to a sensory mode of thinking. It is thought to be the capacity to think in pictures, which apparently explains how we make sense of images or recognise shapes or think creatively. Frequently taken to be the repository of creativity and key to the rare and special art of generating form, it is reckoned to play a significant role in developing an aesthetic way of knowing and is what we use to look at what is in the mind's eye. Visual skill, in this sense, is the ability to express and make visible these ideas. Seeing 'intuitively' is associated with being subjective, emotional and unrelated to intelligence. Many, believing essences, archetypes and the like are intuited through the senses, advocate a heightened acuity of the senses in order to perceive them. The senses are thought to play a pivotal role in identifying what Bryson decries as the 'universal visual experience' believed to be resurrected by great art (Bryson 2001: 25). Given impetus by Langer's suggestion that art expresses 'forms of feeling' and such feeling is perceived through the senses or imagination (Langer 1994: 225) a sensory way of knowing is considered to be the single most important thing that the various art forms have in common. Artistic insight, quintessentially indefinable, is regarded as an intuitive power. Imaginative, spatial insights are thought to belong to a 'metaphorical and mythical' realm existing outside the 'objectivist domain' concerned with a 'non-logical revealing of reality' (Snodgrass and Coyne 2006: 192), and artistic expression is 'engaged

with pre-verbal meanings of the world, meanings that are incorporated and lived rather than simply intellectually understood' (Pallasmaa 2005: 25). As a story it is seductive, familiar and palpably lacking even a shred of evidence.

The overriding concern of art education has been to develop visual literacy or what Eisner calls the 'visual sensory modality', in addition to 'aesthetic sensibility and the capacity to be creative' (Eisner 1972: 67). It remains the case, however, that to talk about teaching artistic sensibility is an oxymoron. Artists are supposed to do, not think. Elkins, for example, suggests the idea of teaching art is 'irreparably irrational' (Elkins 2001: 189), and 'a curious endeavour to teach the unteachable' (Elkins 2001: 104).

At the core of the argument that there are different types of thinking lies the acceptance of different kinds of reasoning, one logical and analytical, the other idiosyncratic and irrational. This, of course, is part of the presumption that there are different ways of understanding the world, typically one being analytical and scientific, the other artistic and subjective. Design is thought to be unusual in that it sits 'uncomfortably' astride these conventional categories of knowledge and activity (Lawson 1993: 7). The sensory mode is what we are supposed to rely on whilst sensing the essences of place, the structure of things lurking invisibly beneath the surface or accessing archetypes that may not be immediately apparent. In fact all of the so-called subjective aspects of design, finding inspiration, a concept, transforming ideas into form and so on are consigned to this arcane and mysterious idiom one way or the other. A significant amount of time is therefore spent creating complex strategies to build bridges or gateways between what is characterised as the emotional, intuitive aspects of design and the logical side, which deals with practicalities and language. Similarly, trying to understand the creative possibilities of a 'confusion of thought and perception' (Davey 1999: 8), working out how we can synthesise thinking in images with thinking in words, as well as how we might teach such a skill has become a preoccupation in design research. In contrast, speculation about what is actually perceived is negligible, despite as Ingold observes, this almost certainly being a far more significant question to ask.

The problems caused by the idea of a sensory modality become all too apparent at the interface between philosophy and practice. In fact query the various assumptions and interrelationships of this paradigm and you begin to realise the near impossibility of working within it as a teacher. Reminiscent of other sensitive, bodily ways of knowing, visual thinking is predictably beyond learning, it cannot be acquired or cultivated. Yet if visual skill is some kind of innate 'gift' or subconscious attribute then how does one develop it? As far as many theorists are concerned, intuitive vision (the sensing of significant structures) is not an analytical skill and so it cannot be 'consciously taught or followed' (Hale 1994: 6). Holl *et al.* acknowledge how difficult it is for students following the phenomenological route, to become 'seers' (Holl *et al.* 1994: 134). Delving beneath the surface, trying to see what is truly there, without the constraints of language, can't be at all easy, although Holl *et al.* promise it to be an intense experience. They insist that 'these are not simply emotional encounters; nor are they strictly intellectual or academic, they are three and four-dimensional pure perceptions' (Holl *et al.* 1994: 134). But what is it that these students are supposed to be seeing? The visual dimension is acknowledged, but invisible. And the suggestion that if you 'think' about what you are looking at, you've not only missed the point but also the chance to ever really 'know' what is there is ethically dubious at the very least. Is it possible to teach something which has no intellectual basis or is purely subjective? Is it possible, as Boden asks, to develop tacit knowledge, or intuitive seeing 'without being explicitly taught?' (Boden 1990: 25). If so, how?

The proposition that we can consult now and again as we wish the mind's eye using a 'special kind of perception, namely inner perception or introspection' (Ryle 1990: 16) is equally whimsical. An integral part of the doctrine, apparently what we find will be 'immune from illusion, confusion or doubt' having a 'certainty superior to the best that is possessed by its reports of matters in the physical world' (Ryle 1990: 17). It is absurd, Ryle concludes, but despite attempts to debunk the legend, it remains a central tenet in many theories about the design process. It is one of the reasons many students rebel against studying the culture and traditions of their own discipline, afraid knowledge might contaminate the purity of their own mind's eye.

Furthermore, if visual skill is innate, why should it be selectively inherent, available only to a chosen few? Schon recounts a student described as 'totally unvisual' because he hasn't 'internalised some of the covert things' (Schon 1991: 81). The presumption is that he is unlikely to make it as a designer. But what does 'internalising covert things' mean? Schon, whilst not defining visual skill, suggests it is not teachable, but it might be 'learnable and coachable' through 'the art of reflection in action' (Schon 1991: 158). This involves a critique, where drawing and explanation, hand in hand, reveal qualities, particularly experienced qualities, which defy verbal description alone. To suggest that visual skill is acquired not through learning, but subconscious empathy and experience, as if it might seep into the psyche by stealth, is singularly unhelpful for a novice student. Just what is experience other than what we have learned? Acquired over time certainly, but learned nonetheless. To suggest there is a kind of osmosis going on is ducking the issue. It is another example of the fusing, merging and blending of irreconcilable opposites, without any convincing explanation as to how this might actually be achieved.

There are many tactics adopted to encourage students to become visually literate, without learning or thinking, simply by sensing the essences of place and navigating the uncharted netherworld of the soul. One option is the suggestion that there is a visual language, one and only one, that can be learned like any other language. As a concept this sounds plausible, convincing even, but the reality is very different. What does this visual language look like? Does anybody know? Surely if there is a visual language there would be a visual dictionary. It would have been well defined, described and articulated by now. In fact there are many different visual languages, such as those described by Kandinsky (1979) and Kepes (1994), or the visual grammar defined by de Sausmarez (1961). But none of these seem to quite fit the bill. When a particular version of the visual language is taken out of its context, be it the medium, the time, or the culture, it fails, singularly. This is what makes it so confusing. What has been defined as the visual language, doesn't look right, make sense, or apply. Clearly it is not culturally detachable or independent of context.

Within psychology and the arts, the link between visual skill, drawing, intuition and perception is taken for granted. Drawings are thought to record not only visual impressions, but also represent a measurement of

visual skill. It follows that an obvious way to improve your visual skills is to improve your drawing skills. This is a well-rehearsed argument. Drawing is thought to improve the power of observation and may enhance the ability to externalise what is in the mind more quickly and effectively. Learning to draw might help people to become more expressive (Thomas 1995: 70), and accessing the 'right side of the brain' (Edwards 1989) or 'the artist within' (Edwards 1990) are ways, according to Edwards, of becoming more aware of intuitive responses, or connecting with the subconscious. The act of pulling a pencil across the grain of the paper is thought to graze or stimulate the senses, giving a more meaningful sensory buzz than could ever be achieved using a computer.

But do drawings really represent a level of visual skill or do they merely show how well somebody can draw? What is actually drawn seems to be irrelevant. Drawing in itself is supposed to enable us to understand more, visually. The question hardly ever asked is, to understand more about what? In what way does life drawing, for example, improve observation or design ability in landscape architecture? Is this knowledge really transferable from one medium to another? From a pragmatic perspective the idea that drawing somehow accesses intuition, a visual mode of thinking, grazes the senses, kicks part of the brain into touch or makes us more sensitive to our emotional responses is not only misguided but also diminishes the importance of drawing in any curriculum because of the way it disassociates drawing from language and intelligence. All in all, the philosophical ramifications of perceptual theory impact directly in the studio, to create real, practical problems. Preventing critical, intelligent discussions about what we are looking at and concealing the visual dimension of a spatial medium, small wonder many consider it altogether impossible to teach design.

The many compelling arguments regarding the interpretative nature of reasoning, even the rationality of feelings, have had little success in wresting artistic practice from the grips of subjectivity. This forces the arts into a weakened academic position. Efforts to bolster this position are eloquent but, in the end, also have to be seen as rather unconvincing permutations on a theme. Strategies include the argument that the conceptual and the sensory are far more closely related than is generally understood, or that the sensory has its own special intellectual kudos or

qualities. Arnheim, for example, emphasises the interdependence of what he describes as the different cognitive procedures of intuitive perception and intellectual analysis. Summarising the 'edifice' of his theory of the psychology of art, he explains that sensory perception, especially the visual, is the dominant way of dealing with the world of reality, because it is not just 'a mechanical recording of stimuli imposed by the physical world ... but the eminently active and creative grasping of structure', adding that it is 'pervasive perceptual expression' that makes the arts possible (Arnheim 1986: x).

Having spent a good deal of effort jettisoning the disastrous idea that artistic learning is simply 'an automatic consequence of maturation', Eisner promotes the critical dimension of the arts by adding a long list of supposedly cognitive benefits. These include helping us to have aesthetic experiences, to see the world in new ways, to engage the imagination, to enable us to tolerate ambiguity and explore uncertainty, to utilise the subjective side of ourselves, to direct attention to what we feel, and to stabilise ideas and images (Eisner 2002). Arguing rightly that perception in the end is a 'cognitive event' and that 'what we see is not simply a function of what we take from the world but what we make of it' (Eisner 2002: xii), Eisner is unable to relinquish the lure of the sensory. He goes as far as to propose that sensory perception is the very basis of all thinking and the source of conceptual ideas, arguing that 'concepts are distilled images in any sensory form or combination of forms that are used to represent the particulars of experience' (Eisner 2002: 3).

Hermeneutic, semiotic and cultural theories emphasising the contingent nature of interpretation reflect a desire to advance the intellectual dimension of the arts, as does a broadening of the debate to include cultural bias, codes of representation, particular ways of seeing and interpretations of visual meaning. The aspiration to create closer links between the supposedly different conceptual realms of knowledge, evident in the specifications of programmes and assessment criteria for both school and university education in the UK, is also recognition of the problems the separation causes. But in each of these examples, the critical dimension is weakened by the fact that theory and practice are still taken to be subjects that are 'distinctly different in fundamental respects' (QAA 2001: 2). So whereas it is accepted that art practice 'almost always

combine(s) the conceptual and the practical' (QAA 2001: 5), little guidance is given as to how this combining might be realised.

No matter how forcefully it is argued that these separate modes of thinking are allied, related or even contain bits of each other and even though Eisner insists he takes his lead from the American pragmatist William James, none of these propositions address the fundamental problem. They all work with the idea that there is a separate way of knowing that remains the antithesis of intelligence. Therefore, the deep-seated misconception that the arts are therapeutic rather than intellectual; subjective, emotional and rarely equal to more 'solid subjects' (Parsons 1987: xiv), lingers on. It may well be that as Parsons pointed out some time ago, we still 'know less about teaching the arts than about teaching any other school subject' (Parsons 1987: xiv), but the question has to be asked, is this actually self-inflicted ignorance?

It is ironic that the very thing that appears to make the arts distinctive and special, this arcane world of sensory, emotional and intuitive thinking, is what continues to isolate artistic sensibility from critical intellectual discourse. For as long as the process of perception is left unchallenged, the metaphysical foundation of artistic practice will continue to cloud the issue, forcing us to seek artistic expression via the myth of artistic fury, genius and poetic rapture, thinking that creativity belongs in the unconscious, is dependent on 'ideational' leaping between different modes of thinking and that learning artistic skill is uncontrollable, akin as Elkins (2001: 95) suggests, to catching an infection.

The alternative interpretative view of perception enables us to envisage visual skill as a truly critical component of artistic sensibility, neither generic nor archetypal, but a learned, cultivated skill, comprised of observation and discernment within the traditions, materiality and ideas of a particular medium. Teaching visual skill on this basis recognises that there may well be cultural resonances and common influences between related disciplines, but these are determined by values that change differentially not by permanent truths, and that understanding what we see is neither subjective nor objective, but interpretative, based on our experience of the physical, material world around us.

Developing an understanding of how our responses are affected by what we have read, seen and heard, recognising the significance of the social and political context of what we see, realising what a landscape might symbolise or represent and being able to interpret the evidence of its history, this is visual skill. All of these things affect our view of a place. When you first see the Manhattan skyline or the Statue of Liberty, the impact is so intense because of the associations gleaned from numerous books, films and anecdotes. These influences flood in because we recognise directly the physical fabric of what we see, its spatial, visual qualities, its form and character, its myths and legends.

When we read a book, examine a painting, or walk through a landscape, clearly, we are looking at and experiencing different things. But, in fact, one medium is no more or less visual than any other. The words or numbers on the page, the brush marks on the canvas, the texture and form of the landscape all have spatial dimensions. They are all things we can see or imagine. How much sense we make of what we are looking at depends very much on our knowledge, experience and familiarity with the medium of our inquiry, whether this is abstract art or nineteenth-century literature, contemporary physics or neo-gothic follies. It also rests on how much notice we take, how casually or keenly we choose to observe. Recovering the intellectual dimension of the visual undoubtedly strengthens the argument for teaching visual skill and drawing as a part of any curriculum.

Shifting paradigms from the metaphysical to the pragmatic enables us to understand more about the nature of visual skill and the role it plays in design. It does not mean that mystery and ambiguity no longer have a place, or even that designs cannot be inspired by metaphysical concepts. But it does mean that we can remove some of the mystery from the actual process of designing. Visual skill can be seen as something that we need to learn in order to become designers. If we want to offer a convincing rationale for art and design education and are seriously concerned with improving the education we offer, then it is time to stop overlooking the visual.

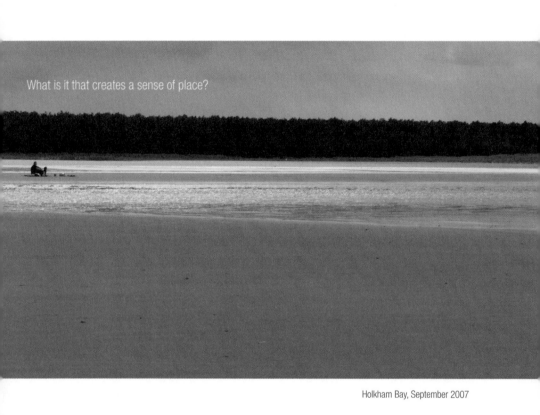

What is it that creates a sense of place?

Holkham Bay, September 2007

Aesthetics:
the truth, the whole truth
and universal truth

Indeed I decided that I lived under a delusion
– the delusion of truth.

(Daniel Everett, *Don't Sleep, There are Snakes*, 2008: 272)

AESTHETICS IS CENTRAL to artistic practice. An examination and critique of the philosophical basis and psychological dimension of aesthetics is therefore crucial to our understanding of the art of design. Suggesting the same philosophical flaw does more harm than good, this chapter uses theories associated with a sense of place to highlight the shortcomings, particularly those created by a dependence on universal truth, in the studio and in practice. Constructing an entirely different basis from which to understand aesthetic experience unlocks a major part of the debate, the trick, once again, is to disengage aesthetics from the primitive bodily ways of knowing, disentangle it from psychology and use a fresh, common-sense approach to bring materiality back into the picture.

Typically, aesthetic experience is believed to be an intense feeling stirred by the perception of beauty, quality and perfect form. Variously categorised as illuminating, comprising of a concentration of attention, revelation, inarticulateness, an 'escape from rationality', enough to take our mind off 'all constraints of cognition or purposive activity' (Shusterman 2001: 136), it is even enough to 'make us forget for a moment about language and reason, allowing us to revel, however briefly in nondiscursive sensual joy' (Shusterman 2001: 148). Associated with a way of knowing that is fundamental or 'sensuous' (Taylor 1992: 2), it is 'experience that brings emotion in its train' (Hill 1999: 86). The mechanics of the process, as much

as they can be, are summarised by Eagleton with some irony. He suggests it is apparently 'felt instantly on the pulse', as 'within the dense welter of our material life, with all its amorphous flux, certain objects stand out in a sort of perfection dimly akin to reason and these are known as the beautiful'. Higher reason is 'necessarily blind' to these things, but the aesthetic faculty knows 'instantly, without arguing or analysing, just by looking and seeing' as 'a rigorous logic' is 'revealed to us in matter itself' (Eagleton 1990: 17). It seems pretty clear that this apparently exultant, near transcendental rapture is thought to have little or nothing to do with intelligence. Judging from the above, it appears to be more akin to a narcotic 'high'.

Most of us shy away from talking about aesthetics, thinking of it as an area of philosophy anchored in the ideas of Plato and Aristotle. But why should they have a monopoly on the subject or even determine how we speak about it? Aesthetics should be an increasingly important part of any discussions about design excellence. It should provide designers with a spatial and conceptual vocabulary to create good quality places. But the way things stand, to consider aesthetics at all is thought to be a bit of an indulgence, it's optional, fine if you can afford it but the first thing to be ditched when the going gets tough. The debate may be interesting, but it carries little weight compared to the provision of schools, amenities, the numbers of homes or books – the quantifiable hard facts. Yet we're aware of aesthetics all the time. We buy things we like the look of, visit our favourite places; admire the views. Take where you live for example. If you have a choice, why do you choose to live where you do? What sort of place would you want your children or grandchildren to grow up in? These decisions almost always relate to the quality of the environment; in other words, the aesthetics of place. Perhaps aesthetics is not as complicated or contentious as we are led to believe.

We need look no further than its philosophical foundations to understand why things appear to be so fraught. Eagleton summarises this in his introduction to aesthetics. 'Born as a discourse of the body' he suggests, the mysterious faculty known as the aesthetic is actually a relatively recent conceit, emerging in the eighteenth century, when reason was established as the 'absolute monarch' (Eagleton 1990: 13–14). In the heady scientific atmosphere of the period, Baumgarten, building on Descartes' theory of

Portsmouth sea wall.

Aesthetic theory should help to explain why we
respond to places the way we do ...

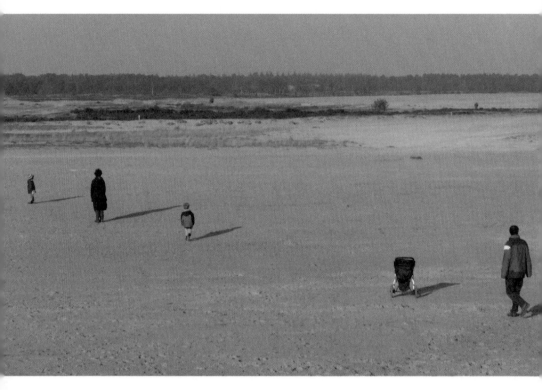

National Park De Loonse en Drunense Duinen, Netherlands.

... and why certain places make
us feel elated or comfortable ...

perception, segregates the aesthetic into yet another separate conceptual sphere of knowing. The burgeoning rationalist paradigm could never retain 'its legitimacy' if 'what Kant called the "rabble" of the senses' (Eagleton 1990: 14) remained out of its ambit. Creating what Eagleton describes as 'the sister of logic ... a kind of prosthesis to reason', would enable reason itself to 'penetrate the world of perception' without risking its own lofty status (Eagleton 1990: 15). Holding the conceptual and sensory in a precarious balance, it brings sensation and feeling 'within the majestic scope of reason itself', whilst keeping them in their place as a kind of 'cognitive under labourer' (Eagleton 1990: 15–16). In other words, what is concocted here is a clever embellishment of the interpretative veil; its purpose to mediate between the irreconcilable opposites of emotion and reason, intelligence and the senses. What is dreamt up is yet another 'hybrid form of cognition' to 'clarify the raw stuff of perception and historical practice' (Eagleton 1990: 16).

Call it a myth, a construct or philosophical sleight of hand, but what it has been without a doubt, is enduringly successful. The conceptual side of the discipline develops as 'the theoretical counterpart to art ... the science of sensuous knowledge' and 'a philosophy of the beautiful' (Staniszewski 1995: 119). As an evaluation and critique of the arts, it is often highly esoteric, intimidating and, to the uninitiated, obscure. The sort of thing we might think of as important for us to know about, without being entirely sure why. The sensual side, the foggy perceptual world of feelings, intuitions and imagination becomes the repository of all things artistic, seductive and creative; a kind of primitive knowing. Straddling the conceptual and the sensory gives aesthetic theory extraordinary flexibility and latitude, but contributes little to developing artistic practice. In fact, by stitching the tenuous relationship between reason and emotion so tightly into the artistic fabric of our culture, this indefinable force, 'the theory that cheats us of seeing' cheats us of artistic sensibility too.

Associated with beauty, taste, genius, and therefore a matter of wealth and privilege, aesthetic discourse becomes an elusive and rarefied subject. In attempts to democratise the concept, it has been widened to encompass revelatory responses to ethical and moral truths and concepts of goodness. No longer restricted to works of art, it is not simply a question of how

… it should provide designers with a spatial and conceptual vocabulary to create good quality places.

The conceptual sketch for the Sundspromenaden, Malmö, overcomes the
3.10m height difference between land and sea to bring you closer to the water.
Sundspromenaden, Malmö, Sweden
JEPPE AAGARD ANDERSEN

The substantial timber promenade and staircase built over the high protective
stone sea wall gives a new horizon to the Øresund, an urban walkway along the
coast and the town of Veste Hamnen a completely new relationship with the sea.
Sundspromenaden, Malmö, Sweden
JEPPE AAGARD ANDERSEN

The swimming area at Barcelona Forum 2004 provides a landscape from coast to island, from the island to the sea, free of boats, free of danger. A cavity formed by massive concrete walls creates a controlled area of calm water for swimming and future facilities related to thalassotherapy. The beach, bounded by a stretch of wetland and shaped platforms of white marble like small ice floes, is situated far out enough to sea to be deep enough for diving.

BB + GG ARQUITECTES, BARCELONA

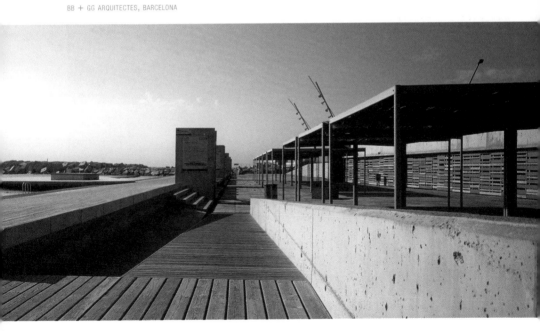

things look, in fact running through a whole range of aesthetic theories is the same highly pejorative attitude towards the visual underscoring the supercilious contention that whatever it is determining our responses, it is certainly not 'merely' visual. It may well be acknowledged as a component, but is also thought to be a distraction.

The physical, material qualities of place are thus edged out of the frame because an appreciation of such things is considered too subjective or ephemeral to matter. In design, marginalising the visual dimension is to sideline the physical form of the landscape, which is systematically overlooked in the search for invisible or hidden meaning to supply the aesthetic buzz, reflecting the position Whitely observes, that 'the attention to art is lost amidst intellectual preoccupations and with it there is lost an art of critical looking' (Whitely 1999: 99). Through long-term neglect and discrimination, we no longer have the confidence, the appetite or even the language to talk about appearances.

Hong Kong Wetland Park
URBIS LTD, HONG KONG

Aesthetic theory should help elucidate the
potential and possibilities of the medium ...

Aesthetic experience is seen as a more extreme, edgy kind of perception, associated with 'shadow lands' inhabited by 'botched representations of perfect forms that exist elsewhere' (Bragg 2005). As in perception, the process whereby the aesthetic faculty perceives these forms without interference from cultural, social or educational conditioning, without language even, remains unknown; indeed some might say, unknowable. Exactly what it is that stimulates this extra-added lift over and above plain, ordinary perception is again a mystery. It comes as no great surprise to find that despite centuries of inquiry, there isn't a template, a definitive way of describing what it is or how it happens. Notoriously intangible and haphazard, there is no way of replicating aesthetic experience or even knowing what might cause it.

The fundamental dichotomy between body and mind enshrined in perceptual theories creates an insuperable quandary that endures within any aesthetic experience. Is the resonance of the experience created by the recognition of something perfect, an unchanging truth out there in the world, or by a frisson with innate, archetypal structures in the mind, the subconscious, pre-conscious or some kind of universal knowledge embedded in our genes? The age old question as to whether beauty is inherent in objects, or projected on to them by the mind. Is beauty objective or subjective? Once again, whichever way it is thought to be determined, subjectively or objectively, emotionally or rationally, howsoever an aesthetic shudder is triggered, there needs to be some kind of psychic connection between the mind and whatever it is 'out there'. Again, it raises the question, can we ever satisfactorily explain how as Ryle puts it 'stimuli, the physical sources of which are yards or miles outside a person's skin, can generate mental responses in his skull, or how decisions framed inside his cranium can set going movements of his extremities' (Ryle 1949: 14)? You have to wonder just how what Arnheim calls the 'expressive qualities borne by stimulus data' can possibly 'provide visual roots for knowledge' (Arnheim 1986: 195–6)? It seems that although the ether may no longer be scientifically viable as a means of transport, the capacity of air to carry messages of one sort or another obviously remains intact.

Les quais de la Garonne à Bordeaux, 'Mirror du eau'.
ATELIER CORAJOUD, FRANCE

… its materiality, its culture and traditions …

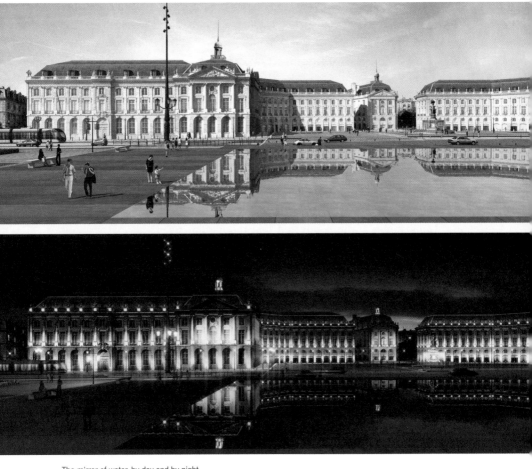

The mirror of water, by day and by night.

The reflection of Gabriel's Stock Exchange Building, Place de la Bourse, Bordeaux, in a puddle on the roof of the former buried hangar was the inspiration for the idea of the water mirror.

Aesthetic discourse more than almost any other, is explicit about the dependence on the idea of universal truth. It may well be unfashionable and often denied, but whereas in other arenas the concept is usually more insidious, aesthetic theory tackles head on the impossible odyssey to fathom the unfathomable. The traditional realist view of an absolute conception of the world that has 'a totality of Forms, or Universals or "properties" fixed once and for all' (Putnam 1999: 6), and the belief that aesthetic experience is the recognition of such forms, demands that a prerequisite of aesthetic theory must be to identify what these universals are. Interestingly, it makes no difference whether the theories emerge from transcendental philosophers believing 'that there was more Truth to be found' than in the natural sciences, or through empirical philosophers who suggested that the natural sciences – 'facts about how spatio-temporal things work – was all the Truth there was' (Rorty 1982: xv). It doesn't seem to matter how much variation there is in 'the *ratio* of personal and impersonal, objective and subjective, concrete and abstract factors' (Dewey 1934: 251), in aesthetic theory, what really counts are the universal superstructures that stand outside culture but act to underpin and unite our responses. These perceptual monoliths are thought to provide a framework that underlies and gives stability to the complexity of our individual subjective worlds, having the potential 'to ground inquiry and communication' as Fish suggests, 'in something more firm and stable than mere belief or unexamined practice' (Fish 1989: 343). The apparent benefit, Fish adds, is that it makes the ordering of beliefs and practices possible so that 'they become anchored to it and are thereby rendered objective and principled' (Fish 1989: 343). The interdependent formal constraints required of such a foundation are to

> be invariant across cultures and even contexts; it must stand apart from political, partisan and 'subjective' concerns, in relation to which it must act as a constraint, and it must provide a reference point or checkpoint against which claims to knowledge and success can be measured and adjudicated.
>
> (Fish 1989: 343)

Candidates Fish identifies include 'God ... rationality in general or logic in particular, a neutral-observation language, the set of eternal values and the free and independent self' (Fish 1989: 343). The search for this 'full

presence beyond the reach of play' (Rorty 1999: xviii), or the quest for universals or absolutes is still very much alive and kicking.

When the subject is tackled within landscape architecture, the concept of aesthetics features predominantly in relation to place, how we understand and what creates a sense of place. Of all the theories put forward over the centuries to explain a landscape's character, the genius loci is perhaps one of the most enduring. Its sheer longevity has lent it a revered, almost 'untouchable' status. Over time, it has become a referential touchstone in design pedagogy; 'consult the genius of the place' is often the only guidance students get as to how to approach the designing of a landscape. Used as a kind of shorthand to indicate sensitivity to the nuances of place, a consideration of its unique qualities and its context, there is not a great deal to take issue with. In the hands of an experienced practitioner or critic, the argument for the genius loci can be pretty convincing. It has a good narrative; it's a great yarn, striking all the right chords, creating a reassuring impression of concern and receptiveness to a sense of place. There is no doubt that it can be used effectively to sell a good idea. But that is all it is – a narrative, one description of a site. It is no closer to the universal truth or essence of place than a drawing of a site's contours or its geology. The problems arise when it assumes a greater significance as some kind of spirit in here, out there, somewhere, waiting to be communed with. Like the sculpture within a block of stone or a primeval echo.

Efforts to make contact with this amenable spirit bring the difficulties associated with the search for universal truths into sharp relief. Embodying the idea that there is something beyond our culture to be sensed, intuited, or perceived, there is a presumption that the best way to sense the genius loci is to empty our minds of contaminating knowledge and forget everything we know. Broadly, this follows the Platonic way of achieving perfect knowledge, of 'stripping ourselves clean of everything that comes from inside us and opening ourselves without reservation to what is outside us' (Rorty 1999: xxvii). Too many students have been told simply to go out and feel the essence of the place, to sense what it has to say. Embarking on some kind of adventure in search of 'knowledge of something not merely human' (Rorty 1999: 20) amounts to 'making knowledge into something supernatural, a kind of miracle' (Rorty 1999:

xxvii). Is it really possible to deliberately forget all we know in order to sense the spirit of a place? From a pragmatic perspective, asking anyone to step outside of what they know in order to understand a place as it really is, without the encumbrances of knowledge and culture, is as pointless as it is ridiculous. We can no more stand outside of what we know or who we are than climb back into the womb. It is simply not possible to set aside either sense or reason in order to receive aesthetic satisfaction. We are what we know and we can't wipe the slate clean.

The same applies to the idea that there is something 'other' to see if you look sensitively enough, that 'each place has a residing invisible spirit and an underlying natural order that must be revealed, searched for, listened to, felt or understood by careful observation' (Potteiger and Purinton 1998: 143). The point being that you can look beyond what is in front of your eyes, using a lingering scrutiny and dwelling on it, not 'hurrying to relate what one sees to a universal, the known significance, the intended purpose etc., but by dwelling on it as something aesthetic' (Gadamer 1960: 92). But to be candid, staring long and hard to find what lies beyond could be the last word in thankless tasks if you don't know what it is you're looking for. Waiting expectantly to achieve 'pure perception' is rather like waiting for Godot. From a student's point of view, if they don't have the confidence to, let's call it 'improvise', it's presumed they are un-visual, insensitive or just not perceptive enough. There is precious little chance of picking up this skill since it is, of course, innate. With hard-line assumptions like these, we enter a kind of educational lottery.

The dice are heavily loaded against the student. Patently self-evident and therefore requiring no further explanation, the genius loci, despite being taken as read, can be infuriatingly elusive, readily available to those in the know but stubbornly beyond the scope of others who are not. Given this kind of peer pressure, who would have sufficient gall to admit the latter? To question the genius loci implies ignorance or, worse still, a lack of sensitivity or awareness. Even those with the nerve to say 'I don't understand this' are hamstrung, because on what basis can there be any misunderstanding? The concept by its very nature has no substance; it is indefinable. Putting things 'beyond the reach of play' may make for lengthy academic arguments, but it certainly doesn't help teach design. Seeking pristine aesthetic experience in the traditional sense is a search

for something that by definition can never be known – this would appear to make the search itself a heroic waste of time.

Ironically, by 'consulting the genius loci' many landscape architects find themselves trying to do just what Rorty satirises scholars as doing; 'cracking codes, peeling away accidents to reveal essence, stripping away veils of appearance to reveal reality' (Rorty 1992: 89). Robin Evans accuses architectural critics of committing the same intellectual clanger. They are not lacking circumspection, he assures us, as they work to:

> delve into, uncover, disclose, reveal, divulge, discover, unfold and show to the reader what lies hidden or unseen, to get to the bottom of things, to plumb the depths, to see beneath the surface, behind the curtain, forced by the conviction that drawings have hidden meanings.
>
> (Evans 2000: 482)

What they end up doing, Evans adds, is 'to fabricate virtual meanings for the drawing to represent in place of what they know they cannot find'. With tongue firmly in cheek he observes 'and remarkably inventive about it they are' (Evans 2000: 484). The impetus for this often tortuous endeavour, Rorty suggests, is the excitement of finding 'deep meanings hidden from the vulgar, meanings which only those lucky enough to have cracked a very difficult code can know' (Rorty 1992: 89). We could do well perhaps to follow Tallulah Bankhead's example when asked her opinion of a new Broadway play, she replied, 'There's less in this than meets the eye.'

It is the immutable tenet that there is something 'other', above and beyond human knowledge, that allows us to abdicate our responsibility. We find moral, ethical and personal bias masquerading as the universal truth that governs aesthetic experience. And we so often fail to realise that as Fish explains, 'Whenever a so-called outside or external or independent constraint is invoked, what is really being invoked is an interested agenda ... of a project already in place' (Fish 1989: 13), and since the visual dimension in particular is increasingly swept under the philosophical carpet, other criteria are called upon to do the aesthetic legwork.

In this way, the concept of the genius loci obscures a whole range of aspirations, including the call for a return to old ways of seeing, utilitarian pleas to design the practical way, the search for symmetry and balance, ecological diversity, public participation and classical architecture, process rather than product and, like John Major's cricket and warm beer, sentimentality, a longing for a time and place that exists only in the imagination. Such constraints become integral parts of what Johnson describes as a 'false consciousness' projected by architects 'about the correctness of what they design, mostly without external verification' (Johnson 1994: 394).

But perhaps most damaging of all is that an implicit and pervasive dependence on concepts such as the genius loci often serves to reinforce existing preconceptions and prejudices rather than encourage a more challenging or imaginative approach. It's an easy way to relinquish the responsibility we have as designers to investigate, analyse and interpret the significance of what we see in a critical, grounded, culturally astute way. Legitimising a numbing passivity in the eye of the beholder, it has a stultifying impact on design practice. It is an easy option and a bad habit.

Challenges to traditional aesthetic theory, following the lines of perceptual questioning, seek to patch up the division between reason and emotion either by stressing the proximity and entanglement of the two, even arguing to reverse the usual bias, forever looking for new ways to freshen up old propositions. Some focus on the aesthetic nature of scientific thought or language and the consensual, rational basis of poetic discourse. But to concentrate on issues of permeability, flexibility or the balance of power between the senses and intelligence is to miss the point. Explanations for these quirky, philosophical posers have mutated over the years as terms like intuition, sensation, will, association and emotion are each given varying interpretations depending on the psychological and artistic Zeitgeist. Dewey, despairing that aesthetics is so encumbered by psychological debris, blames what he calls 'the professional thinker' for being 'the one who is most perpetually haunted by the difference between self and the world' and by doing so, 'is just the one most fatal to aesthetic understanding' (Dewey 1980: 249, 214). It really will be impossible for aesthetics to be seen as anything but 'at once haughtily elitist and

parochially uncritical' (Shusterman 2000: 133) whilst the senses are typically characterised as 'a gateway between inner experience, personal to each of us, and the outer world' (Day 2002: 214). Little wonder that Rorty questions if we need an aesthetic theory or an aesthetic programme at all (Rorty 2001: 156).

Our reliance on grand theories like the genius loci is the kind of thing Dewey hoped we might grow out of. Understanding that there is nothing out there to refer to, no universal truth or framework informing our culture, represents a significant shift in human inquiry. Rather than believing it possible to find the real truth about the world, we have to work with the idea that there is nothing beyond our culture to rely on and no means 'to uncover the intrinsic nature of things' (Rorty 1999: 115). Rorty describes this as a movement away from 'an attempt to correspond to the intrinsic nature of reality' towards 'an attempt to serve transitory purposes and solve transitory problems' (Rorty 1999: xxii). To rethink aesthetics in a very broad sense, without the clutter of these conceptual MacGuffins, provides the perfect opportunity to work and theorise independently of the idea there are either 'truths which are changing and relative' or 'that there is higher kind of truth which is neither (but) instead is fixed for all eternity' (Eagleton 2003: 103).

This gives a completely different perspective to aesthetic theory. Discarding the idea that a place can 'speak' to you, reveal what it 'wants to be' by imposing on your thoughts as if the mind were an inert wax, we can now see it as simply something to which we respond. So when we are convinced and excited by architecture or a landscape, what moves us is a function of our needs, purposes and preferences, rather than a primal tug of recognition from somewhere deep in our subconscious or a mysterious empathy with the murmurings of a site. Ecologists will be excited by the possibility of increasing bio-diversity, hardened urbanites by the opportunity to create vibrant urban nightscapes or dramatic urban squares. Those who live in the countryside will aim to preserve the integrity of their environment, whilst city dwellers may look for something modern and dynamic. Importantly, although these might appear to be separate agendas, they needn't necessarily be mutually exclusive. We can, with wit and imagination, learn to appreciate culturally diverse situations and points of view sometimes radically at variance with our own. Ultimately,

Concept diagram: a simple ring of water held within a necklace of stone that rests lightly across an undulating landform was given the conceptual title, reaching out – letting in.

The Diana Princess of Wales Memorial Fountain, London
GUSTAFSON PORTER

... aesthetics beyond psychology is
culturally and socially framed and
has political and social connotations,
marked indelibly by memories,
associations and preconceptions ...

we are bounded only by the breadth of our knowledge and the depth of our prejudices.

In philosophical terms, take Dewey's premise that 'There are no intrinsic psychological divisions between the intellectual and the sensory aspects; the emotional and ideational; the imaginative and practice phases of human nature' (Dewey 1934: 247) to its logical conclusion and it is evident that there can be no separate aesthetic faculty any more than there can be a visual mode of thinking. 'Thought, emotion, sense, purpose or impulsion', as he dryly observes, needn't necessarily come apart and be 'assigned to different compartments of our being' (Dewey 1934: 252). All such distinctions, including the aesthetic faculty, can be seen as philosophical distractions resulting from what Shusterman calls the 'rationalising differentiation of cultural spheres that gathered momentum two hundred years ago' (Shusterman 2001: 134), myriad theoretical subdivisions spawned from a worn out philosophical cliché. It is an old and largely bankrupted conceit that has little to do with how we actually experience the world, worse still, it separates us from the world, and in particular separates art and aesthetic experience from everyday life.

If there are no special corners of consciousness to coalesce, no strands of emotion and intelligence to synthesise no matter how sublime the moment, aesthetic experience can be understood just as Dewey suggests, as a 'clarified and intensified development of traits that belong to every normally complete experience' (Dewey 1934: 46). Right from the start, it is framed by what we know. On reflection and with hindsight we may well be able to interpret and distinguish different influences that make up the experience, but we experience it holistically.

To argue aesthetic experience is not triggered by the senses alone does not undervalue the experience in any way. Suggesting that there is no special kind of sensory understanding is not a question of reducing aesthetic experience 'merely' to cognitive merit, with the implication of cool rationality and detachment, or even to the mundane ordinariness implied by Shusterman's term 'practical utility' (Shusterman 2000: 29). It doesn't dumb down the experience, make it any easier to understand or subdue its passion or power, just as to question the value of consulting an amenable spirit does not in any way undermine the importance of the

Worsley Woods, Salford.

… this locates us, not as cool observers of a world 'out there', but as an indispensable part of that world.

site or its context or suggest that a sensitivity to place is superfluous. All that it does is boot out the presumption that there is something psychologically elemental in our responses.

This has dramatic consequences for our understanding of aesthetics. As with any other kind of human experience, the aesthetic occurs in response to our interaction with the physical world about us, in all its multifaceted, cultural, social and complex sensuality, marked indelibly by memories, associations and preconceptions. We react and respond holistically, to 'the environment that is human as well as physical, that includes the materials of tradition and institutions as well as local surroundings' (Dewey 1934: 246). The response is inevitably influenced by knowledge, mood and context. This locates us, not as cool observers of a world 'out there', but as an indispensable part of that world.

The Williamson Square fountains celebrating the pool from which Liverpool takes its name.
Williamson Square, Liverpool
CAMLIN LONSDALE

Pleasurable, emotional, moving and inspiring experiences can happen when reading a classic novel …

… or merely wandering down the street …

Portsmouth stilt men.
PORTSMOUTH CITY COUNCIL

... the complex and multilayered artistic and intellectual nature of these experiences and responses to place, lie at the heart of aesthetics beyond psychology.

Explaining the relationship between the Fire in the Grove, and the Washington Capitol, the reflections between the walls of light and the volatility of the water ...

... and the multiple quotes, stories and narratives etched into the glass walls.

American Veterans Disabled for Life Memorial, Washington, DC

MICHAEL VERGASON LANDSCAPE ARCHITECTS LTD

Aesthetic experience is real enough, but not in the way it has traditionally been conceived, not as a kind of mystical recognition of 'something sufficiently like us to be enviable, but so superior to us as to be barely intelligible' (Rorty 1999: 52). In fact, what might cause an aesthetic experience, the object or the activity, is immaterial. It's the response that counts. If we are lucky, we will be rendered speechless by the power of a painting, the beauty of a landscape, or the balance of a mathematical equation. It could be George Best in his pomp or the Mona Lisa. Pleasurable, emotional, moving and inspiring experiences can happen when reading a classic novel or merely wandering down the street. Aesthetics beyond psychology deals with the complex, artistic and intellectual nature of these responses. It understands them to be culturally and socially framed and to have political and social connotations. It makes sense of our reactions through knowledge, experience and critical reflection. What is more, this same knowledge is the basis of artistic, critical judgements, not only in relationship to theory but also to practice.

Remove the metaphysical dimension of aesthetics and we can concentrate on what we see rather than anything beyond or hidden beneath the surface. This removes at a stroke, a whole series of puzzles that are bewildering and undemocratic for the student and is how we get a grip of the material world as Bryson advocates, not from an outmoded positivistic or formalist position, but in a way that makes it possible to engage in an energetic artistic and conceptual discussion about the aesthetics of place; the social, cultural and physical context of our lives.

Shifting the focus towards the experience itself, away from attempts to define the object or the subject, is what essentially changes the nature of artistic debate. Rather than seeing art as something we look at, an object or event to be studied and absorbed, it can be viewed Dewey explains, as 'a quality that permeates experience; it is not, save by a figure of speech, the experience itself, but the material of aesthetic experience' (Dewey 1934: 326). On this basis, whether something is artistic or not has nothing to do with the type of materials involved, say pencil, clay or bricks and mortar. It is not a question of one medium being seen as 'an art form' such as fine art, whereas another is considered to be craft based, too mundane and humdrum to clear all the high hurdles in the aesthetic stakes. It is immaterial whether the person who has conceived the work

is an artist, a writer or a mathematician, or whether the work deals with issues of passion, glory, quantum physics or quarry blasting. Distinctions made between art and design on the basis that one is functional and the other without purpose, apart from being pleasant or easy on the eye, are actually a diversion. It is not the painting that counts, or the landscape or the music, but the quality of the experience. Since the quality of the experience we have is defined by what we know, this makes it entirely accessible. Knowledge we can teach, judgements and values can be learned. The considerable benefit of this move is that rather than keeping aesthetics out in the cold as a rather obscure branch of artistic theory, this brings it back centre stage into everyday life.

Collapsing the visual, intelligence and language and many other fragments of consciousness into a holistic concept of perception takes the supernatural element of aesthetic experience out of the equation, exposing as a myth the part of the story suggesting that a deep-seated sensory resonance or recognition of a universal truth is needed to quicken the pulse. The surprising revelation is that the breathtaking nature of the aesthetic experience is dependent on and limited by what we know.

With metaphysics out of the picture there are no universal qualities of beauty, no perfect forms to find. Some things are enduring in their appeal, like Trafalgar Square or the gardens at Stowe. Others are more ephemeral, their appeal, short lived, like almost any shopping centre created in the latter part of the twentieth century or BMX bikes or graffiti. The role of fashion and style, so pivotal when purchasing cars, shoes, T-shirts etc., changing as it does from week to week, year on year, is not merely inconsequential second-hand aesthetics; on the contrary, it is absolutely key to our sense of culture, identity and visual awareness. Dewey's suggestion that aesthetics is 'a manifestation, a record and celebration of the life of a civilisation, a means of promoting its development and is also the ultimate judgement upon the quality of a civilisation' (Dewey 1934: 326) hands us the responsibility to ensure the record is a good one.

Design concept: raw flows. Seeking to transcend the overused term
sustainability, Cormier investigates the idea of trajectories of movement through
the site, of water, cars, electricity, trains and wildlife, to address a need for
higher site porosity as a means to create a free flowing system of sustainable
components in, around and through the area.

Evergreen Brick Works, Toronto, Ontario

CLAUDE CORMIER

We can't grasp the physical parameters of any site without value
judgements no matter how rigorously scientific our approach or language.

Objectivity without neutrality

The next step in this strategy to negotiate the territory between the subjective and objective, is to expose the fallibility of the notion that we can think in a way that is objectively neutral and see things as they really are, out there in the world. An approach that leads irrevocably to the view that there is an objective *modus operandi*, often defended in the studio as the only true, legitimate way to design, both the antidote and a counterbalance to subjective whimsy and artistic illusion. But in reality, the idea of engaging an objective mode of thinking is no more an aid to good practice than subjectivist conceptions and as profoundly unproductive as listening to singing rocks, communing with the genius loci or gleaning primordial resonances. Tracing its reductive influence on cognition, the design process and practice, this chapter redefines what it means to be objective and absolutely true and sets out the contribution this new approach makes in the development of artistic practice.

Working in a way that is objective, value free and only concerned with practicalities or scientific facts is neither as reassuringly safe, obvious, self-evident nor as intellectually profound as many would think. The various sides of the debate can be summarised as follows. A man walks into a room and is shown a table. 'What's that?' He's asked. 'A table.' He replies. A table, pure and simple, it seems to be a perfectly objective, value-free assessment of what the man sees in front of him. But from the moment he first sets eyes on that table he is seeing it contextually, framed by personal experience and knowledge. It's a blue table or a brown table; an Ikea table or a Jacobean table; it's elegant or kitch, modern or retro. Like it or not, the man will never see just the table, alone, in isolation, without context. The rationalist supposition, however, is that

it is possible to see, think and therefore behave in a way that is neutral and value free. Being objective is supposed to be simply a question of organising or working out the plain facts, then adopting a scientific or workmanlike approach, unencumbered by opinions, values, emotions and sometimes even concepts. If you stringently employ all the relevant data, using the most up to the minute scientific extrapolations, methodology and language, you will be able to define absolutely what, for example, a table is, right down to its molecular structure. The relativist would argue that whether the table exists or not is entirely subjective. The pragmatist, cutting through this wearying dichotomy, would argue that, yes, the table does exist, but what we have to say about it defines the table and this depends on many things; its molecular structure is just one way of looking at it. It might be Jacobean, Bauhaus or flat pack; cheap or 'priceless', elegant or hideous, depending on fashion, mood and taste. There is no purely factual explanation that can be given that is not value laden because 'values' are not added on after the fact. As far as the pragmatist is concerned, it makes no sense to think there is a special corner of experience that deals with 'value' any more than there is a special faculty dealing with aesthetic experience. It is 'something that has to do with all of experience' (Dewey, quoted in Putnam 2002: 135) rather than a bit added on to a 'pure' uncontaminated response. Facts and values are *so* well and truly entangled, Putnam argues, that every experience, even the most mundane, comes to us 'screaming with values' (Putnam 2002: 103). There is literally no escaping them. We can't see things without prejudice. We don't grasp facts such as the physical parameters of an abandoned clay pit or the colour of a chair without value judgements, no matter how rigorously scientific our approach. In the same vein, we cannot make value judgements without information and knowledge.

Although few theorists would nowadays agree with the distinction made between objective facts and subjective values and fewer still would claim it is possible to be objectively neutral, in practical terms, the beliefs and ideas emanating from this old assumption are culturally endemic, as widespread and pervasive as ever and an integral (if unstated) part of epistemology and our culture, a further outcome of the continuing reliance on theories of perception. Born out of the dictum that 'value judgements are subjective' and therefore cannot possibly be based on

fact, and that 'statements of fact are capable of being "objectively true"' (Putnam 2002: 1) its dominance is essentially a lingering hangover from the logical positivism of the early twentieth century. A position determined by the impression that 'objectivity means correspondence to objects' (Putnam 2002: 33), in other words, being 'objective' is simply a matter of describing the object or fact correctly, and at first glance this seems reasonably straightforward. A fact is a fact. But the fact is, it's not actually that easy to know or define what a properly objective 'fact' is. Definitions vary. A fact is often thought of as something observed, measured, proven, it can be scientific or statistical. However, as we all know, a proven 'fact' can be used to serve diametrically opposing arguments. A scientific 'fact' remains so only for as long as the science holds up and a statistical 'fact' is indisputable until the measurement of the statistic is called into question. And despite their unerring black and whiteness, we are all aware that statistics can be flexible friends or implacable enemies.

The close relationship with science also guarantees the endurance of 'the cult of the fact' as Hudson characterises it (Hudson 1976). We are dazzled, not only by the idea that the physical sciences are 'set apart above the rest of life', as Midgely observes, but also, the power of technology 'impresses us so deeply that we are not much surprised by the claim that scientific methods ought to be extended to cover the rest of our thought' (Midgley 2001: 59). This underlies, she adds, 'many desperate attempts today in other studies, especially in the social sciences, to make themselves in some sense, ever more "scientific"' (Midgley 2001: 59).

The design professions are in no way immune to the desire to be loftily scientific. Look at the demands placed on researchers to adopt scientific methodologies either to obtain a PhD or research funding and the increasingly common legal requirement for teachers to obtain scientific doctorates before they can even begin to teach design. Within landscape architecture, the rationalist methodology made popular by pioneers like McHarg, for example, lives on. He aspired to be so objective he even anticipated that 'any man, assembling the same evidence would come to the same conclusion' (Turner 1996: 146). Dependent on the mathematical analysis of soils, vegetation, runoff, ecology and the like, aided by GIS (Geographic Information Systems), it famously helped to establish a 'legitimate' role for the profession in the planning process (see Walker and

Simo 1994). As with the first generation design methodologists, the aim was to reduce the design process to pure science so that it would 'not be held back ever again by individual values, opinions or personal "creativity"' (Broadbent 1988: 321). This kind of thinking was part of the quantitative revolution that produced the formidable mathematical equation that became known as the Manchester method of landscape evaluation (see Robinson *et al.* 1976) which, after five years of research, disappeared almost overnight when its inherent weaknesses were exposed.

Despite the considerable misgivings, a continuing yearning for neutral detachment has led to a proliferation of scientific methods being developed or re-invigorated to analyse place and space. Certain parts of the discipline, such as in spatial and regional planning, sometimes urban design, landscape assessment and evaluation, confidently proclaim themselves to be more of a science than an art, and by association, therefore more legitimate, objective and value free, less to do with concepts, more to do with factual analysis. The distinction might be as basic and spurious as the idea that these studies are predominantly written rather than drawn, thought to be diagrammatic rather than conceptual and based on the 'objective' evaluation of resources and statistics. Yet all deal with decision making in a spatial medium in one way or another.

From an objectivist point of view, once all those 'values' have been stripped away, rather than rely on an invisible spirit to do the work for us, a pseudo-scientific interpretation is required, based on the logically deduced or verifiable facts that represent the objective, value-free truth. It is hardly ever recognised that the whole objective edifice is built on a set of preconceptions that disguise a very particular view of the relationship between people and their environment, influenced by factors such as functionalism, standardisation, economic imperatives, ecological diversity or a narrowly scientific definition of sustainability. These are actually nothing more than arbitrary limitations, based on a restricted set of assumptions rather than statements of the unequivocal and blatantly obvious.

The problems inherent in this way of working are manifested in, for example, the site survey, usually epitomised as merely a question of

$$\overline{V}_j = \alpha_0 + \sum_{i=1}^{q} \beta_i F_{ij} + \sum_{h=1}^{m} \gamma_h Z_{hj} + u_j$$

where

\overline{V}_j = the mean quality score for the j^{th} survey unit.

α_0 = the regression constant.

β_i = the regression weight associated with the i^{th} factor in the j^{th} survey unit.

F_{ij} = the value of the i^{th} of q factors in the j^{th} survey unit.

γ_h = the regression weight associated with the h^{th} external variable in the j^{th} survey unit.

Z_{hj} = the value of the h^{th} of m external variables in the j^{th} survey unit.

u_j = the random disturbance term.

Buoyed up by the quantitative revolution it took many years for the Landscape Evaluation Research Project to devise the ultimate equation to solve the evaluation of landscapes (Robinson et al. 1976)

describing the site 'as it really is', a clear-sighted gaze that puts to one side knowledge, social and cultural influences, suspending value judgements whilst the facts are collected, measured and recorded. By strictly limiting the way the problem is tackled, it makes it seem possible to leave what Putnam calls our 'large stock of both valuations and descriptions' (Putnam 2002) at the site boundary, thereby eradicating or avoiding subjective interpretation, gut feelings and emotional responses. What remain are the relevant facts such as structure, fundamental needs and physical details, practical issues, things that can be tested empirically using scientific methods. It's these physical facts, separated from culture, values and experience that are thought to be the valid and true components of the survey. The evaluation of all this data can come later when all the relevant information has been amassed.

This presumed neutrality sets up serious problems in the design process that have a direct impact on design quality. Compounded by the mantra 'survey before plan' and the 'survey, analysis, design' (SAD) methodology (Thompson 2000: 99), it leads to the misconception that the survey is a detached stage in a linear and sequential process, seen as the mechanistic work to be done before the more subjective, value-laden elements can get a look in. Technical rather than creative, it is often recognised as something to be accomplished most effectively with camera and notebook in hand, a matter of recording, mapping and researching information such as levels, contours, access, transport links, vegetation cover, etc., to establish details of the site's physical fabric, its context and configuration. Photographs are taken and annotated. Maps are traced and overlaid. Watersheds identified, ecologically sensitive areas recorded. Historical and community data collected. Social surveys, community consultations, economic and hydrological information collated. The use of professionally produced base plans to plot survey information contribute to the perceived neutralism of the process since these are generally taken to be as Corner suggests, unequivocally 'stable, accurate, indisputable mirrors of reality providing the logical basis for future decision making', rather than 'highly artificial and fallible constructions, virtual abstractions ...' (Corner 1999: 251–16).

This idea that we can and should be objectively neutral is central to the partisan belief that 'site-based design' is the only right and proper way to

go. Dictating that any analysis or design has to come *from* the site, safe from outside influences, the presumption is that the point of the survey is to determine what the site 'wants to be' based on the scientific evidence. Thought of as infinitely preferable to anything brought in 'from the outside' by the pejoratively labelled 'egotistical' or 'top down' designers, it narrows the scope of attention to the physical fabric of the site itself, or, with a bit of luck, the communities and areas that are immediately adjacent and physically accessible. Use a concept from 'outside' the site as a means of investigating its potential and you are likely to be pilloried either for making arbitrary judgements or expressing merely subjective preferences.

It translates into an approach that appears superficially to be clear and straightforward. Cultivating the idea that this is a no-nonsense, self-evident and practical methodology, it again manifests itself in a kind of impassive cultural and theoretical disengagement. 'I just design the practical way', I have been assured by students and practitioners alike and even more bizarrely, 'I don't have to use concepts because I deal with planning or strategic visions', as if these can somehow be dealt with in splendid isolation. With this kind of blanket dismissal, hands are effectively washed of any further debate.

The parochial sorting of physical information and the separation of technical knowledge from ideas as well as wider theoretical and interpretative issues, discourages important cultural exchanges that should be an integral part of the design process. To withdraw from proper reflection and engagement at any point in this process, whatever the scale of the project, is to consign practice to the critical hinterland.

It creates an objective drag. In tandem with the concept of the genius loci, it contributes to the naturalistic fallacy Johnson describes as 'projecting what ought to be from what is' (Johnson 1994: 394). A variation on McHarg's ecological determinism, it has led to a depressing sense of homogeny in the landscape. Places that fit in, are unobtrusive or invisible, merging in, integrating, blending, being 'absent'. The results are more often than not anodyne and blandly generic rather than subtle, moving or engaging. Faced with the global challenges of quality, sustainable design, we need people in the landscape profession who can deal with ideas and concepts, who are able to push the boundaries in order to realise the full potential of their

discipline. They should always be looking for new ways to describe the landscape, rather than simply evoking an impression of the countryside in the city or straining to be contextually sympathetic. Fitting in with the context is fine as long as the context is worth fitting in with, if not, the results can be aesthetically moribund, not to mention culturally suicidal.

The rationalist legacy is probably the single biggest stumbling block to quality being built in as a visionary, holistic ambition from the beginning of the development process. Generally, employment, housing and transport studies are thought to establish the quantifiable hard facts that characterise an objective spatial framework. Whilst some of these studies may refer to the quality of the environment, this is usually little more than lip service; in reality, no one seems entirely sure what 'quality of the environment' actually means. It is either assumed to be self-explanatory, a matter of technology, or an issue to be resolved at a later stage. As a consequence, landscape architects and other professionals usually become involved on a relatively small scale at various stages of the process, after the important decisions have already been made.

The concept of 'objective neutrality' is untenable, unworkable and, above all, unrealistic. It comes wrapped in its own prejudice, the bias towards technology away from ideas. We need technological know-how, of course we do, but we also work in an ephemeral world of shifting values that are responsive to broader cultural and social attitudes. These bigger cultural ideas are not disengaged from the design process as if they are just a kind of background noise. What designers do is as contingent on social and economic priorities as it is in any other discipline; it's an inescapable part of what Dilnot calls 'the operational context' (Dilnot 1989: 233–50). These ideas shape the meanings and significance we give to the landscape, the extent to which we value quality in the environment and what is important aesthetically. They are absolutely integral to design activity, defining the attitudes and aspirations of institutions, clients and stakeholders alike. Whatever scale we operate at, whatever stage of the process, designers and planners cannot, must not, be immune to this cultural flux.

Consider the striking differences between plans such as the 1920s infrastructure prototypes of Benton MacKay (see Easterling 1999). Gibberd's master plan for Harlow New Town from the 1950s, inspired,

Easterling writes of the 2,000 mile Appalachian Trail, 'though it was only a footpath, MacKaye characterised the proposal as a "transportation project" because by its placement the trail inverted the conventional hierarchy of transportation and development infrastructure'. The proposal is often attributed as being the precursor to the motorway.

Benton MacKaye, "An Appalachian Trail: A Project in Regional Planning." Journal of the American Institute of Architecture IXX (October 1921): 7.

according to Jellicoe, by Nicholson's painting, *Mousehole 1947* (Jellicoe 1993), the 1960s wavy grid of Milton Keynes, 1997 landscape masterplan for Osterad, the large-scale strategy for Malmö, 1997–2004 and Leek-Roden inter-municipal masterplan 2005–7. These demonstrate the extent to which strategic regional planning is contextually determined and dependent on the conceptual vision of the author, the culture, time and place. All are underpinned by assumptions that change, norms that are

Mousehole 1947

The 1950s' first plan for Harlow New Town by Frederick Gibberd, described by
Sir Geoffrey Jellicoe as a 'strikingly beautiful plan seemingly inspired by the painter
Ben Nicholson'. He realised Gibberd was drawing inspiration from his pictures quoting
Gibberd as saying 'they pour electricity into me' (Jellicoe, 1993: 32).

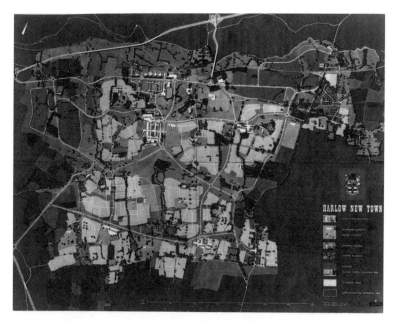

A refined and elaborated version of the masterplan for Harlow New Town.

FREDERICK GIBBERD PARTNERSHIP

The 1960s' wavy grid of Milton Keynes – the non-place, interactive grid inspired by network theory and the communications and rapid mobility the grid is supposed to facilitate, was pushed and tugged into a wavy grid in response to the gently rolling landscape of valleys and ridges, water and woodlands. The important public transport networks were lost as the scheme for Milton Keynes emerged. Given how much transport policy has changed over the years it now seems incongruous that Derek Walker (1982), Milton Keynes's chief architect suggested 'The grid roads could be the most enjoyable part of the city – our Venice canals'.

Milton Keynes masterplan, Llewelyn Davies

HOMES AND COMMUNITIES AGENCY, COURTESY OF MILTON KEYNES CITY DISCOVERY CENTRE

objectivity without neutrality

Ørestad is a new city district on the polders of the Amager peninsular to the south of Copenhagen. The masterplan proposes covering the entire area with linear plantations of trees, to give an identifiable grain and resilient pattern that will determine any development. The plan is that the construction will have to work around the lines of trees, as if having to work around a couple on the corner who don't want to sell their piece of land. Once construction begins, 8 per cent of the trees have to remain leaving remnants and fragments of the spaces and lines of the forest within the new development. The idea has captured the imagination to the extent that although the trees have not yet been planted, the lines are being adhered to and implemented in new proposals.

Landscape planning for Ørestad Selskabet 1997 (310 hectares)

JEPPE AAGARD ANDRESEN

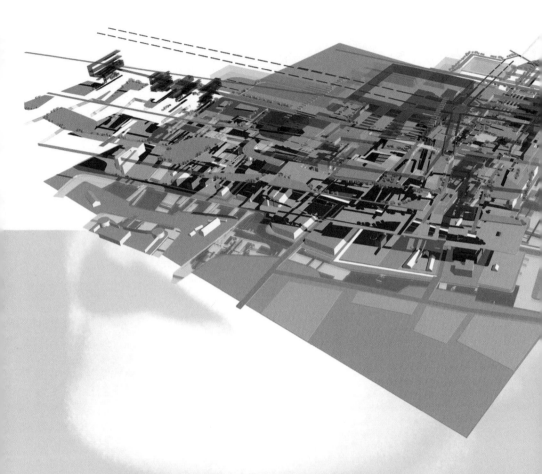

In order to achieve a shift in identity from shipyard village to University Island in Copenhagen harbour, Juul I Frost focus on the relationships between all those involved in the planning process. The masterplan reflects the complexity and diversity of existing conditions and qualities such as the varied scales of space in relationship to the existing structures, including the harbour, the canals, existing infrastructure and context of the wider city. To ensure a link between this overall vision and individual proposals, they created four quality books (Q-Books). Acting as sturdy tools of implementation, the Q-Books establish a common frame of understanding aimed at making decisions for the future of the city. Pedagogical as well as operational implements, these set out guidelines to cover the overall urban strategy, the city floor, comprising of plazas, market squares and public/private spaces, a spatial strategy to deal with the interface between the developments and the body of water and, finally, art in the public spaces.

The large scale strategy for Malmö 1997–2004

HELLE JUUL & FLEMMING FROST

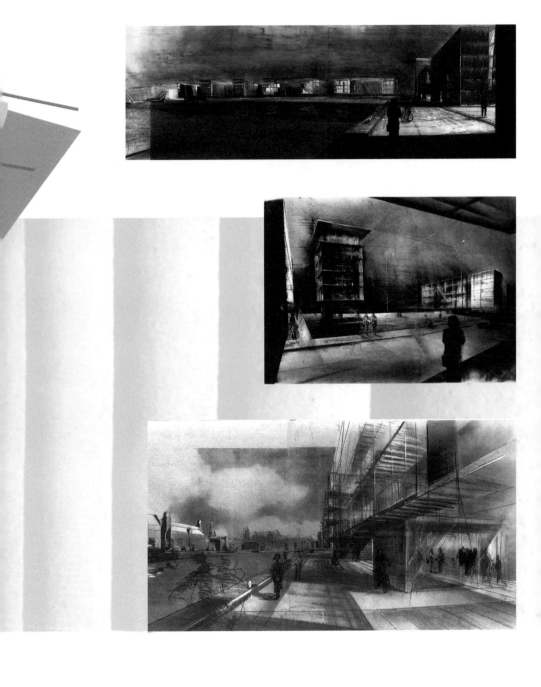

GRONINGEN

LEEK

RODEN

The Leek-Roden inter-municipal master plan proposes a new park to accommodate 6,000 dwellings and 110 ha of business activity in an existing diverse and fine-grained landscape of maple forests and exploited ground on the edge of the Drents plateau.

Concept drawing explaining the relationship between villages and landscape. Surrounding the park, a model of scattered urbanity is used to create great diversity in living environments by spreading the dwellings along different landscape types.

(facing page – top)

The masterplan. A network of pathways melts the fragments of landscape into a coherent whole. The new main road no longer cuts though the villages but becomes part of the park. Infrastructure works and the distinctions made between small and large-scale business activity contributes to the design by overcoming an abundance of monotonous and generic space whilst allowing both municipalities to maintain their own identity.

(facing page – right)

Landscape structure and park based on old farmlands and valuable landscape fragments.

The Leek-Roden inter-municipal masterplan 2004–2009

JUURLINK [+] GELUK

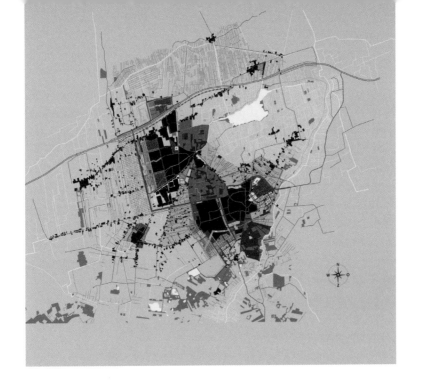

challenged and government policy that is reversed. Just compare today's transport, housing and agricultural policies with those of 15 years ago. Were all those 'experts' just plain wrong back then or simply working under different circumstances and with a different set of ideals? The point is that in science just as much as in the arts, our interpretation of problems and their potential solutions change as Bryson suggests, 'as the world changes' (Bryson 1983: xiv). There can be no final analysis based on absolute knowledge. We need a healthy measure of scepticism to deal with the hard facts enshrined in regional spatial plans, perennially used to justify the economic imperative for new roads, the distribution of new settlements, how big they should be or the cost the market will stand in terms of quality housing or town centre development. The evidence of such quantitative 'factual' decisions quite literally litter our landscape.

Attempts to balance the two old irreconcilables of objective reality and subjective perception, between what Burns and Kahn call the 'de-centred vantage point of the theoretical scientist' and the 'centred viewpoint of the subject' (Burns and Kahn 2005: xxiii) are all but doomed from the outset. The way to solve this riddle is to return to the philosophical root of the problem, and question the way we hold real, unchanging truth to be the ultimate end point of inquiry, whilst at the same time, avoiding being sucked into the argument that the only alternative is to believe everything is relative and dependent on a point of view. What this comes down to is rethinking from an interpretative perspective, what it is we mean by absolute or real truth.

It turns out that defining truth is every bit as difficult as establishing hard facts, but again, from a pragmatic perspective it is important to avoid falling into the trap of thinking that because there might not be anything universally true to be found, there is no truth. Eagleton rails against what he calls the 'peculiarly pointless maneuver' of those who 'claim not to believe in truth at all' despite the 'fuzzy, sceptical, and ambiguous' world of the relativist being supposedly more democratic (Eagleton 2003: 103). Deriding what he calls the 'ludicrous bugbear' (109) that has been made out of the philosophical conceptions of absolute truth, he argues that there is nothing particularly special about absolute truths or factual statements. For example, the fact that the train is coming is absolutely true, but not necessarily important. It only becomes important if you are standing in

its path or waiting to catch it. It is absolutely true that the disused quarry is 30 m deep at one end and 15 m deep at the other. This is a statement of fact, just one way of regarding the quarry, but in isolation it has no real consequence. However, in relation to the need to get access to the bottom or as a guide to health and safety, it becomes important, sometimes crucial. Thirty metres might mean nothing at all to a rock climber but is impossible to contemplate if you have difficulty walking.

Not all things are true to all people. The phrase 'one man's meat is another man's poison', neatly sums up the objective/subjective dilemma, since 'cultures make sense of the world in different ways, and what some see as a fact, others do not' (Eagleton 2003: 107). Some statements are only true from a particular perspective, such as 'France is hexagonal' which it is, but only from a particular cartographic point of view (Eagleton 2003: 104). Some things can be true at one time or can cease to be true at another. But the fact that what we believe to be true reflects the values we hold and that these change over time doesn't reflect the discovery of new truths, but, as James explains, is a development of what we believe, because 'new truth is always a go between, a smoother-over of transitions. It marries old opinion to new fact so as ever to show a minimum of jolt, a maximum of continuity' (James 1907: 101).

Establishing the truth, therefore, is not a question of peeling away myriad layers of experience to reveal a collective subconscious well of knowledge, but 'a taxing messy business often enough and one which is always open to revisions' (Eagleton 2003: 106). Truth is shifting, flexible, sometimes enduring but never immutable. And its transient nature is no bad thing. Pierce explains, 'in science (or any other field of knowledge) we do not have or need a firm foundation; we are on swampy ground, but that is what keeps us moving' (Pierce quoted in Putnam 2002: 102).

Significantly, this is not a matter of questioning the existence of objects in the world. If there were a tiger in the bathroom, even the most militant existentialist would not sit there questioning the reality of it being there. Most people would run and not because of some deep-seated recognition of the intrinsic nature of 'tigerness' but because they *know* that tigers are dangerous. The tiger, exhausted quarries, oncoming trains; they all incontrovertibly do exist. The point is, what do you make of them?

As sure as eggs is eggs, you absolutely cannot be neutrally objective about things, no matter how scientifically you describe them.

Objectivity should never imply neutralism. One of the most important lessons to learn is that it is possible to redefine what we mean by objective and realize that it is after all, only possible to be objective if we are informed, if we make judgements from a position of knowledge, aware of our prejudices, preconceptions and desires. The hard part of course is to recognise what these are and then to have the courage to put them to one side if necessary. To work through our preconceptions, is a difficult, 'emotionally taxing affair', Eagleton suggests, not a question of rising 'majestically above the fray' but being in the thick of it, 'assessing the situation from the inside, not loitering in some no man's land' (Eagleton 2003: 134). Objectivity 'requires a fair degree of passion – in particular the passion for doing the kind of justice which might throw open your most deep-seated prejudices to revision' he adds, and no one enjoys that (134), and above all, it is 'recognition that objectivity and partisanship are allies not rivals' (136).

All of this has a direct bearing on how we think we make judgements and therefore how we teach design. To return to the survey. Novice students can amass huge quantities of information in the optimistic belief that it is bound to be of use one way or another. But determining where to research and what to look for, as well as how to properly evaluate all this information, how to decide what is relevant, what is appropriate, what to keep and what to ditch, can be tough and bewildering. Working out the implications of all this data given the plethora of artistic, cultural and technological decisions that need to be made, together with the scope, purpose and ambition of the project, requires skill and judgement. Rather than rely on the mind's eye, innate skill or the certainty of objective neutrality, something else has to guide the valuations and decisions made in the studio and library. Whichever methodology has been adopted and when all the lists have been checked, one big question remains; without the light of universal truth to guide us, what do we use to judge whether things are good, bad or plain indifferent?

The bottom line is that in any study, design or otherwise, we are both liberated and constrained by the language and concepts we have at our

disposal. Our knowledge alone frames our perception of the opportunities and problems we face. Nothing else determines the scope and manner of our work. There is no other way of knowing, no other kind of meaning to uncover, no genial spirits to give us a nudge in the right direction.

However we encounter the site, there are a number of ways to describe it and these are always open to question and subject to change. We are continually interpreting and reinterpreting concepts, hunches and ideas, whether we are daydreaming or focusing intently on the writing or drawing in hand. And when we make judgements, crystallise our ideas and make sense of what we feel about the site, it is always based on our experience and expertise. We may dismiss particular interpretations as too strange, off the wall or out of the box, but with reflection, through explication and discussion, we could begin to accept new perspectives, not because we have discovered 'the truth', but because we may well have learned something new, something seductive and compelling enough to change our minds.

Far from being objective in a neutral sense, more often than not we gravitate towards familiar ideas because these all have a reassuring ring of authenticity and credibility about them. The problem and focus of much design education is to ensure therefore that we become aware of these easy assumptions. In the studio this can be achieved by introducing a new frame of reference to view common problems, and since there is no way of approaching any of the so-called objective parts of design that cannot be put in a wider cultural context, any number of theoretical points of view can quite legitimately be used to investigate the questions raised in response to a brief. Connections can be made across disciplines and from one idiom to another.

As far as the site survey is concerned, recognising its conceptual dimension liberates it from its purely physical constraints. Imaginatively construed, it may relate to grid co-ordinates or a collage of its shifting shadows. Juxtaposing different scales or contexts, overlaying watercolours, scans, photographs and text, or even establishing a relationship between the site and something as elusive as the meandering line of the magnetic north pole are ways to challenge accepted horizons.

There are a number of ways to
describe the site, but they can
never be neutral …

... they are always open to question
and subject to change ...

The green giant, dolls and toy cars are used to make the point that the transformation of an industrial brick factory into a new incarnation will serve as a catalyst for fresh ideas about the relationships between nature, individuals and cities.

Evergreen Brick Works, Toronto, Ontario

CLAUDE CORMIER

CLAUDE CORMIER AND FERRUCCIO SARDELLA

Investigations aiming to challenge 'macro scale masterplan
thinking and signify the importance of touch and scale, the
collapsing of time and the value of age'.
Stouport Restoration Project
DAVID PATTEN

… watercolours, scans, photographs and text overlaid
to coax a more inventive response to the site …

A colour palette study of found objects and existing painted walls, extended through a colour spectrum, to open up a conversation about how colour could be used to pull together the disparate site at Electric Wharf, for the development of a former power station and canal frontage in Coventry, UK.

Electric Wharf, Coventry

DAVID PATTEN AND BRYANT PRIEST NEWMAN ARCHITECTS

... what counts is how well these inventive interpretations
prompt a different way of thinking about the site ...

In this competition entry for a park on the Chicago lakeside, the concept is to
shift perceptions of the city by disturbing the ubiquitous local grid. Establishing a
relationship between the site and the meandering line of the magnetic north pole
provides the opportunity to encounter Chicago afresh with a series of new, radically
different corrective jogs, creating a contemporary, romantic engagement with the city
beyond the grid and between the lines, the project is about locating by landscape;
knowing where you are in time and space.
MOORE AND DYDE

Chicago lakeside – patterns in the landscape change in intensity through 24 hours. They are designed both to reveal and conceal as the sun shifts, clouds drift, smog settles and snow falls. Location and distance are measured by texture and quality not merely numbers on a street map or the position of the sun. The ephemeral landscapes float, are sometimes lush, sometimes flooded, frozen, sparse and muddy; prairies and meadows in the summer, skating rinks and a barren wilderness in the winter …

… there is a transition of shadows and light, from diffuse, muted, cool and misty in the north …

… to warm, intense and contrasting in the south of the park. These not only reflect global climatic patterns but also the sequencing of the sister city lines. The sister lines, emanating from points along the repositioned line of magnetic north, create local links to the heart of Chicago's multicultural community, presenting design opportunities for landscape architects, artists and architects from these sister cities as well as initiatives for development, sponsorship and reciprocal projects, including viewing platforms, bridges, terraces, cafés, bars, theatres and studios.

This exploratory research does not simply provide background information, but gives very real parameters to shape and determine the nature and scope of the survey. For example, seeing Birmingham's Spaghetti Junction as a point of arrival rather than as a means of escape, as something to look at and watch from nearby and far away requires an investigation in terms of its topographical location, locally and regionally.

The studios run to demystify the art of design challenge the habits of day-to-day practice. To give pause for thought and coax more inventive responses, a specific conceptual framework or set of ideas is defined and clarified before going to the site. No single one of these descriptions is more 'real' and representative of its identity than any other, although the descriptions themselves may vary in quality and verve. An inspired response to the site will of course be more persuasive in terms of defining the direction of the project. It can provoke new ways of seeing the issues, help recognise the site's potential and reframe the possibilities of intervention.

None of these investigations, the models or the collages speak for themselves any more than the site does and this is critical, even the most artistically elegant or scientifically produced survey means nothing without interpretation. What matters is how well they are analysed and applied, where they lead the project, whether it is highly ecological, historical or contemporary. No one approach to the survey is inherently superior to another, more realistic or authentic. It is the calibre of investigation that is the key here. It is what the designer brings to the project rather than anything intrinsic to the site itself.

The survey can't be seen as an isolated part of the design process. Research undertaken for the survey should certainly have a bearing on the development of the brief, indicating that it might be appropriate to proceed as gently as possible, opting for a bare minimum of intervention, or alternatively that something more radical is required. The brief in turn plays a critical role in shaping the site survey, and it's the same with the concept. As this becomes more fully understood, it triggers a better appreciation of the kind of information required. No matter how strategic or early in the process, researching a project and evaluating its potential is about exploring ideas, and these ideas frame the investigation. The research stage of a project is in itself a form of criticism. It should follow the

MANHATTAN DENSITY 25,000 PERSONS/Km2 △

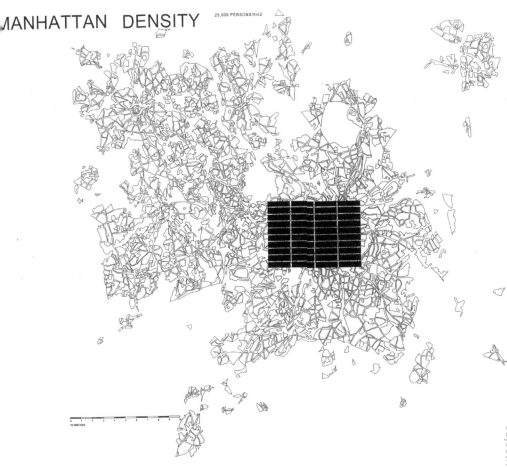

Expressing the concept of remoteness by comparing the density of Manhattan with that
of Birmingham to gauge what 'dense' actually means in the context of a peri-urban site is
not an arbitrary imposition, but a tool, a rational way into an investigation.
SCOTT DYDE, MAJOR DESIGN PROJECT, FINAL YEAR, PG DIP LA, BCU

simultaneous stitch

criteria:
-colored bands are perceived as belonging to two orientations simultaneously
-the "stitch" consists of two contrasting components with distinct directionality
-switches rely on an intensification of adjacent conditions to heighten the juxtaposition
-both components of the stitch are unique and not a part of the adjacent system

effect/implications:
-because they simultaneously fit within both systems, the stitch suggests both reads simultaneously
-the point of conflict becomes the that which enables the simultaneous read
-the stitch both disrupts and connects both systems
-the point of conflict shapes the understanding of areas beyond its immediate influence

negotiating ground

Using a new conceptual framework derived from the analysis of a painting
is just one way to coax more inventive responses to the site.

Spatial principles gleaned from paintings synthesized with contextual issues such as urban agriculture, climate change and a reduced dependence on the car, help generate the commitment needed to break away from the predominance of the grid and the diagonals of L'Enfant that currently structure the city, in order to locate a Center for Sustainability and American Culture in Washington.

Those of 'agitated ideal', 'negotiating ground' and 'simultaneous stitches' from *Guitar 1913*, Juan Gris prompt the idea of seeing E Street, Roosevelt Island and the Kennedy Center, as an urban archipelago …
DAVID MALDA, LAR 701, UNIVERSITY OF VIRGINIA, FALL 2008 MOORE + SUZUKI

… the boundary as threshold, guided flow and rhythm, derived from Malevich's *Black Square* (1913) are used to explore the topographical rhythm of the region, the relationship between art, nature and health and ideas about connecting the city to its rainwater and the Potomac …
SARAH SHELTON, LAR 701, UNIVERSITY OF VIRGINIA, FALL 2008 MOORE + SUZUKI

… and investigations of Severini's *la Danza dell'Orso* (1912) propose a weaving of the city's spatial structure to its pace of life and the flow of storm and rainwater …

… the principle of inversion is expressed in a warped landform that alternately hides and reveals water processes along the site.
LAUREN HACKNEY, LAR 701, UNIVERSITY OF VIRGINIA, FALL 2008 MOORE + SUZUKI

'I know it is beautiful but what does it mean?'
The site response drawing, when analysed,
establishes the ethos, brief, form and quality
of the project adjacent to the Bristol Channel,
exploring wind energy and the fluctuation of
the tides, as well as determining the scope
and manner of every subsequent stage of
the process.

The first model summarizes the research for the
brief, the site and the concept of a breath, or gasp
of air ...

... the ideas are developed into a three dimensional
conceptual masterplan for the project ...

lines of any good inquiry, be open, experimental, observant and analytical. Engagement in the process may be conducted in 'full blooded critical spirit' (Eagleton 2003: 61) or with studied indifference, carelessly or skilfully. But however we encounter the site, we will always interpret and reinterpret what we see, armed with a wealth of experience, knowledge and opinions. We can never be wholly dispassionate or neutrally utilitarian. Rather than describe certain aspects of design as being subjective or objective, artistic or scientific or a complicated irreconcilable mixture of the two, every part can be seen as an interpretative and culturally defined investigation. The design is in the research and vice versa, at every stage of the process.

... which is analysed and interpreted into a design, knowing the site constraints and the cultural and technological possibilities of its potential uses.
MARK PUMPHREY, MAJOR DESIGN PROJECT, FINAL YEAR, PG DIP LA, BCU

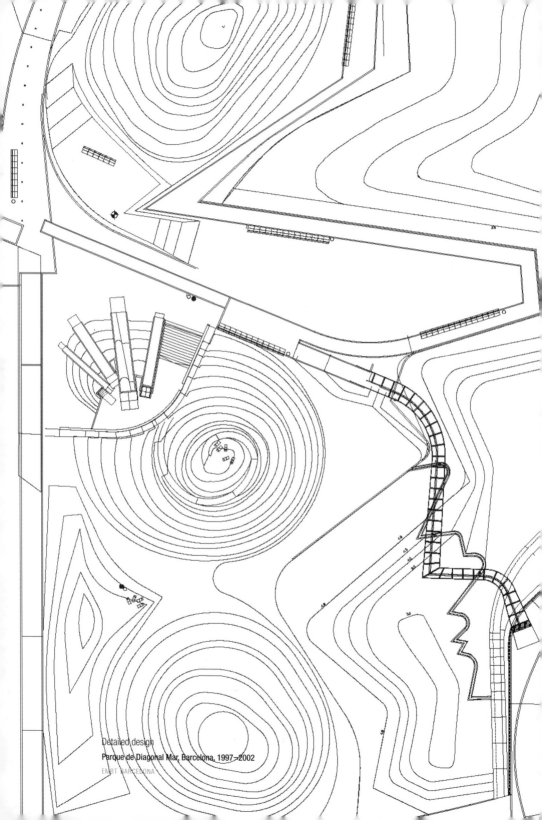

Detailed design
Parque de Diagonal Mar, Barcelona, 1997–2002
EMBT BARCELONA

Studied ignorance

This new philosophical position also has startling consequences for our conceptions of language, intelligence, meaning, the emotions and subjectivity, as these are adjusted to become independent of the shape shifting sensory lode. The pedagogical impact of these transformations becomes evident in the design process studios. A defining moment for many students, this is where preconceptions are undermined, assumptions redefined and new habits acquired. Demonstrating that philosophy really isn't as pure or remote from practice as some philosophers would like to think, it is this series of fundamental reappraisals that taken as a whole, could be used to question the curricula and strategies adopted to deal with the very earliest stages of general education as well as in many other fields of study.

The studios make a nonsense of the idea that we can choose when to be creative, use value judgements, use our imagination or even choose to be dispassionate. Countering the impression that language is rational whereas the emotions are not, the studio rescues meaning from the bridge supposed to exist between body and mind, whilst making evident the slippery, evocative and manifestly central role of language. What distinguishes the sequence of projects and lectures aimed at developing artistic sensibility is that at all stages the investigations tackle the many and varied guises of the foundational dichotomies of rationalism. The studies are given a clear purpose. A directed, intellectual and artistic activity involving the analysis of commonly used images such as advertisements, abstract paintings and iconic landscapes, they connect, for example, intelligence and the emotions, visual information with verbal information, theory to practice and intellectual criticism to formal expression. It is not just a question

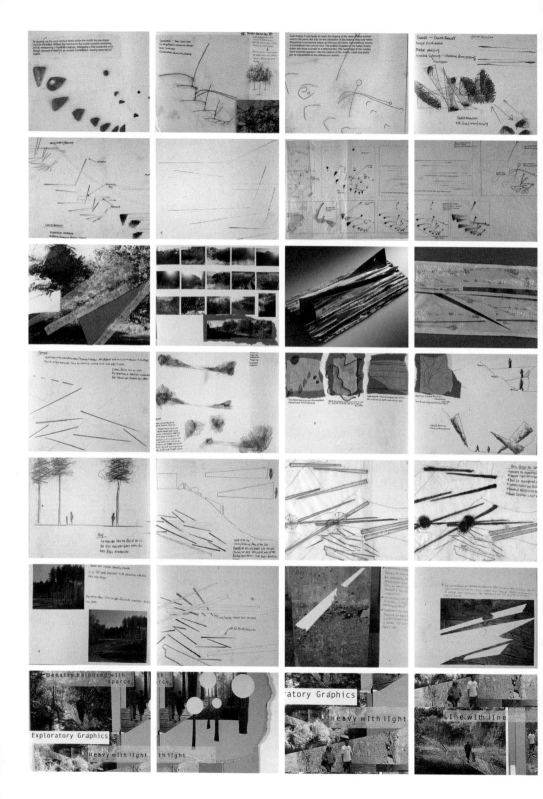

Density balanced with sparce

Exploratory Graphics

Heavy with lIght

lIne with lIne

To develop artistic practice and critical visual skill, the interpretative
and transformative studies are given a clear purpose ...

An investigation of the work of Alexander Calder to
establish what feelings the image evokes and articulating
why, in drawings and words, based on the composition of
the image, theoretical investigations as well as memories
and associations.

Exploring the implications of the spatial principles within
the medium of landscape architecture ...

Working to draw out spatial principles from the image to
act as the conceptual basis of a design.

... to create the circulation system and make decisions
about the spatial structure of the scheme at a strategic
level ...

Using the spatial principles to respond to the site and brief.

... as well as detailed instances within the site.

Exploring the three dimensional qualities of the spatial
principles in conceptual models.

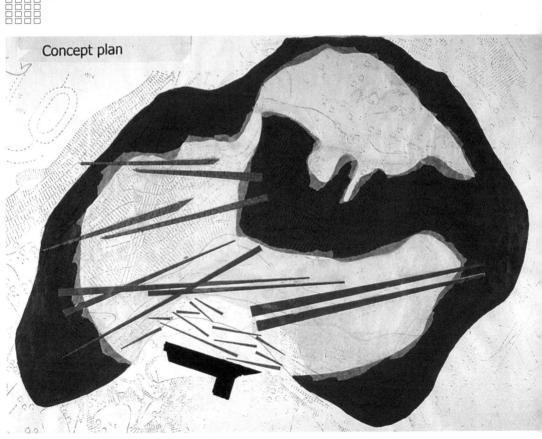

Concept plan

JENNY ROBEY, DESIGN PROCESS STUDIO, BA (HONS) LANDSCAPE ARCHITECTURE YEAR 2, BCU

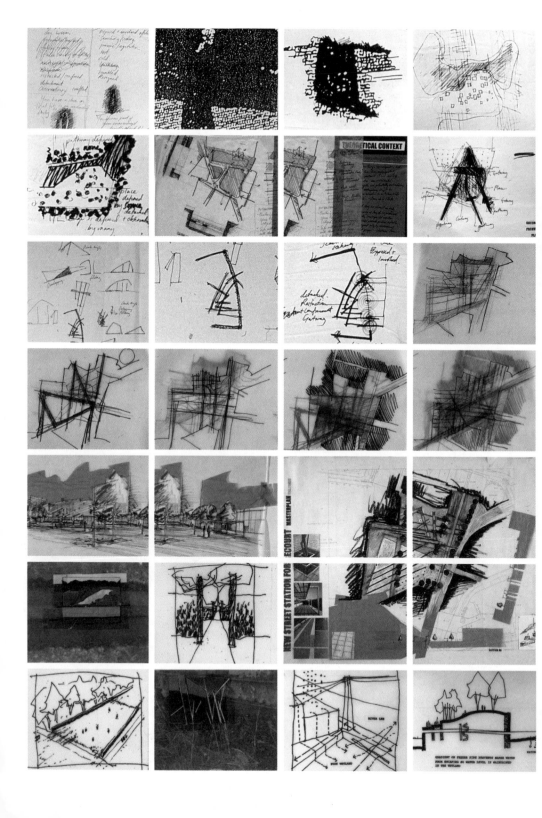

... and as students become more aesthetically aware, gradually in the studio, well-established myths separating language from emotions and art from intelligence begin to evaporate.

The concept of inside and outside is explored using the metaphor of being inside or outside of a raincoat.

A spatial and conceptual framework is created against which decisions can be made for the rest of the project.

This gives a vocabulary and a set of ideas to interpret the site, in the context of theories about public space, and as an inventive way to interpret the brief.

Emerging from studying micro details on site, spatial principles of magnifying the concept of repair through the use of water, rhythmic ordered movement, and expressing a working landscape govern the strategic design of this final year project.

An analogical, abstract model synthesising the site, brief and concept responses, is interpreted to create spatial principles.

Sketches exploring the application of these principles to the site demonstrate the extent to which drawing is an investigative tool of design.

The threshold between the urban and parkland components where the tidal river waters enter and exit the park. Angled walls indicate change in the depth of water, the boardwalk through the wetland contrasts with hard-edged busy paths providing a speedy and uncomplicated commute.

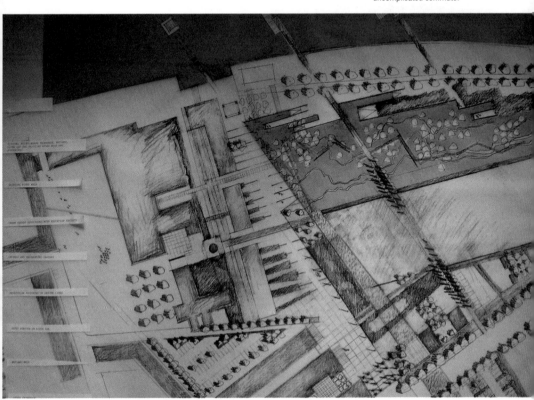

TRISH TUCKER, DESIGN PROCESS STUDIO, GRAD DIP CONVERSION YEAR, AND MAJOR DESIGN PROJECT, FINAL YEAR, PG DIP LA, BCU 2001–2004

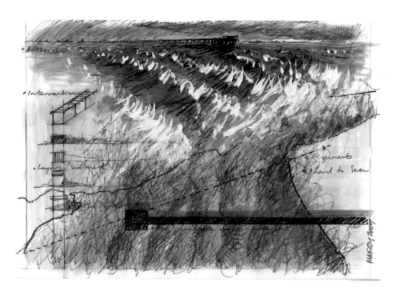

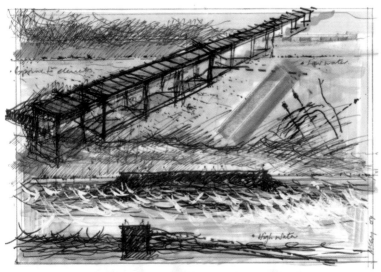

The initial responses to the site shift the focus of the project
towards the relationship between land and sea, the experience of
the wind, sky, water and horizon.

MARTIN MCCOY, MAJOR DESIGN PROJECT, FINAL YEAR, PG DIP LA, BCU 2009

Students gain confidence and fluency in the expression of ideas in
form and interpreting form through ideas …

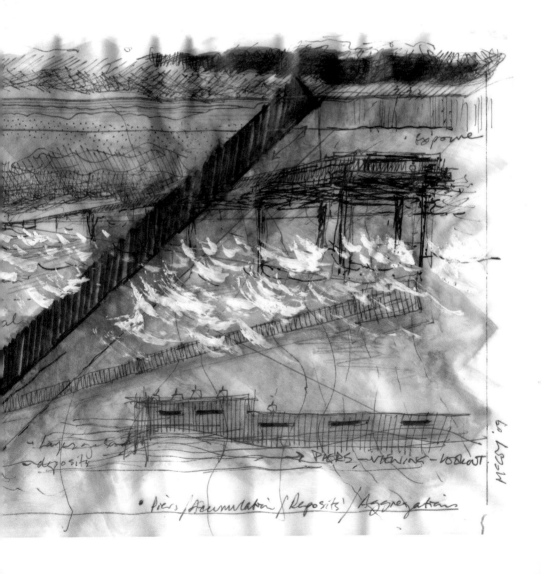

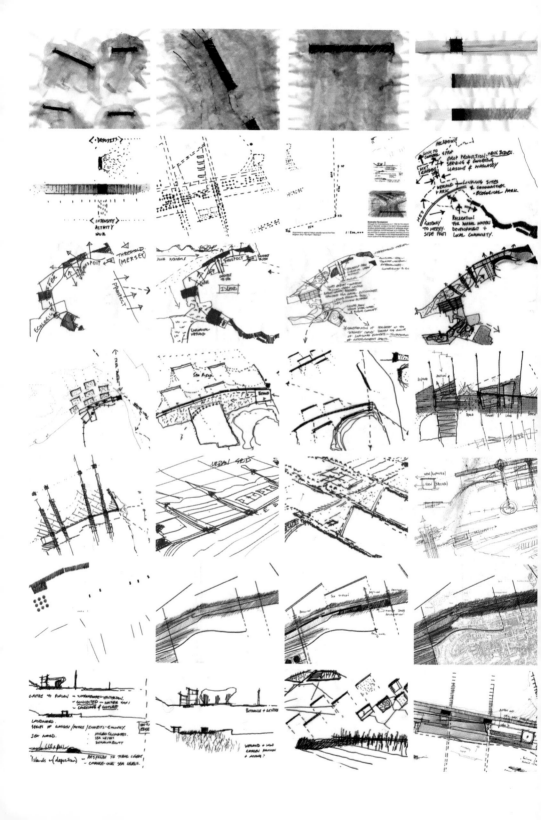

... are able to delve into the particularities of place, to inform their research into
the social, cultural and physical context of our lives ...

Paintings exploring erosion, deposition and the significance of the sea walls, which along with physical, historical and cultural research shaped the design principles that underpin the project for New Brighton.

Alignments connecting the site to distant points on the horizon, re-uniting the site with the river and sea, understanding its historic role as a strategic gatekeeper for the Mersey estuary, as a once famous seaside resort and in the context of the proposed regeneration along the North Wirral coast, from Birkenhead to Wallasey, and in the City of Liverpool.

Applying the concepts of erosion and deposition, using sea walls and piers to create a sequence of seascapes and landscapes that exploit the relationship between the site, town, river and sea, and allow visitors to experience the great fluctuations in the volume of water between high and low tide.

Exposure to the elements, the weather, wind noise and salt spray inspire the idea of making interventions into the sea.

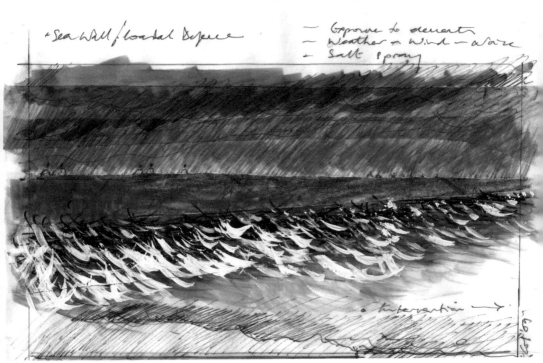

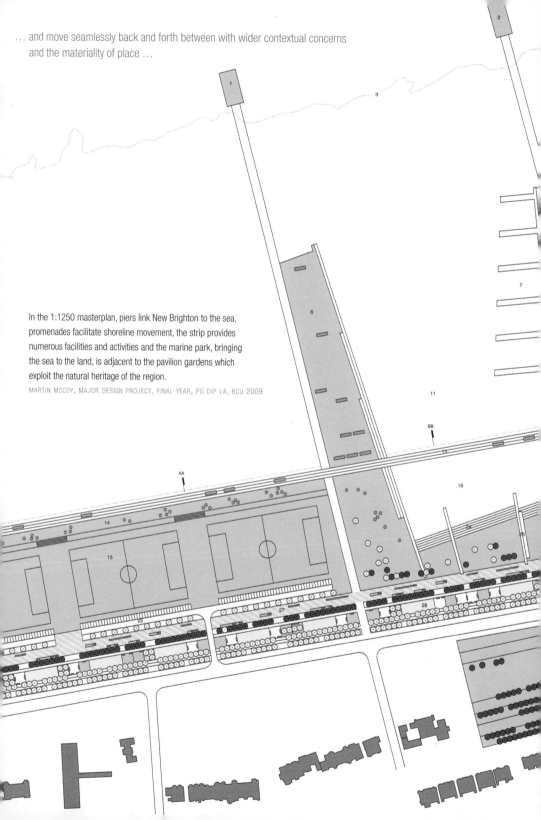

... and move seamlessly back and forth between with wider contextual concerns and the materiality of place ...

In the 1:1250 masterplan, piers link New Brighton to the sea, promenades facilitate shoreline movement, the strip provides numerous facilities and activities and the marine park, bringing the sea to the land, is adjacent to the pavilion gardens which exploit the natural heritage of the region.

MARTIN MCCOY, MAJOR DESIGN PROJECT, FINAL YEAR, PG DIP LA, BCU 2009

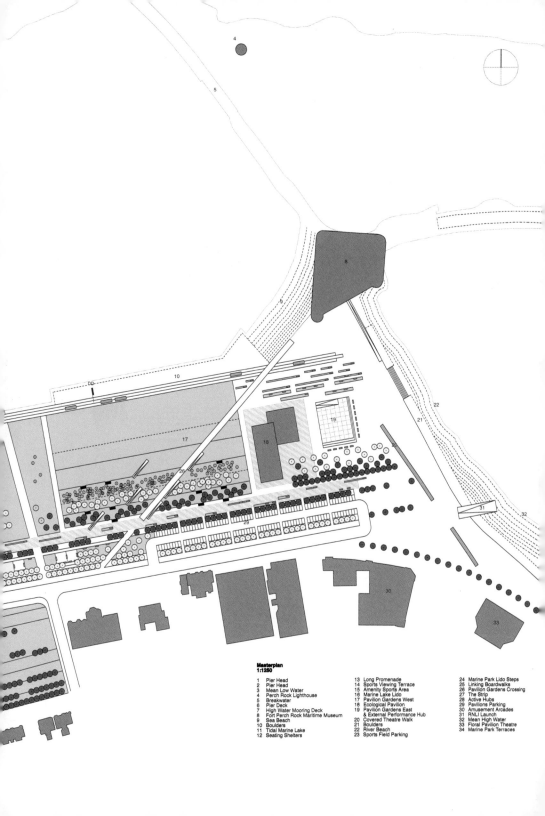

Masterplan
1:1250

1	Pier Head
2	Pier Head
3	Mean Low Water
4	Perch Rock Lighthouse
5	Breakwater
6	Pier Deck
7	High Water Mooring Deck
8	Fort Perch Rock Maritime Museum
9	Sea Beach
10	Boulders
11	Tidal Marine Lake
12	Seating Shelters

13	Long Promenade
14	Sports Viewing Terrace
15	Amenity Sports Area
16	Marine Lake Lido
17	Pavilion Gardens West
18	Ecological Pavilion
19	Pavilion Gardens East & External Performance Hub
20	Covered Theatre Walk
21	Boulders
22	River Beach
23	Sports Field Parking

24	Marine Park Lido Steps
25	Linking Boardwalks
26	Pavilion Gardens Crossing
27	The Strip
28	Active Hubs
29	Pavilions Parking
30	Amusement Arcades
31	RNLI Launch
32	Mean High Water
33	Floral Pavilion Theatre
34	Marine Park Terraces

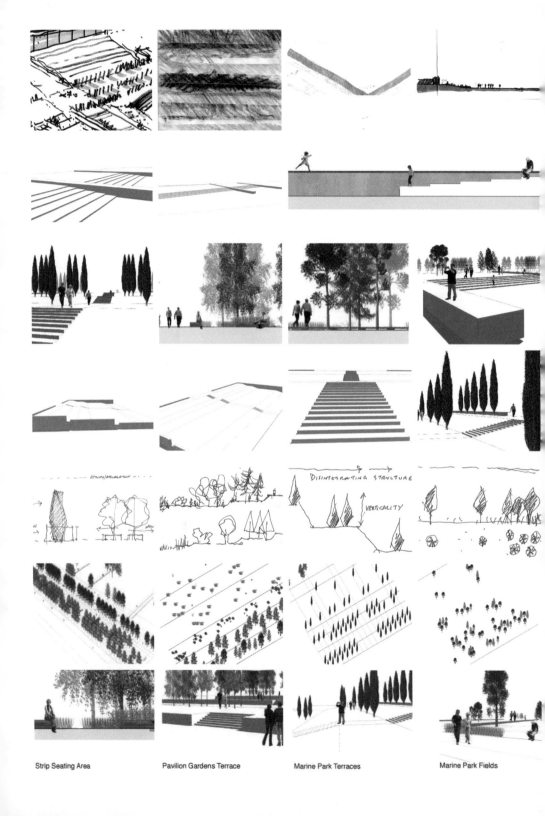

Strip Seating Area

Pavilion Gardens Terrace

Marine Park Terraces

Marine Park Fields

... working artistically at a strategic as well as at a detailed level.

The marine park cuts through the longitudinal landscape to connect the urban quarter to the coastal zone.

Interpreting the concepts and principles to explore the design of the terraces, which offer key views of the site, exaggerating their elevation by columnar tree planting. The piers become linear hubs and lookouts as well as routes from the land to the sea.

A college is the inspiration for the terraces stretching from the elevated edge of the land physically defining New Brighton, to the edge of the sea, which is constantly eroding it.

The accumulations of sedimentation and deposits are represented by physical objects, the increasing stratification of planting or as sites of activity.

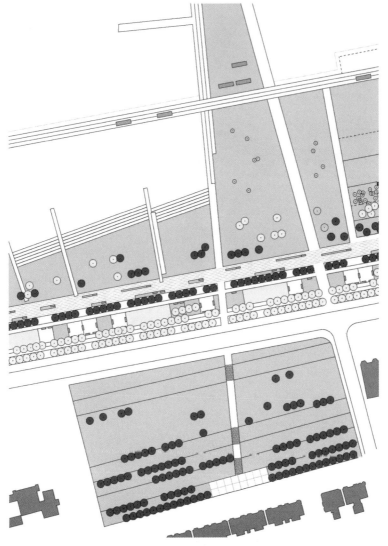

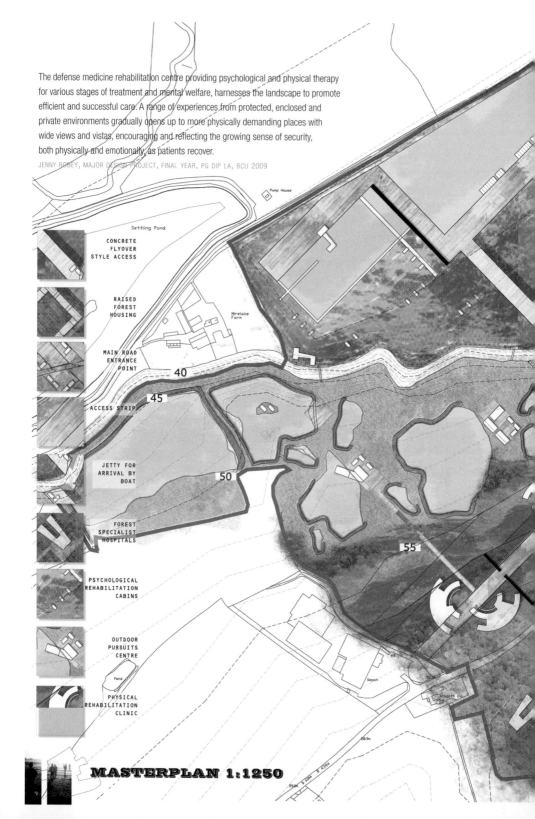

The defense medicine rehabilitation centre providing psychological and physical therapy for various stages of treatment and mental welfare, harnesses the landscape to promote efficient and successful care. A range of experiences from protected, enclosed and private environments gradually opens up to more physically demanding places with wide views and vistas, encouraging and reflecting the growing sense of security, both physically and emotionally, as patients recover.

JENNY ROBEY, MAJOR DESIGN PROJECT, FINAL YEAR, PG DIP LA, BCU 2009

CONCRETE
FLYOVER
STYLE ACCESS

RAISED
FOREST
HOUSING

MAIN ROAD
ENTRANCE
POINT

ACCESS STRIP

JETTY FOR
ARRIVAL BY
BOAT

FOREST
SPECIALIST
HOSPITALS

PSYCHOLOGICAL
REHABILITATION
CABINS

OUTDOOR
PURSUITS
CENTRE

PHYSICAL
REHABILITATION
CLINIC

MASTERPLAN 1:1250

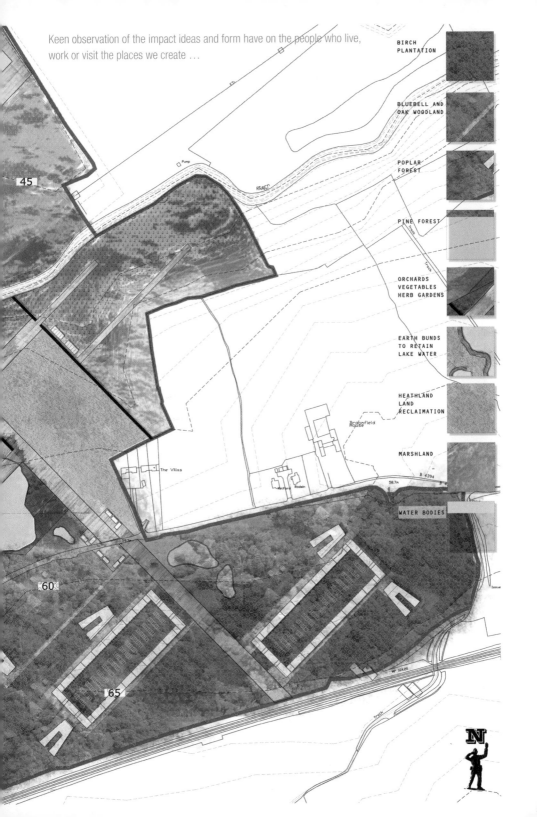

Keen observation of the impact ideas and form have on the people who live, work or visit the places we create …

BIRCH
PLANTATION

BLUEBELL AND
OAK WOODLAND

POPLAR
FOREST

PINE FOREST

ORCHARDS
VEGETABLES
HERB GARDENS

EARTH BUNDS
TO RETAIN
LAKE WATER

HEATHLAND
LAND
RECLAIMATION

MARSHLAND

WATER BODIES

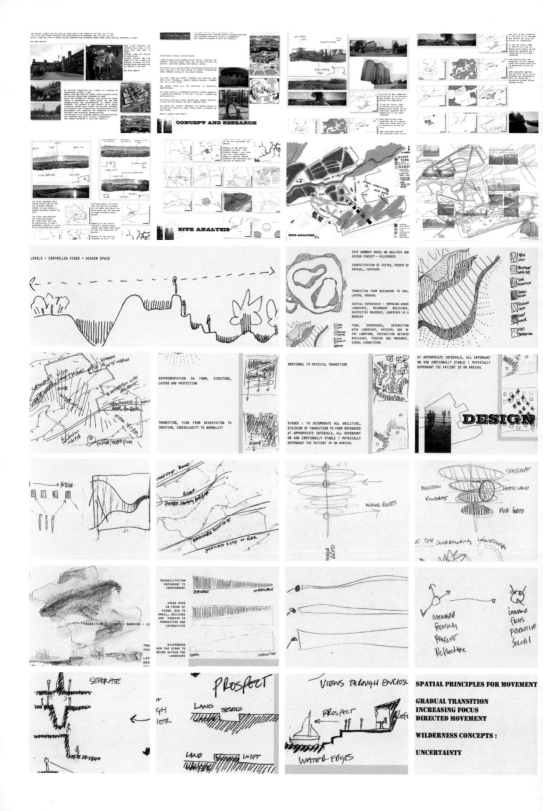

CONCEPT AND RESEARCH

SITE ANALYSIS

SITE ANALYSIS

LEVELS - CONTROLLED VIEWS - HIDDEN SPACE

DESIGN

SPATIAL PRINCIPLES FOR MOVEMENT

GRADUAL TRANSITION
INCREASING FOCUS
DIRECTED MOVEMENT

WILDERNESS CONCEPTS :

UNCERTAINTY

PROSPECT

VIEWS THROUGH ENCLOSURE

Understanding the site in its geographical, cultural, visual
and physical context, its materiality and its potential given
the desire to manipulate visual and spatial connections
with the surrounding landscape, focused by research into
the concept of wilderness.

Exploring a transition from points of arrival into a
wilderness that is a dense, restricted landscape, isolated,
controlled and singular, to points of departure that are
cultivated, productive and social.

Addressing the spatial implications of these conceptual
explorations at a strategic scale.

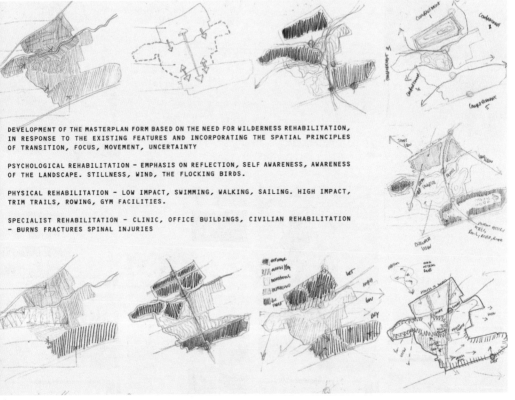

DEVELOPMENT OF THE MASTERPLAN FORM BASED ON THE NEED FOR WILDERNESS REHABILITATION,
IN RESPONSE TO THE EXISTING FEATURES AND INCORPORATING THE SPATIAL PRINCIPLES
OF TRANSITION, FOCUS, MOVEMENT, UNCERTAINTY

PSYCHOLOGICAL REHABILITATION – EMPHASIS ON REFLECTION, SELF AWARENESS, AWARENESS
OF THE LANDSCAPE. STILLNESS, WIND, THE FLOCKING BIRDS.

PHYSICAL REHABILITATION – LOW IMPACT, SWIMMING, WALKING, SAILING. HIGH IMPACT,
TRIM TRAILS, ROWING, GYM FACILITIES.

SPECIALIST REHABILITATION – CLINIC, OFFICE BUILDINGS, CIVILIAN REHABILITATION
– BURNS FRACTURES SPINAL INJURIES

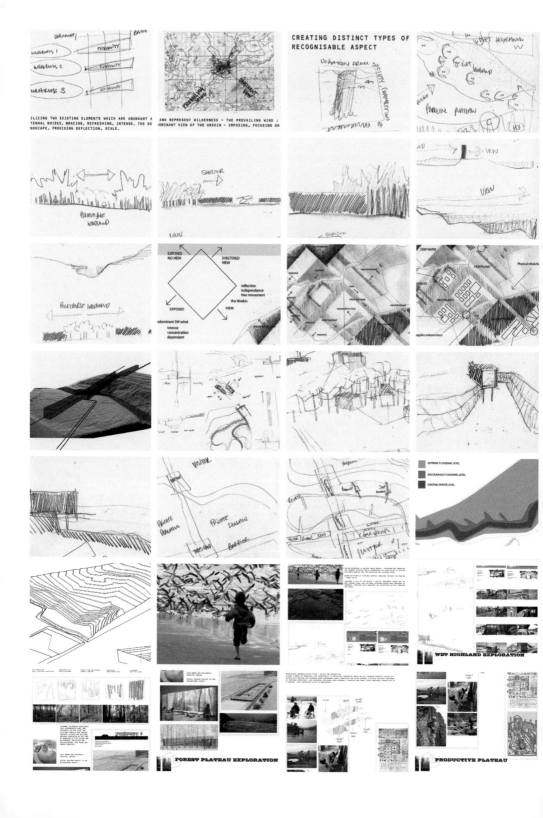

... with knowledge of the culture and traditions of the medium, the skill and confidence
to manipulate this spatial, visual and conceptual discourse ...

Defining the concept of wilderness more precisely to fit the site, creating a range of landscape qualities using the degree of exposure to the wind, dominance of views to distant hills, the concept of uncertainty and difficulty of navigation to contrast with areas with a sense of protection, calmness and certainty.

Increasing wildlife capacity and patient engagement with the landscape by broadening the flood plain, increasing water retention, creating secluded areas and promoting social interaction.

Allocating spaces to specific uses, matching the stages of rehabilitation with the landscape qualities. Each medical centre has a distinct landscape to create a strong sense of place.

Extended settling pools and increased flood plain improve the marshland and habitats for flocking birds.

A sense of suspense comes from the bridge crossing from the wet highland to the dry plateau, hiding the river that can be heard. It frames views, yet shields patients from public gaze.

The river used as a natural barrier to create a site of two halves, with protected, secluded initial treatment cabins for the most severe cases and more populated spaces as patients recover.

Developing the character of the wet highland, the forest plateau, and the productive plateau.

Wilderness experience provided by woodlands of markedly different character giving immediately identifiable locations, protection and navigation for long term patients and staff.

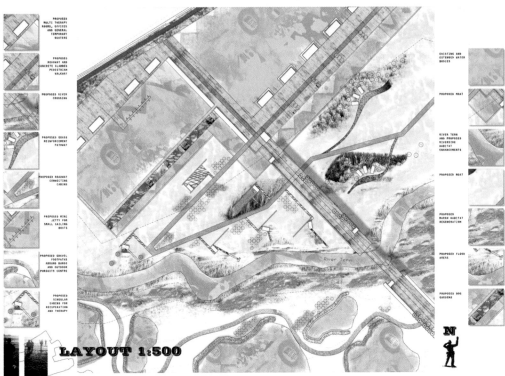

LAYOUT 1:500

JENNY ROBEY, MAJOR DESIGN PROJECT, FINAL YEAR, PG DIP LA, BCU 2009

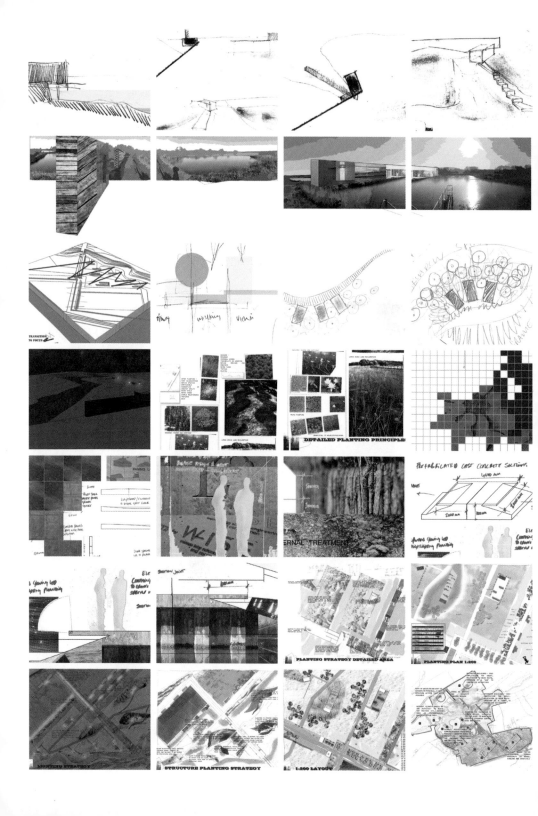

DETAILED PLANTING PRINCIPLE

PERFABRICATED CAST CONCRETE SOLUTIONS

ERNAL TREATMENT

PLANTING STRATEGY DETAILED AREA

PLANTING PLAN 1:200

LIGHTING STRATEGY

STRUCTURE PLANTING STRATEGY

1:200 LAYOUT

... nourishes and invigorates every stage of the process, to build a critically rigorous, artistic body of work.

Cabins nestle into the earth, close to the river, the translucent wall creating a voyeuristic, safe way for patients to observe visitors, but remain hidden from view. Changes in levels and surfaces restrict access from the public domain, fastigiate hornbeam and close-planted alder create windbreaks deflecting the gaze of visitors in contrast with the wide-spaced poplar plantations making the most of the breeze, opening up distant views.

The stars and the sky become the vista at night. The planting is playful, tactile and wild and detailed construction, limited to bleached, polished, in situ, ridged or translucent concrete.

The artistic rationale is expressed in every detail of the design to shape the quality of everyday life and experience.

Critical analysis of design decisions ...

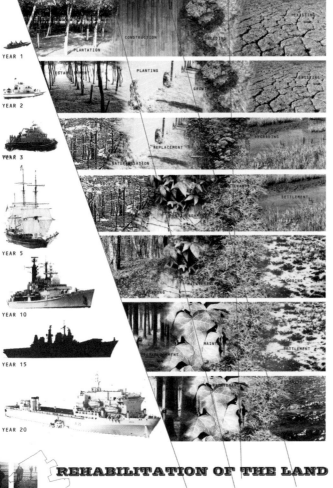

YEAR 1
YEAR 2
YEAR 3
YEAR 5
YEAR 10
YEAR 15
YEAR 20

... in a project concerned with physical, psychological and ecological rehabilitation.

REHABILITATION OF THE LAND

JENNY ROBEY, MAJOR DESIGN PROJECT, FINAL YEAR, PG DIP LA, BCU 2009

of saying what feelings or emotions an image evokes, but articulating why, in drawings and words, based on the image's composition and the memories it evokes, together with theoretical investigations. It is a case of transforming an image into spatial principles that have the potential to act as the conceptual basis of a design, in response to a site and brief.

Initially the process is met with resistance if not outright hostility, but the benefit is that, eventually, many students learn how to design systematically without 'just plonking things down' in the vague hope that it will all work out okay in the end. Students and external examiners involved in the monitoring of courses in the UK respond very positively to this approach. One novice student wrote,

> Critical for me has been the realization of designs which are reasonable resolutions of site potential and problems, site briefs and the application of spatial principles. Yes, it feels as if I am actually designing, inefficiently of course, but perhaps with a degree of potential.

Introducing students to the idea of critical visual, spatial analysis produces a variety of predictable responses. Studying an advertisement should be a relatively painless way into the visual world. Everyday, modern cultural artefacts, they surround us, appearing on hoardings, television, the cinema, magazines and the Internet. Designed specifically for popular consumption, sophisticated, subversive and eye-catching, whether easily understood or provocatively cryptic, they are available to almost everyone. Yet many of us, when asked to analyse what an advertisement makes us feel and why, are blissfully unaware of the amount of time and effort, not to say money, spent on every nuance of its composition in order to achieve a specific and particular response. Asking highly educated students to analyse its physical composition often induces shock, not because it is complex (although it can be) but because the task is so unfamiliar.

The scant attention paid to abstract art in general education makes the interpretation of a painting even more mind-boggling than dealing with an advertisement. Choosing an abstract work for interpretation helps undermine old certainties, not least because the forms do not immediately obviously represent anything. By definition, the image has to

be interpreted, but in addition, the project opens up a world of influential ideas that have a continuing and significant physical, visual impact on our environment. Accompanied by a wealth of critiques, texts and manifestos setting out the aims and aspirations of the art movement, it makes for an explicit and ready-made theoretical context.

It soon becomes apparent however that this sort of analysis is un-charted territory for many and that learning to look carefully is not as easy as it seems. Even those coming from an artistic background, having to critically analyse their responses to images is just not something they have ever been asked to do before. There is an awful lot of catching up to be done. The embarrassment, even disgruntlement it creates is down to the fact that for all but a few, the visual world is a closed book. They struggle to hazard a guess about form, line, tone and composition and are positively squeamish about discussing what it makes them feel, let alone why. Bemused at the thought of dwelling on emotional matters (things that are so often left unsaid), hesitant and unsure of their ground, students will often do anything to describe what they see rather than say what it makes them feel. When pressed, cursory comments such as, 'it makes me feel nice' or 'it makes me feel miserable' are diffidently offered, a kind of implicit pleading for someone to change the subject.

Convinced there are rules to follow but not knowing what they are, or that there is more to it than meets the eye, students complain that the project feels alien, or that they don't possess the critical faculties or confidence to be sure of what it is they are looking at; they are reluctant to go out on a limb. The whole process introduces a degree of ambiguity that is firmly discouraged in education. Novice grade 'A' students, for example, are almost unflinching in their desire to do things that *should* be done (is this what you want me to do?) rather than exploring the possibilities of what *could* be done. Used to conforming rather than challenging, geared up to find the right procedure and following it to the letter rather than see it as a starting point to be interpreted if not subverted, they often seem ill-prepared for the artistic milieu that expects them 'to tolerate ambiguity, to explore what is uncertain, to exercise judgments free from prescriptive rules and procedures' (Eisner 2002: 10).

A number of familiar myths contribute to their disquiet. Primarily, current perceptual theories make it seem almost inconceivable to think of anything drawn or visual as having an intellectual basis, explaining why working with images is barely addressed in education. Visual illiteracy is made all the more acute by the recent preoccupation with treating an image as a façade or 'sign which connotes meaning' (Whitely 1999: 108), or to simply 'illuminate cultural and political conditions'. A manifestation of the 'colonisation of the visual by the literary', this epitomises the tendency to 'denigrate the visual and downgrade visual scrutiny' (Whitely 1999: 116) which, in turn, encourages visual indolence. It is symptomatic of the kind of criticism Whitely describes as being 'marooned in a sea of generalities', non-particular criticism that 'seems like it can be brought off the peg and *in absentia*, rather than made to measure from a personal fitting' (Whitely 1999: 113). A habit derived from art criticism abandoning any kind of formal analysis in favour of a fervid concentration on interpretations of political, cultural and social factors, it is part of the same post-modern fallacy that ignores physical attributes in search of invisible meaning. Attention deflected from materiality, encourages lazy looking, no second glances and the excuse to float into the ether without a paddle. Emotions, popularly characterised as passions that can overwhelm reason, shaped by 'slow, deliberate forces of evolution' (Goleman 1996: 5) are left languishing in the subjective realm, disassociated from intelligence. In trying to sense without thinking, unconsciously urging the painting to communicate or give up its secrets, the expectation is that the right answer, the real truth of what the artist had in mind, the essential meaning embedded in the picture, will emerge if you look long and hard enough.

The metaphysical and discriminatory ways in which visual, artistic or subjective information is treated in education are of course partly to blame, but the problem is compounded further by the reductive way we typify language and intelligence. In mainstream cognitive science (and many other disciplines), '*thinking* is strongly identified with language' (Goldschmidt 1994: 159). From a pragmatic perspective this is fine, there is nothing to disagree with in this respect. What is of great concern, however, is the restricted way in which language and intelligence are characterised and the premium placed on such a narrowly defined conception, described by Hudson as an 'oversight of such magnitude that it is a little hard to credit' (Hudson 1976: 38).

The current ethos (some would say obsession), holding language to be rational, linear and convergent, obviously has its foundations in Cartesian dualism, but the seamless correlation of language with intelligence is contributed to by a number of other related factors. From the nineteenth century onwards Rorty explains, philosophers put forward language itself as a kind of barrier between us and the world, in other words, another interpretative veil. Establishing the idea of language as something that represents, corresponds to, or acts as the medium in which we form pictures of an objective reality, paved the way in the 1950s for the concept of 'universal linguistic unconsciousness' (Stafford 1997: 5), in other words, that language or grammar, whilst allowing for certain variations, are innate and universal, a position promoted by the influential linguistic theories of Chomsky.

The investment in the underlying universal structure of language intensified Hudson remarks, in the heyday of analytical philosophy in the mid-twentieth century when 'an excessive rationality tended ... to treat problems of knowledge and meaning as though they were matters of logic' (Hudson 1976: 38). Prompted by the logical positivist view that characterises 'everyday language' as too confused and vague to be analysed or classified, many analytical philosophers 'continue to think that meaningful language must be understood on the model of the language of physics' (Putnam 2002: 10), leading to what Putnam calls the 'profoundly wrong' idea that the 'language of science was the *whole* of cognitively meaningful language' (Putnam 2002: 34). In combination with what Goldschmidt calls a 'sweeping linguistic imperialism' (Goldschmidt 1994: 159), and what Stafford describes as a 'hierarchical "linguistic turn" in contemporary thought', this seals the deal on the 'identification of writing with intellectual potency' (Stafford 1997: 5).

As a consequence, studies in educational theory, development psychology and intelligence have an overwhelming if not exclusive emphasis on language acquisition and development. Tests measuring visual skill invariably focus on non-verbal inductive and deductive reasoning, worlds away from anything that might help with critical visual or artistic analysis. And we are stuck with the results; Hudson's anguish is evident as he writes that despite whatever might be said to the contrary, educational experts still implicitly take convergent skills to epitomise 'all that is

morally, personally and educationally desirable' (Hudson 1976: 133). It remains the case, as does the firm belief that when we are thinking about words, we are thinking in a linear, logical fashion. Yet writing can be an agonisingly slow and circuitous process, there doesn't appear to be anything particularly linear about it. The words aren't 'in there' waiting to march on to the page in a neat procession or a straight line.

Recent efforts to retrieve language from the role of epistemological bullyboy rely increasingly on the crucial part played by interpretation. Language for example, is thought to connect aesthetics (in the traditional 'perceptual' sense) with context, via interpretation (Parsons 1995: 12–13). As with aesthetics, attempts to democratise language emphasise its ambiguous, interpretative nature, but still depend on what Gallagher calls a universal conception thought to exist beyond the 'written text and spoken word' (Gallagher 1992: 6) or what Snodgrass and Coyne characterise as a 'forestructure of understanding' (Snodgrass and Coyne 2006: 37). The real irony in all of this is that the 'tyranny of language' is made more potent by those fighting to support the visual actually buying into its storyline. Arguing for the need to overcome the dominance of language by championing irrationality and freeing the arts from its narrow constraints, language is held responsible for the 'downgrading of sensory awareness to superficial stimuli and false perceptions' (Stafford 1997: 5). Aesthetic experience is valued as virtually the only thing that can 'make us forget for a moment about language and reason, allowing us to revel however briefly in non-discursive sensual joy' (Shusterman 2001: 148). Language is seen as so controlling that it is only work in the arts that provide the opportunity to utilise 'the so-called subjective side of ourselves' or enables us to 'stop looking over our shoulder and to direct our attention inward to what we believe or feel' (Eisner 2002: 10). This escape from language does have its contradictions, however, take for example poetry. Poetry, we are led to believe, somehow balances on the threshold of both language and sensuality and therefore has 'the capacity of bringing us momentarily back into the oral and enveloping world' (Pallasmaa 1994: 25).

This philosophical tug-of-war would never have developed had we not placed language on a lofty perch in the first place. It's time to realise that it is this residual misconception of language that does damage to the arts,

not language *per se*. Establishing a credible educational and intellectual basis for the arts is going to take more than the mere tweaking of a jaded and spurious scientific view of language and intelligence.

The legacy of Western rationalism has, Eagleton suggests, 'severed intelligence from the emotions leaving it menacingly frigid and unfeeling' (Eagleton 2003: 85). This position is so firmly wedged into the cultural psyche he believes very few theorists would 'even recognise an artistic emotion, let alone have anything to say about it' (Eagleton 2003: 85). Marginalised and excluded from 'serious' discourse, talking about feelings, emotions and sentiments is just as much a taboo as aesthetic experience and the visual. Sir Geoffrey Jellicoe, for example, confessed that had he discussed the design concept for the water gardens at Hemel Hempstead (designed and built in the 1950s) he would have been carted off to the asylum and Rykwert notes that to talk about the art of town planning in this context would be 'ridiculously passé' (Rykwert 1989, preface).

Although it may well have become acceptable to talk about subjectivity, to even acknowledge that feelings exist, it remains the case as Whitely points out that it is not 'desirable or even politically correct' to make judgements about aesthetic issues and most think its not even possible or credible (Whitely 1999: 111). So-called value judgements are still 'dismissively relegated to the realm of personal and arbitrary likes and dislikes' regarded as 'entirely relativistic and subjectivist' (Whitely 1999: 110). You only have to listen to the justifications from house builders and developers alike, affronted by damning criticism of the poor quality of mass housing to appreciate how much this remains the case. It seems near impossible to shift the conviction that facts can and should be separated from values. Neutral objectivity remains the gold standard despite compelling evidence that it is unachievable. Subjectivity can never properly recover from the logical positivist belief that if something is not factual, it is 'cognitively meaningless' (Putnam 2002: 10). It's an attitude that is threaded through all levels of education, hence the shuffling of feet when students are asked to explain their emotional response to an image or to articulate the quality of their experience of a place.

As the studio progresses, however, such well-established 'givens' separating language from emotions and art from intelligence begin to evaporate.

Drawing and tracing over the image whether it is a landscape, painting or advertisement, focuses attention on physical qualities and materiality, demonstrating that not only do images have compositional qualities that can be analysed intelligently and inquisitively, but also that drawing is an investigative design tool. Discouraging a reliance on underlying nuances or the invention of schematised abstractions, it also prompts more careful observation. In fact, analysing the image in such a focused way is similar to detective work, searching for clues, a particular phrase or words to explain what is seen or felt, tracing and drawing over again to analyse the composition this way then that. The narrative explains the drawings, the drawings illustrate the words and with time and tuition, it throws light on what the image makes people feel and why. Further stages use a similar process to help define principles, albeit in an embryonic way, to establish a spatial and conceptual framework against which decisions can be made for the rest of the project, as part of an artistic rationale that can be explained, defended and used as inspiration for the overall spatial structure as well as every detail of the design.

The sheer diversity of interpretations, whether in words or diagrams is enough to demonstrate that there really isn't one right answer, one right way to go. It takes a while to realise that adjusting to the idea that there are no permanent truths to discover, does not mean the process is without end, just that the end is not a fixed destination. A design or a criticism is a snapshot of what we believe and value at a particular time in response to a particular problem and context. What we feel to be the case may shift as the problem is seen from a different perspective. All this can come as something of a shock to students new to this approach, but gradually the question 'is this how you want me to do it?' is asked less and less as they begin to take responsibility for their own work.

Our emotions are stirred by things that have been read, seen, or heard, however trivial or profound. These emotions may change through experience, fade over time; they may disappear altogether and re-surface without warning. When analysing a painting for example, feelings may well alter as more becomes known about the history, theory, symbolism or ambitions of the movement being studied, but the shifting nature of these responses relates to Dewey's observation that emotions are not 'simple and compact', but 'are qualities, when they are significant, of a complex

experience that moves and changes' (Dewey 1934: 41). Understanding Robert Rauschenberg's work in the context of men landing on the moon can dramatically affect an initial judgement, as can trying to make sense of Mark Rothko in the context of the tragedy of his life. A colleague's or critic's point of view, a different interpretation can cast a new light, create another impression. Unexpected and sometimes even unwelcome ideas might take a bit of adjusting to, but they can also help develop our understanding and actually encourage something new, revelatory and illuminating if we are open minded enough to allow them.

That emotional responses, rather than being subjective and separate from intelligence are 'in principle open to the possibility of change, as a consequence of reflection ...' demonstrates what Best calls the 'rationality of feeling' (Best 1992: 2). Understanding that 'reasons can confer new possibilities of feeling' and that 'artistic experience is as fully cognitive and rational and as fully involves *learning and understanding* as any other subject in the curriculum' (Best 1992: pxii, his italics), makes it possible to recognise that as Dewey says 'All experience is emotional but there are no separate things called emotions in it' (Dewey 1934: 42). Developing emotional literacy, like learning to read text or appreciating music, is part and parcel of understanding what it is to be critically and culturally aware, getting to know the medium and understanding how it shapes our experience.

Efforts to legitimise subjectivity have centred on the idea of meaning, traditionally placed at the intersection of the sensory realm and language. Considerable thought has been given to establish what meaning is and what makes it accessible. In design this translates into attempts to establish what sort of configurations of space or activities are likely to promote meaningful experiences. But in effect, in this sense, meaning is just another metaphysical safety valve.

A new interpretative view of perception removes the need for any such junction. The difference it makes can be illustrated by analysing Gallagher's discussion of Dewey's take on language. Gallagher suggests that when Dewey says, 'meanings do not come into being without language', he is implying an intrinsic 'connection' between language and meaning, such as the well-established notion that language captures and expresses meaning,

In the following sequence of illustrations, Miralles takes the development of his ideas from the initial inspiration, such as an inkblot, through various transformations as it is drawn, modelled and theorised, manipulated to create a design. The drawings are enticing romantic gestures for clients, students, and fellow professionals alike, the transformation he achieves into physical reality is often startlingly close to the conceptual scribbles and doodles, as technological, physical and cultural boundaries are pushed and challenged at every turn.

Miralles describes this sequence of drawings as exploring the fluidity and delicacy of movement associated with a basketball player jumping towards the basket, together with the flick of the wrist as the ball is lofted through the hoop.

Benedetta Tagliabue Miralles describes the importance in the design process of selecting the lines in a drawing that are capable of expressing the 'richness of the idea, and things that might not have been thought about', which, she adds, 'tells you that you must concentrate in order to understand that reality' (Tagliabue and Zaragoza 2001).

Parque de Diagonal Mar, Barcelona, 1997–2002

EMBT, BARCELONA

childrens quarter

pred

THE CITY WOVEN THE
PARK THROUGH
LIGHT.

direction of
light
(not walking)

Hill +
topographic
work

More
urban

water

?

To find a larger scale of the park in the city.

City direction

valley

City arrow

City arrow

beach
landscape
into the
park
MIRAGE GARDEN
EFFECT

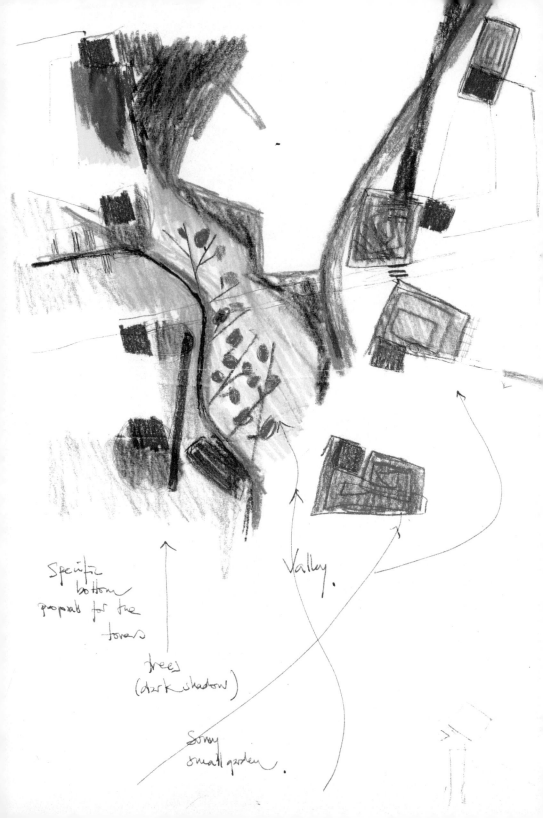

Specific
bottom
proposals for the
towers

trees
(dark shadow)

Valley.

Sunny
small garden.

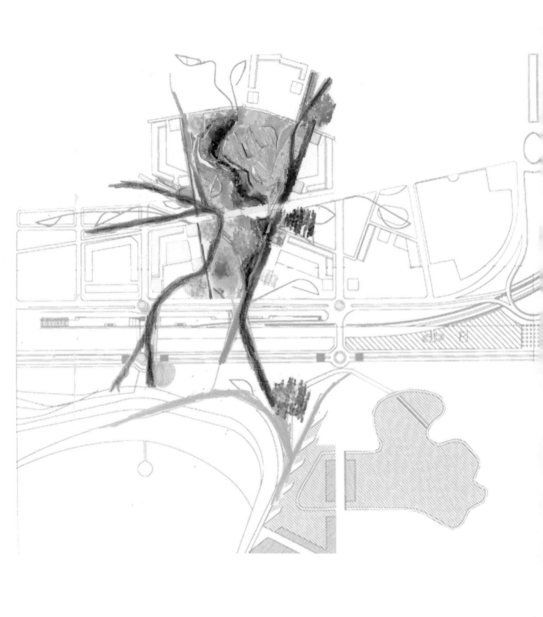

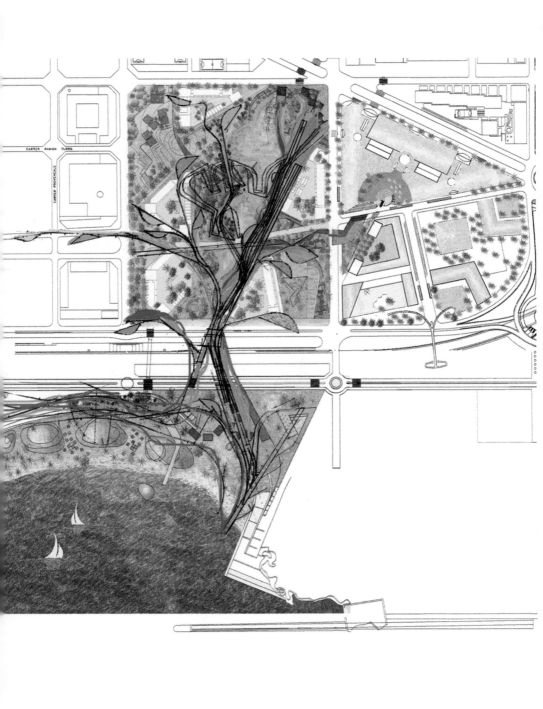

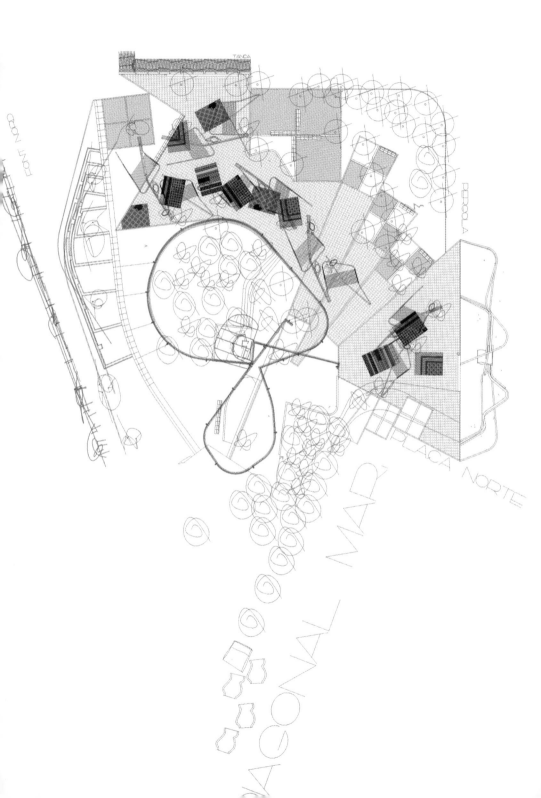

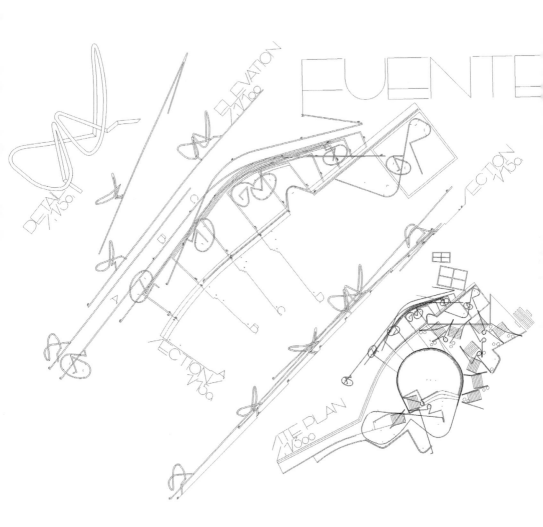

FUENTE

ELEVATION 1/100

DETAIL 1/50

SECTION 1/50

SECTION 1/50

SITE PLAN 1/500

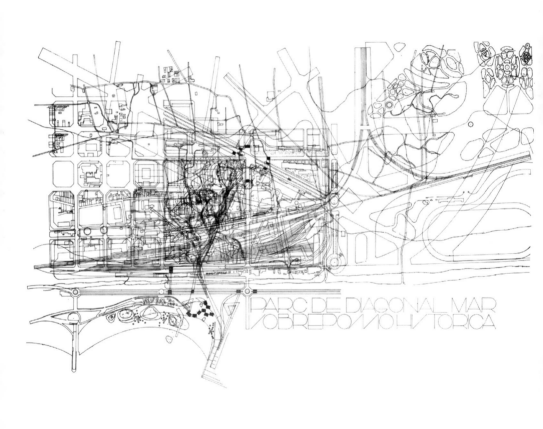

PARC DE DIAGONAL MAR
SOBREPOSSIO HISTORICA

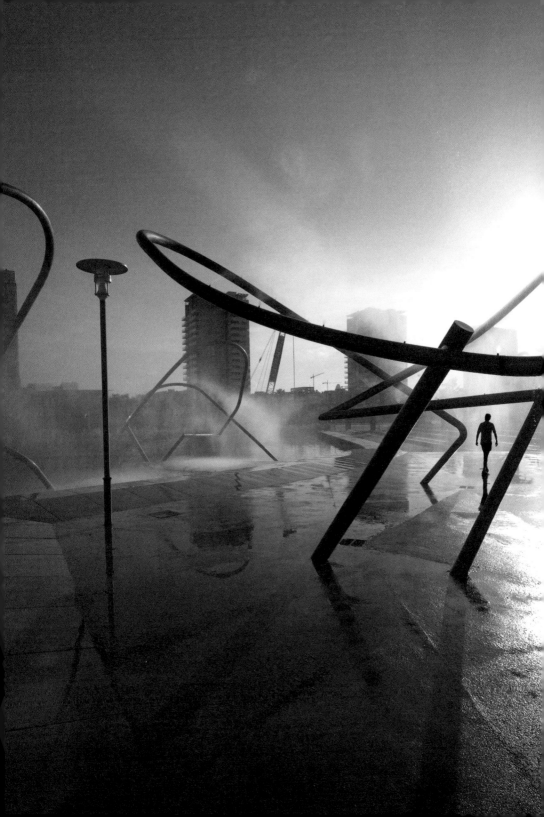

structures our interpretations, or that meaning requires language in order to manifest itself (Gallagher 1992: 119). Put the accepted version of events to one side and it can be seen that actually Dewey is refuting any such connection and suggesting something far more straightforward. It is, as Eagleton explains, more a matter of realising that 'meaning is not simply something "expressed" or "reflected" in language: it is actually *produced* by it' (Eagleton 1983: 60). There is no other way for meaning to be manifest. This is the case in all experience. Taking on board the idea that language, as much as perception, *is* interpretation is to recognise that meaning can only come from the language and concepts we have at our disposal. Whether investigating paintings, iconic landscapes or advertisements any meaning we might glean is dependent on what we know, it comes from the language we use, the explanations and observations we make. That is as far and as deep as it goes. As far and deep as our knowledge and experience can take us.

The studios really bring home the slippery nature of language. Trying to find the right words to express what is seen and felt students quickly realise that, as Hudson remarks, 'to examine the use of words is to plunge into muddle, innuendo, ambiguity, fantasy and internal contradiction' (Hudson 1976: 38). An analysis of even simple sentences or words demonstrates the 'elusive, shifting world of everyday meanings' (Hudson 1976: 39). Language, laden with emotion and ambiguity, is far more surprising and sensuous than its cool, rational reputation would suggest. The important thing to note however is that whilst this in no way diminishes the role of language, it does have a dramatic impact on the nature of that role.

This analysis of the role of language, emotions and intelligence has profound pedagogical implications. A painting or drawing does not have a universal visual meaning, no quintessential truth for us to find. No image is ever self-evident. We have to communicate its significance and purpose, to ourselves and to others. In the studio, text needs a visual, graphic explanation to demonstrate its spatial implications and images need a textual explanation to show how and why they are relevant to the problem in hand. Presented without explanation, it is easy to misunderstand or even forget why an image was felt to be important in the first place. Always open to interpretation, it's plain foolish to leave it up to others to make of it what they like without some kind of written

analysis whether it's for an assessment or a client appraisal. Pinning down how words are interpreted spatially and how images are interpreted conceptually leaves less wriggle room for the assessor, less chance for someone to throw up their hands and say, 'Oh, I didn't know that was what you meant!' Similarly, as a teacher, it is irresponsible to show novice students images of brilliant designs without making it clear exactly what it is that makes them memorable.

What we hear in everyday conversation as much as what we read in academic papers, shapes our thoughts, as well as influencing our artistic judgements and criticisms. As the context within which we operate it really is, despite what Elkins suggests, impossible to teach art, even visual arts, 'without words' (Elkins 2001: 93). We really don't 'learn simply by mute staring' (Gallagher 1992: 121). On the contrary, the indispensable role of language in both the studio and lecture theatre is crystal clear. Consciously or not, this is where the duality between subjectivity and objectivity, facts and values is reiterated and the irrationality of the emotions in contrast to the clarity of language hammered home. The only way to shift paradigms from the rationalist to the pragmatic is to become conscious of the habits of speech we rely on and then change them. This is to teach without depending on the dichotomy between word and image, logical processes or intuitive reactions. Rorty explains that:

> The views we hope to persuade people to accept cannot be stated in Platonic terminology. So our efforts at persuasion must take the form of gradual inculcation of new ways of speaking, rather than of straightforward argument within old ways of speaking.
>
> (Rorty 1999: xix)

Put simply, we have to talk about things in a different way, using a new frame of reference. The arguments need to be re-invented in order to be reinvigorated, removing metaphysical undertones to make it everyday, rather than psychological. Instead of making distinctions between factual and emotional responses, for example, it is important to lead the conversation in a different direction, to ask why an idea has been expressed in a particular way, what it represents and why it is appropriate. For too long criticising work as merely visual or subjective has been used as a smokescreen for personal preference and bias. We should demand

of students a much more exacting justification for their work than simply 'this is my subconscious or intuitive response'.

A holistic view of consciousness has implications for cognitive-based teaching strategies that have been reliant on the existence of different kinds of intelligence, somehow reflected in the internal structure of the mind 'which is composed of, or can be modelled in terms of, independently constituted parts' (see Prosser and Trigwell for a criticism of this position, Prosser and Trigwell 1999: 13). Pragmatism disposes of the idea that we can gently prod separate working parts of the subconscious, achieve swift imperceptible but productive shifts from one cognitive system to another, or that deep learning comes from provoking the psyche with forceful clarity and enthusiasm. From a pragmatic perspective, students learn 'in the same (and only) way we learn about anything, by having been convinced of it' (Fish 1989: 21). Our role as teachers is to be persuasive, to encourage or 'spark a spirit of inquiry' (Prosser and Trigwell 1999: 146) and cultivate 'curiosity, open mindedness and conversability' (Rorty 1999), helping students to explore conflicts, develop exchanges and a desire to draw on the expertise of others. This is the learning process, it always has been.

Dispensing with the stereotypical view of language, intelligence and the emotions, overcomes the discomfort of dealing with visual information on anything more than a casual basis. Looking carefully at visual images in an informed manner begins to expose something of the complexity of artistic practice, it also makes it clear that gaining a better understanding of it is neither scary nor necessarily onerous, rather it is an intelligent, analytical and investigative endeavour.

Familiarising students with the methodology and technique to talk and write in detail about the way emotions and ideas can be expressed in a critical way, without embarrassment, is a real preparation for the journey from theory into practice. As far as design is concerned, it ensures that discussions about the psychology of place are encouraged. Rather than relying on primeval memories we can adopt a culturally astute perspective with open discussions about the aesthetics of place, the materiality of place, the elegance of technological expression and the role of ideas in design.

Taken as a whole, the argument presented in this and previous chapters helps build a sound philosophical basis for arts education. It is time to have a radical rethink about what has long been taken for granted to be the nature of intelligence, language, critical skills and approaches to learning, whatever the discipline, whatever its traditions or culture. This is the challenge for education across the board. Within design, the next stage is to examine what difference this new palette of concepts makes in understanding how we learn the language of a discipline and how this knowledge can be used to generate form.

Digitally defined blocks of stone are textured to create the water effects,
likening the eroding action of water to the changing patterns of a life.

The Diana Princess of Wales Memorial, London

GUSTAFSON PORTER

Seeing is believing

RECOGNISING THAT BOTH perception and language are interpretative is like removing a blindfold. It is the final radical shift that makes it possible to understand one of the most obscure and important aspects of the whole design process, that of generating form. Clarifying the role of previously neglected aspects of the design process such as theory, concepts, imagination, transformation and the significance of fluency in the language of the medium, helps make the creative act a tangible one. Wresting design away from a pedantic preoccupation with technology, the process begins to inhabit the more appropriate realm of ideas, judgement and artistry. The true nature of design expertise becomes apparent.

Rarely taught in any structured way, generating form is left languishing inaccessibly at the crux of the private and deep-seated creative act, safely ensconced from intellectual interference. Fragile and easily contaminated, dependent on responses eked from the mind's eye, or creative subconscious, it's an insight that is typically thought to be encouraged by daydreaming or like Kekulé, dozing in front of the fire, as creativity is left unfettered to work its magic. The reason it is largely neglected is primarily down to the distinction made between form and content. Form, usually associated with what something looks like or how it is represented, is typically allied to the affective, sensory sphere, whereas content, referring to its meaning or narrative, resides in the immaterial world of meaning and ideas. The irony is, as Dewey points out, it could easily be vice versa since each of these kinds of distinction is 'equally arbitrary' (Dewey 1934: 131). How these two interact with one another is, as ever, a matter of intense speculation and debate, apparently involving separate ways of thinking and knowing, distinct areas of learning and different kinds of practice.

Splitting theory from practice, dividing critics who write, from artists who 'do', it is central to the idea that history and theory belong in the lecture room, technology is simply understanding how things work and on entering the design studio, students should leave their intelligence at the door and become mindlessly, primitively innocent. Like any form of apartheid, this obsession with separation and compartmentalism is intellectually bankrupt and ultimately unworkable.

The habit of rejecting form as unnecessary, subjective and devoid of intellectual content, in conjunction with the vituperative dismissal of the visual in favour of the Grail-like lure of the invisible, explains why discussions about form rarely surface in design literature. With attitudes like these prevailing it is small wonder that those brave enough to admit paying any attention to form run the risk of being accused of frippery or labelled design snobs rather than caring, ecological or socially responsible. It can lead to glaring absurdities, such as the suggestion made at a recent conference that issues of form should be dropped from every landscape architectural course in the USA in order to concentrate on the processes of ecology or the technology of sustainability. This is typical of the anxiety that a preoccupation with form may lead us so far astray that we might miss the bigger picture and that the disastrous environments created by modernisation are caused by an over zealous interest in form rather than content. Caught in the crossfire, terms such as 'modernism' and 'design' are used pejoratively. This line of criticism is specious, a failure to recognise that whatever the style of intervention, all landscapes, constructed or imagined, have spatial form one way or another. All have been designed. This form may have emerged from lengthy and intense community participation, inventive storytelling, the application of ecological principles or from an investigation into pop art. It may have been casually or carefully considered, seemed to be obvious or difficult to resolve. But one thing is for sure somebody has decided where particular elements go as well as determining the scale, quality and character of the landscape. This is design. It isn't a question of whether or not a particular landscape has been designed, but whether or not it has been designed well.

Many tutors, reluctant to intervene in a process they feel is so subjective, prefer to concentrate on the resolution of technical details or the manner

and quality of their communication. Some students may find it an imposition to be asked to explain the provenance or rationale of their work, believing its efficacy to be largely self-evident. Why should their methodology be interrogated when they have access to special, innate skills, which cannot and should not need to be explained? Then there are those who appear like rabbits stuck in the headlights, paralysed with fear, their confidence shredded, lost as to how to begin to create the form of the design. These two poles are entirely symptomatic of the inequitable nature of much design education.

Steering clear of concepts and ideas as well as avoiding discussions about form, scuppers any real opportunity to teach anything about its meaning or significance, let alone how to create it. From a novice student's point of view, the damping down of any kind of discourse or exchange of knowledge that could inform the design process is massively frustrating and one of the reasons there is a constant call for more theory in design. Some might argue there is already quite enough theory, unfortunately, not that much of it explicitly helps us learn *how* to design. We live and work in a visual, spatial medium and it's both pretentious and foolhardy to think we can manipulate it without knowing the implications of what we are dealing with. One of the fundamental issues to tackle if we are to improve the quality of the built environment and one of the most important skills to teach a design student, it's plain daft to imagine that generating form can't or needn't be addressed.

The interpretative theory of perception and language helps resolve the matter by demonstrating the indivisibility of ideas, theory, expression and technology in practice. The exercises previously discussed regarding the development of visual and artistic sensibility, provide a firm basis from which to guide students through what are usually taken to be the impossibly enigmatic, subjective and therefore un-teachable aspects of design. The primary function of the work is to encourage students to recognise that generating form is not an unfathomable or mysterious rite, but is reliant on acquired know-how, artistic sensibility and technical expertise. Helping them develop the confidence and ability to provide a convincing explanation, poetically or prosaically as to its materiality, ensuring that decisions made about any part of the project can be properly justified.

This gets to the heart of artistic practice. For Dewey it is defined by how well a particular medium has been transformed. It isn't just technical prowess, although of course this is needed, it is not just emotion, although this too is requisite, rather it is a measure of how elegantly an idea or emotion can be transformed 'by a single operation' (Dewey 1934: 75). As far as he is concerned, the medium is unimportant. It can be words, space, light or form. Cutting across a number of what are usually considered separate and distinct threads, this demands a different conception of the roles of theory, ideas, expression and technology. It provides new criteria by which to assess and evaluate and a different way of defining what is meant by design and its pedagogy.

What is important to understand is that each medium, be it landscape architecture, calligraphy or mathematics, has its own peculiar language in which students must gain a degree of fluency. Few would be lucky enough to spend a year, as Jellicoe did, pacing out the Italian gardens to measure and draw them up each day in conjunction with Shepherd's sketches. Being fully immersed in the texture and form of the gardens, having to understand the relationship between the spaces and sequence of spaces in order to map them out, equipped him with a design vocabulary that he used for the rest of his life. The majority of us learn the language of design as we would any other, by getting to know its vocabulary, becoming acquainted with it's nuances, its characteristics and traditions, re-adjusting as the language morphs and develops over time, changing with fashion, style and culture. Understanding the culture of the medium is a question of recognition, not in a pseudo-psychological way that refers to subtle sensory perceptions, the transmission of perceptual material through layers of interference, semiotics or the recognition of biologically innate structures, but in a straightforward way that is based on a knowledge and familiarity with what we see. This recognition is in no way instantaneous. Raking over obscure recollections, finding odd things that jog the memory, flashes of clarity or inspiration are all part of the process, just as feelings accrue over time, whether from long periods of deliberation, quiet moments of reflection or repeated associations.

Redefining the relationship between form and content brings the full thrust of artistic and critical investigation back to the physical materiality of place. This is why students must develop a thirst for precedents,

images and theories about what is happening in the design world and to realise that this won't contaminate their mind's eye but will actively help them become better designers. It affirms the role of history, theory and criticism, not as vaguely useful contextual adjuncts to creative design practice, but as crucial ways to build up an intimate knowledge of the historical, cultural significance of the potential of the medium.

Sometimes philosophically highbrow, preoccupied with the esoteric nuance of the non-material world, theory has been given a bad press, some of which it must be said, is well deserved. There is a tendency to assume that the more complex and indecipherable the language, the more insightful the theory, explaining the propensity to become all the more obscure and self-referential. Although this may well make for intimidating prose and lengthy reading, it rarely throws light on the designing part of the design process. But there is no real need for theory to be complex or remote.

Foster identifies the misconception 'that art is not theoretical, not productive of critical concepts in its own right; and that theory is only supplemental, to be applied or not as one sees fit ...' (Foster 1996: xvi), in design too it is often characterised as something to be applied, or invoked as and when necessary, thought to be the language of critics, not designers. Redefining the relationship between artist and critic and therefore between theory and practice, Dewey argues that when creating art, 'the act itself is exactly *what* it is because of *how* it is done. In the act there is no distinction, but perfect integration of manner and content, form and substance' (Dewey 1934: 109). Explaining that it is only upon reflection that distinctions can be made between what is done and how it is done, this is the kind of theory that is needed, a body of work that will indicate if it does its job properly, the relationship between materiality and ideas, form and content. Esoteric or down to earth, jargon laden or straightforward, these reflections are precisely what develops an understanding of the language of the medium.

It sets a new agenda for theory. Placing new demands on academics, teachers and practitioners, it is a shift that identifies an urgent need to refocus and develop theory that is insightful enough to inform design. This new kind of theory would not be particularly concerned with identifying

Developing theory to connect materiality and ideas, form and context.

Spatial principles of opposing intensity, defined transitions, and imposed layers, from Yves Brunier's Museum Park, Rotterdam, inform the design of a garden with a view …
DAVID BROWNE, BETWEEN THE LINES, PG DIP 1, BCU 2007

An elevated, cantilevered walkway creating shadows and wind buffering, informed by Neolithic and Bronze Age track-ways and …
EMILY BETTS, INTERNATIONAL STUDIO, PG DIP 1, BCU 2009

… those of sudden revelation, order and chaos and reflection, inspired by Richard Haag's Bloedel Reserve, are used to create a hidden garden for the profoundly deaf.
DOUG HOLLOWAY, BETWEEN THE LINES, PG DIP 1, BCU 2008

… the idea of capturing the noise of the wind using aural railings and tactile surfacing, give orientation to those who are visually impaired.
LAURA DOBSON, INTERNATIONAL STUDIO, PG DIP 1, BCU 2009

Manipulating shadows and light in combination with principles from the Diana Memorial and the needs of people with limited mobility, underpin the design of a sinuous bench and shadow catching wall …
GLORIA CHAN, INTERNATIONAL STUDIO, PG DIP 1, BCU 2009

The principle of two distinct planes connected by a horizontal line or plane, derived from George Descombe's Swiss Way, determines the planting design of a courtyard for display and performance …
EMILY BETTS, ABSTRACT TO REALITY, PG DIP 1, BCU 2009

… and with the work of Richard Serra, to inspire a lookout on Hackney Marshes.
STEPHEN WOOD, INTERNATIONAL STUDIO, PG DIP 1, BCU 2009

… and principles derived from the Leek Roden Inter-Municipal Plan give an artistic rationale for ecological planting design at Gosta Green.
STEPHEN WOOD, ABSTRACT TO REALITY, PG DIP 1, BCU 2009

Monika Gora's *Two Piers* marking the isostatic postglacial rebound at Nas, Sweden, inspires the design of a woodland glade and lookout.
JAMES SEWELL, BETWEEN THE LINES, PG DIP 1, BCU 2008

Dieter Keinast's *Garden of a Mathematician* informs the design of a health centre forecourt for the profoundly deaf.
TRISH TUCKER, CONSTRUCTION/INCLUSIVE DESIGN, PG DIP 1, BCU 2003

whether an approach is semiotic, structuralist, or post-structuralist, phenomenological or even hermeneutic. There would be no need to fight one philosophical corner against another and unnecessary to depend on the language or jargon of that discourse in order to make a point. The main purpose is to delve into the particularities, appropriateness and expression of certain ideas.

This kind of constructive theory is out there. Take for example, Evans' analysis of the relationship between projective geometry and architecture (Evans 1995), Weston's explanation of development and realisation of Utzon's vision for the Sydney Opera House (Weston 2002) or Bryson's analysis of still life paintings (Bryson 1990). Engaging and illuminating, these critics explain why particular structures, paintings or designs are valued or are culturally important. Explaining what ideas have been worked with and how well they have been articulated and expressed in built form, it is criticism of this nature that informs practice. If these reflections have inspirational value, it is not because the critic has hit on or revealed a universal truth or essence of what was intended; it's more a question, Rorty explains, of re-contextualising 'much of what you previously thought you knew' (Rorty 1999: 133). In other words, we learn something new.

Students contribute to the development of theory informing practice, by investigating through drawing and research, the spatial implications of ideas and the conceptual implications of form evident in a range of iconic landscapes. Re-interpreting spatial principles derived from these studies in a completely different context encourages them to be interpretive and more skilful in the transformation of ideas. Switching between form and ideas and back again shows that form as much as aesthetics can generate its own concepts. The process demonstrates that theory, as Weston observes 'is latent in the work and develops at the drawing board grappling with the problem in hand, not from transferring ideas in philosophy or literary criticism, of which buildings all too easily become little more than cumbersome illustrations' (Weston 2002: 405).

Although there is an obvious difference in the medium of expression between the critic and the practitioner, one uses words, the other space, light and form, this is not a distinction between theory and practice. The

only distinction Dewey thinks worth drawing is 'between those modes of practice that are not intelligent, not inherently and immediately enjoyable, and those which are full of enjoyed meanings' (Dewey 1997b: 236). What becomes critical is the manner in which we practice, not the materials we use, whether it's a pen, a computer or a 6B pencil, whether we write or draw, manipulate the processes of ecology or materials like steel and stone, water or plants. The demarcation we need to make is not between conceptual or practical designers, but between those who design well and those who do not, whatever the context, approach or medium.

Appreciating what this analysis means for the role of concepts and ideas in design, requires a closer look at our understanding of consciousness, the very definition of which is ambiguous and uncertain. It is important to do so in order to dispel the deep seated prejudice against what is often referred to as a conceptual approach to design. From the argument presented so far, it should be clear that whichever design approach we are persuaded by, we are unquestionably full of concepts, prejudices and presumptions about the relationship people have with the environment, full of moral and ethical judgements about what constitutes a quality environment and good quality design. At the most fundamental level, the use of concepts in design is beyond question, because as sentient beings, we can't get away from ideas, the genie is most definitely out of the bottle in that respect. The reason Dewey explains is that the mind is a field of meanings, meanings that are the background and foreground of consciousness (Dewey 1997, and see Chapter 8, pp. 299–353). We are not and cannot be aware of all of this at any one time, but it is when a meaning impinges on our consciousness that it becomes an idea. It can stay with us for long periods or disappear almost as quickly as it arrives. Critical language, concepts and prejudices, they all enable us to function and make sense of anything. Our ideas may be artistically savvy or technologically crude, they may even re-visit the things we learned 20 years ago; irrespective of these and many other possibilities, we can never actually choose whether we work with concepts or not. But we *do* have a choice as to which concepts we work with in order to design well. If we are to teach intelligent artistic practice, we need to make sure these are explicit rather than implicit by encouraging students to become conscious and fully aware of what they are doing and why.

The extent to which we are creatures of habit should not be underestimated. The contextual landscape of our mind comprises all the habits we have learned and acquired, habits that we take to be spontaneous, natural, and instinctive. They define and determine the conscious direction of our thoughts, the things we pick up on, notice and take interest in, as well as framing our responses. As a whole, this contextual field is akin to what Kubler describes as the:

> cage of routine that binds (the individual) so closely that it is almost impossible for him to stumble into an inventive act: he is like a tightrope walker whom vast forces so bind to the cable that he cannot fall, even if he wishes, into the unknown.
>
> (quoted in Bryson 1990: 139)

We habitually use familiar and predetermined solutions to old problems, rather than looking for new methods of investigation and interpretation. They are the cushioned responses we fall back on in our struggle to find the real truth, sniff out the essence of place or generate form and the ones that are most habit-forming, the most difficult to break, are those of 'which we have least awareness' (Dewey 1997: 311). It is therefore all too easy to be thoughtless, unquestioning or even plain lazy about the attention we pay to the assumptions we make and the decisions we take.

To avoid the drudgery and debilitation of inertia, mechanical responses and what Dewey calls the 'narrowing effect of habituation' (Dewey: 1980: 269), we have to make sure we don't respond predictably and end up creating interventions that are uninteresting or, worse still, simply unnoticed. Homogeny, monotonous almost by definition, rarely impacts on our consciousness or provokes the reflective inquiry that creates meaning. What is needed then, are new ways to break old habits. To give ourselves the opportunity to work with different ideas rather than sliding into habitual responses, a set of investigative tools must be found to help us challenge our preconceptions in such a way that it forces us to see the problem from a different perspective. This is the purpose of a design concept.

All this can lead to a conflict with the long cherished idea of intuition, the sacred cow so central to many theories of creativity. Intuition apparently

occurs in those magic moments when access is gained to the subconscious and we allow our instincts to inform our actions. To suggest that this is a question of relying on old habits rather than insights of a more universal nature, creates a certain amount of discomfort, as does working with a concept that questions automatic, reflexive responses and appraises them using an altogether different set of values. This is not to deny that we all have intuition, of course we do, but rather than it being a quick subconscious fix, it is based on knowledge, experience and reflection. Dewey defines intuition as 'that meeting of old and new in which the readjustment involved in every form of consciousness is effected suddenly by means of a quick and unexpected harmony, which in its bright abruptness is like a flash of revelation; although in fact it is prepared for by long and slow incubation' (Dewey 1997: 266).

Many of the tactics employed in the studio are designed specifically to divert students away from a reliance on the snap judgements based on first impressions, to avoid stereotypical or linear solutions. As practitioners, it is important to resist the easy option, sticking to the tried and tested; the temptation to do business as usual. We should be instead, pushing the parameters of the client's aspirations, rather than being inhibited by them. Jellicoe made a point of doing this. Acutely aware of how easy it is to resort to well worn responses, he adopted various strategies to deliberately force himself to 'disorganise or redo the plan and put it out of the straight orthodox' (Jellicoe 1993). He would draw up an initial plan after visiting the site, his 'safety net', place it at the other end of the room upside down, and look at it from a distance to see what he'd got there to work on. His intention was to subvert what he called 'any dominating intellectual control' (Jellicoe 1993) and so avoid the standard solutions to design problems. He demanded of himself a more analytical approach.

This new perspective also has dramatic repercussions for our approach to technology. So often, technical expertise is considered to be the simple practical knowledge of knowing 'how to do it', the jurisdiction of the artisan or engineer rather than the artist. Filled with practical details that can be objectively resolved, it is at worst thought to involve little genuine inquiry apart from the selection of the appropriate catalogues, samples and specifications. Reflected in many offices, standard details are churned out irrespective of concept or place, as if technology bears

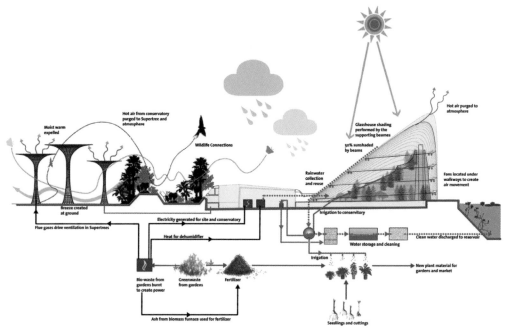

Conservatory ecosystem.

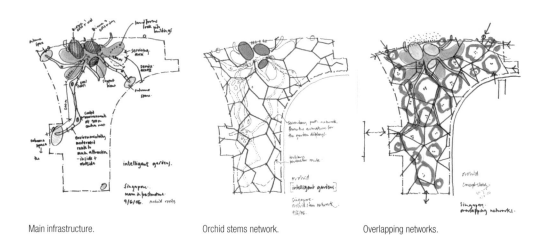

Main infrastructure.

Orchid stems network.

Overlapping networks.

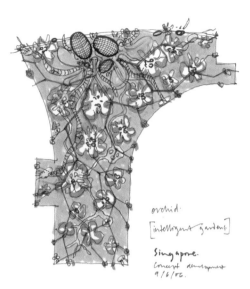

orchid.
[intelligent gardens]
Singapore.
Concept development
9/6/06.

Concept development.

The master plan for the Gardens by the Bay, South
Marina, Singapore, evolved from an initial study of
the organization and physiology of the orchid, into
a highly sophisticated and integrated 3D network
of horticulture, art, engineering and architecture.
GRANT ASSOCIATES

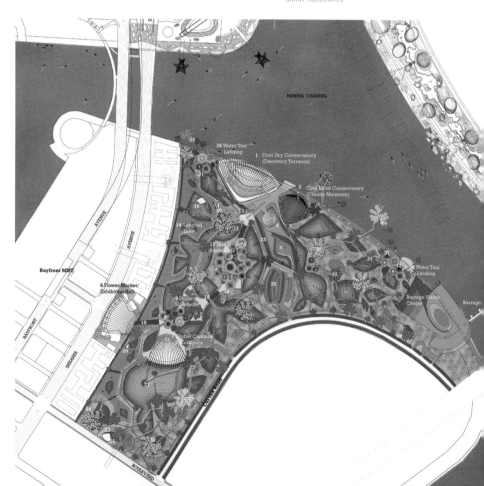

MARINA CHANNEL

1 Cool Dry Conservatory
(Discovery Terraces)

2 Cool Moist Conservatory
(Cloudy Mountain)

26 Water Taxi
Landing

14 Languid
Lake

11 Lion Grove's
Serpentine

Bayfront MRT

6 Flower Market/
Exhibition Hall

9 Pride of
Singapore

Global Common
Centrepiece

26 Water Taxi
Landing

Barrage Visitor
Centre

Barrage

AVENUE

AVENUE

BAYFRONT

SHEARES

BOULEVARD

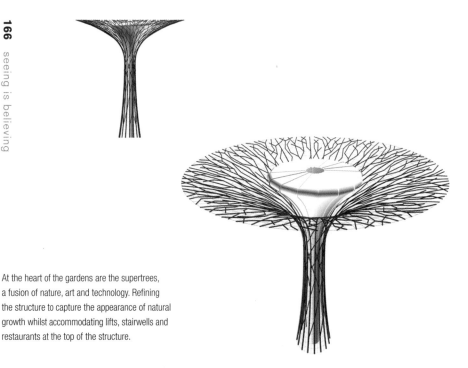

At the heart of the gardens are the supertrees,
a fusion of nature, art and technology. Refining
the structure to capture the appearance of natural
growth whilst accommodating lifts, stairwells and
restaurants at the top of the structure.

The supertrees, spectacular vertical tropical gardens saturated with ferns, orchids and climbers, are also the environment engines for the gardens, equipped with photovoltaics, solar thermal collectors, rainwater harvesting devises and venting ducts.

Gardens by the Bay, Singapore

GRANT ASSOCIATES

An illuminated, changing woodland flora garden enclosed by lime,
sequentially planted with foxgloves and a madness of ferns and grasses
beneath the changing canopy …

The Lover's Wood, British Pavilion Garden, Japan Expo 2005

GRANT ASSOCIATES

... at night the garden became a favourite place to meet among the illuminated foxgloves and ferns.

A grid of two metre diameter matt cast iron discs organise trees, lighting, seating, shelters and signs in New Islington, Manchester.

The relief refers to the locally found rare and European threatened species of floating leaved plantain.
Polka Dots, Manchester
GRANT ASSOCIATES

Water emerges from the ground as a bubbling spring and falls
in two directions. Passing over a babbling brook, effervescent
stream and chadda cascade on one side. Whilst on the other side
water passes over stepped rivulets, a gliding plain, before rolling
over in the swoosh and entering the pool at the memorial's base.
The Diana Princess of Wales Memorial Fountain, London
GUSTAFSON PORTER

The fountains, articulating the level changes between the terraces, provide colour and movement to counterbalance the Future Systems' Selfridges building, creating a lively atmosphere for the café terrace next to the lower level restaurant and entrance.

The first collage was made to convince the developer. The other images show the development of the feature through a process of testing and sophisticated engineering to make a glowing feature out of glass.

The Bullring, Birmingham

GROSS MAX

The steel and stone obelisk faces
off the medieval castle at Caerphilly.
CAMLIN LONSDALE

Concept drawing for the riverside setting
for the Waterfront Hall, Lanyon Place, Belfast.
CAMLIN LONSDALE

Tree boxes as theatrical props
temporarily rolled out of the auditorium.
Lanyon Place and Donegall Quay, Belfast
CAMLIN LONSDALE

The heraldic threshold of massive stones.

The robust edge of the city.

The trophy fish celebrates
the re-purification of the water.
Donegall Quay, Belfast.
JOHN KINDNESS WITH CAMLIN LONSDALE

A celebrity setting for the Grand Canal Square, Belfast, demands a red carpet.
A bright red resin-glass promenade with red light sticks to represent the
carpet bustle, connect the theatre to the canal. Connecting the new hotel to
the office development is a calmer green carpet with extruded polygons filled
with marsh vegetation and immaculate lawns for lingering and enjoying the
view. The square is criss-crossed with paths and holds markets and fairs.

Grand Canal Square, Belfast

MARTHA SCHWARTZ, INC

(top) Conceptual sketch.
(bottom) Site plan.

(top) Early morning.
(bottom) Night time view.

There can be no better example of the extraordinarily close relationship between the design concept, acoustics and structural engineering than as evidenced in the Sydney Opera House, as each of these elements informed the other. It took Utzon three years before he was satisfied with the design and quality of the tiles used to clad the shell structure.

Sydney Opera House (begun in 1957)

JORGEN UTZON

no relation to expression, form or context. There's a sign on the door and it says, 'Just get it built.' A related problem is that a 'narrow focus on the technical mastery of the material' as Eisner observes, 'leads to a neglect of matters of intention' (Eisner 2002: 51), making it all too easy to become immersed in, even obsessed by, performance specifications rather than deal with the more difficult question as to how technology can be used to contribute to the true expression of a particular idea.

Materiality in landscape architecture is complex. It includes technological know how in the sciences and processes traditionally associated with ecology, horticulture, geology, microclimatology and so on, together with the basics of construction and engineering, of plastics, fabric, concrete, bricks and stone. Then there is knowledge of the more ephemeral and ambiguous, like spatial structure, visual envelopes, horizons, views, seasonal change. All of these components can be manipulated, exaggerated and controlled, to give different qualities of light, shadows and spatial volumes. The work of Grant Associates, Gustafson Porter, Gross Max, Camlin Lonsdale, Martha Schwartz Inc and Utzon, to name a few, demonstrate the expressive potential of technology. Rather than the mechanical or practical part of a project, it is seen as a means of understanding how far materials might be pushed or manipulated in order to express ideas with style and confidence. The way things fit together; the treatment of surfaces, planes and the quality of light is determined by the concept, by the kind of place being created, how it reflects the aspirations of the community, its cultural and social ambitions. Having a dramatic effect on the visual quality of a scheme, as well as its texture and character, the use of technology in this sense is without doubt as artistic a part of the process as any other.

Whatever the scale, good design, that is to say the skilled transformation of ideas, is founded on craftsmanship, technology and the physical possibilities of the medium. If we have a limited knowledge of materials, the translation and expression of ideas will also be limited. As Martha Schwartz reflects, 'In language, one's lack of vocabulary limits what one can think, in the same way, the lack of material possibilities limited conceptual thinking in landscape architecture' (Schwartz 1997: 106). There is little point in having ideas without having the wherewithal to apply and transform them into a reality. And the best designers are those who

Taking the inspiration from the Atlantic Ocean, the spatial strategy for Vaguada de las Llamas Park in Santander comes from interpreting the geometry of the Atlantic geography to define the contours, geographical character and vegetation.

Parc la Vaguada de las Llamas

BATLLE I ROIG ARCHITECTES

(top left) Staggered timber banks give continuity and overcome the significant level changes along the valley, generating stairs, ramps and amphitheatres, forming different levels and spaces imbued with perceptions from various Atlantic cultures.

(top) The vegetation, organized in transverse stripes in order of the lines of latitude, demonstrates the richness of the landscape and biodiversity of the Atlantic region.

(left) Each stripe has vegetation to represent its latitude and reflect the richness of the landscape and the diversity of the vegetation of the Atlantic climate.

are inventive, imaginative and knowledgeable about the use of materials. It takes real skill to avoid creating a compromised mishmash given all the demands made by various stakeholders, accommodating the many different expectations and using them to strengthen rather than dilute the concept.

So where do we start? The inspiration for a project can come from anywhere; a painting, the brief itself, music, dance, or something discovered on site. Serendipitous, triggered by things remembered, recovered or seen, it might come from something casually glanced at in the studio, a phrase read in the paper or an image from a film. It might be an unresolved idea carried over from an earlier project, an exploratory model, the outline of the Atlantic Ocean, or an inkblot.

Whatever, wherever, the point is, it grabs our attention. We seize upon it because it feels right and appropriate, given the context of the brief and the site and a hunch as to how things might go. It takes time and experience to judge whether or not an idea or line of inquiry is worthy of further exploration. To short circuit the process in the studio, it is perfectly reasonable to provide an image, even the same image as a starting point to the project, something 'ready to go' for all to use. The widely varied responses generated right from the start, leave no doubt that ideas do not reside in the image itself, but are most definitely in the eyes of the beholder. There is no need to search for definitive explanations of a phrase or image, the essence of a painting or the expressed intention of artist or author to act as the conceptual basis of the project. The value of the concept comes from the way it is interpreted, what is brought to it by the designer, rather than anything inherent in the image or phrase itself.

The concept then, is a powerful mechanism, a tool to help the designer make decisions inventively, to prompt the consideration of different possibilities and build the confidence to ask 'what if?' and 'why not?' rather than follow the line of least resistance. It draws all the strands of inquiry together to give a fully cohesive picture. It doesn't have to be esoteric, in fact for novice students the more specific and precise it is the more manageable the process. A simple metaphor makes it easier to investigate. It is much more convenient to research and define ordinary, everyday events than grapple with the Big Bang theory. The point here is

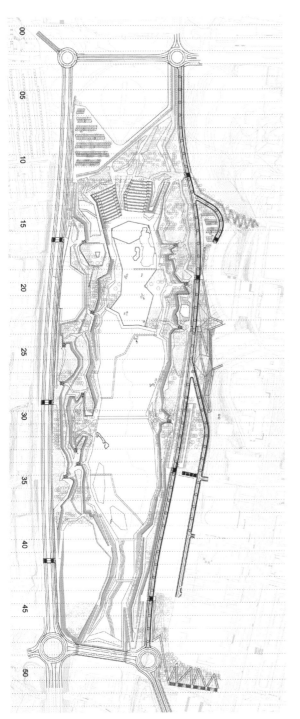

The masterplan for
Parc la Vaguada de las Llamas.

The terraces, islands, floodplains and
stormwater catchment areas of the park …

... the planted timber terraced retaining walls ...

... and a view of the islands representing the Caribbean.

Parc la Vaguada de las Llamas

BATLLE I ROIG ARCHITECTES

that whether it is in words or images, developing a concept is a question of research, drawing, observation and analysis rather than staring into the middle distance, waiting for a flash of illumination. The earliest conceptual drawings, rather than mediating between visual and verbal thinking, as cognitive science would have us believe, are just embryonic ideas, a first stab or draft, rather than something that emerges from a direct line to the subconscious.

Whether it is conceptual ideas, phrases, images or sketches, all are just as enigmatic and open to interpretation as a key phrase or the first few bars of a melody. Corner suggests their interpretation is a question of distinguishing 'between weak fanciful ideas and the more potent images and symbolic structures relevant to landscape architectural experience, by recognising archetypes, deep structure and universally significant situations peculiar to the human condition' (Corner 1992: 268). But from a pragmatic perspective it's not nearly so tortuous. We make sense of these conceptual ideas by trying to understand our so-called 'scribbles', feelings and responses to what we see. This naturally depends on the knowledge we have, which in turn relies on our familiarity with the forms and practices of landscape architecture and its medium of expression, in other words, its language. Students, by definition do not possess a wealth of experience to draw on to forge connections between ideas and form, or have the confidence to refine and edit their work. This is why tutorial support is so essential. Students may be able to create the most wonderfully detailed drawings as design concepts, but if they have only a limited knowledge of the medium, these drawings will almost always be interpreted or transformed in a crude and simplistic way.

A conceptual sketch obviously needs further illustration, amplification and definition. Once an idea has a perceptible form, whether in the imagination or on paper, in writing or as a sketch, it enables us to clarify and develop it further. Seeing it reveals both problems and opportunities, provokes the imagination and new possibilities emerge. There is an ongoing and developing relationship between form and content, between words and images and between the designer's intention and its formal expression. As the concept becomes more well known, the limitations of the site and the brief become clear as possibilities emerge through research and

refinement. The idea is transformed as it shifts and develops, on the page, in the imagination, back to the page.

Conceptual drawings on their own make little sense without explanation; as Lawson has noted, 'scribbles designers make while talking make almost no sense at all when viewed out of the context of the conversation' (Lawson 1994: 141). A conceptual drawing has to be worked on to explore its potential through further drawings and discussion, or as Scarpa describes 'perseverance, constant commitment and long periods of concentration on the drawing board' (quoted in Hansen 1992: 43). To approach the investigation creatively, to use it as Leonardo da Vinci proposed, 'as a way of enhancing and arousing the mind to various inventions' (Kemp 1989: 222), is an entirely rational process. It may be 'complex, elusive, unsystematic, and ever subject to modification' but, as Corner points out, this work is done in 'critical response to something' (Corner 1992: 268). It is purposeful, not arbitrary. It is not simply an exercise in lateral thinking, it is certainly not about suppressing one side of the brain to favour another, but is a focused, analytical and artistic process.

Working on small-scale thumbnail plans of the site encourages a strategic application of the concept. Enlarging and investigating a 25mm square of a drawing or model (an exercise from Betty Edwards (Edwards 1990) demands an inventive re-interpretation of the project, making it necessary to refine, reframe and simplify ideas. Collage, projection, painting, models or photocopying can be used to prompt us into thinking imaginatively about a design problem. Similarly, switching from a familiar medium, say, from drawing to collage or from clay and plaster to projective geometry, may sometimes cause a degree of unease, but on the other hand it can be liberating, the different physical qualities of the material help to break the routine.

Whatever the scale or context, from the strategic vision to detailed design, drawing is a vital part of this process, enabling us to make connections, reveal unexpected opportunities and 'discover new ground' (Corner 1992: 268). Drawing is not a means of mediating between the conceptual (and) the visual, or arousing 'shifts to a state of creative visual thinking' (Kemnitzer 2003). It is simply a way of working things out, exploring

(above and right) The drawings show the design development for the massive photovoltaic canopy (4,500 m²), constructed on the waterfront in Barcelona to produce energy for the city. Another industrial facility typical of the Forum 2004 area, the canopy is a skewed plane, with a 30° inclination, oriented due south.

The Photovoltaic Canopy, Barcelona

JOSÉ ANTONIO MARTÍNEZ AND ELIAS TORRES

14.12.00
Reyen
Infrastructure 2004

10.3.2002

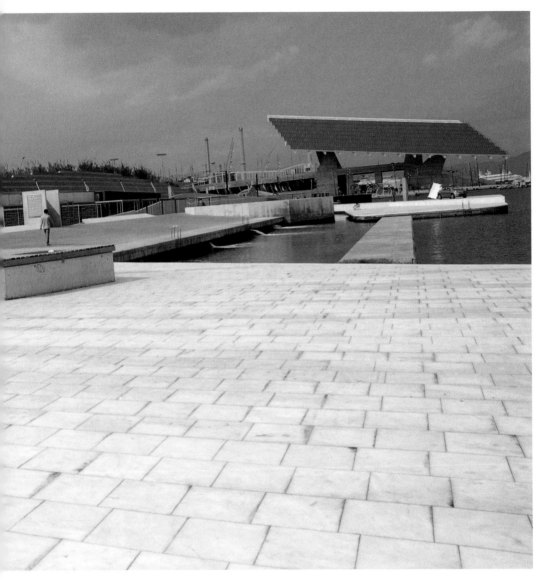

The roof of the building provides a geometrically unexpected end to the Avenue Diagonal.

The Photovoltaic Canopy, Barcelona

ELIAS TORRES

Supported by four twisted legs that stick out of the Sailing School finger of the Forum, it is the last viewpoint or belvedere of the city over the water, which can be reached by descending a large staircase, as if 'under a pallium' (a woollen cloak).

ideas and speculating about possibilities. As an investigative tool it is hard to beat.

The concept, applied properly, is a set of ideas expressed through a combination of words and images, not just an ill-defined heading, something used to conveniently kick-start the design then dropped as soon as the design takes on a life of its own. It's not a pattern or image to be literally transferred on to the site. It should act to inform and guide an ongoing investigation, infusing the soul of the project. Once the overall spatial structure has been resolved, any design should always be energised by its conceptual underpinning. It is there to help explore and develop relationships between space and form at different scales and in different contexts as well as deal with shifting parameters and constraints.

The truly expressive act according to Dewey requires the 'primitive and raw material of experience' to be reworked (Dewey 1934: 74). The significance here is that it is not just the transformation of physical materials, but also of images and memories. This gives an important focus to the experience we have of places. A common misunderstanding is that the concept should be evident at first glance to anyone who happens to visit the scheme. There is no reason whatsoever for this to be the case. It is not for public consumption, it is not something to be literally built, installed or placed *in situ*. It's an aid to design. It isn't there to be adhered to or followed slavishly no matter what. It doesn't actually make the decisions, the designer does that, but working within the framework imposed by the concept, even though it might sometimes go against the grain of what initially seems to be better judgement, often provokes the most inventive and imaginative ideas and resolutions.

Providing a source of nourishment and provocation, a visual, spatial concept is far more effective than a purely verbal narrative. It provides the intellectual scaffolding for the project, helping to make decisions about space, form, scale and detail as well as character and expression.

Design work in the studio should never simply be landscapes of the imagination, or a series of graphic flourishes designed to fit the page. What grounds the work is aesthetic sensibility, visual skill and cultural awareness. This is what it takes to imbue a creative appreciation of how

we respond to places and to understand how we might manipulate and shape this experience for others. As teachers we have to build up a range of tactics and strategies to develop close observation, the ability to interpret and manipulate ideas in form and forge links between theory and practice. From this standpoint, the assessment of work must be based on the judgement and expertise of academics and professionals rather than the vague application of absolutes.

Focusing unequivocally on knowledge within a particular medium rather than any notion of innate generic skill, pragmatism accepts that all perceptions, observations and analyses (even the most scientifically based) are ambiguous, flexible and open to interpretation. Reappraising the role of concepts and language illustrates the point that rather than masking or hindering aesthetic and artistic experience, these are what actually allow us access to the arts, both in its making and criticism. Shifting any inquiry away from the unequivocal towards the ambiguous is perhaps one of the most difficult aspects of this paradigm and it is not just another way of saying that anything goes, but rather that work must be judged against different criteria.

Adopted in the studio, what makes this approach more democratic is that students, instead of being left with the sinking feeling that they must be missing that indefinable something, are able to start working confidently with ideas, expressing and adapting them within the medium or brief. They can be assured that progressing their design skill is a question of learning not voodoo. No one is suggesting that every student will become a brilliant designer, but at least everyone stands an even chance of learning *how* to design which has to be better than being led to believe that it's an inherent ability, a gift you might never manage to open.

The wall at Batavia Harbour, Markermeer Coast.
VERBURG HOOGENDIJK ARCHITEKTEN VHA

Theory into practice

THE DISCUSSION SO FAR has concentrated on the implications of a holistic view of consciousness for design philosophy, theory and pedagogy in the educational arena. By examining how a set of fundamental philosophical ideas has led to the fragmenting of consciousness into different faculties and looking at the ways in which the expression of these underlying preconceptions and assumptions are expressed in the classroom and studio, it becomes increasingly apparent that rather than being *the* account of the way things are, these ideas are simply a collection of psychological and philosophical beliefs, packaged, promoted and sold so successfully over time, that they have become part of our way of life.

The central premise outlined at the beginning of this book has been used systematically to construct an alternative view of the world to understand how to teach the art of design. The approach has proved to be incredibly useful pedagogically but its repercussions go way beyond the educational milieu. Making design less elitist and more accessible, recognising the extent to which designing is dependent on knowledge and ideas rather than the luck of the draw, has profound implications in the wider cultural and social realm for a number of reasons. For one thing, it offers a far more inclusive and convincing definition of design.

Of particular interest to professions tasked with improving the quality of the environment, are the ways in which it legitimises arguments about design expertise and makes it far easier to appreciate the social and economic value of good looking, quality environments. Dispensing with the damaging nature/culture divide encourages a more holistic view

of the landscape (in its broadest sense) as the context for sustainable development. Moving the debate away from the arcane and unknowable into the real world informed by knowledge and ideas, serves to remind us how much theory and philosophy can learn from practice, rather than the reverse. Finally, it drives home the point that theory and philosophy need not necessarily be metaphysical by nature.

The unequivocal focus this analysis of consciousness gives to knowledge enables us to define design more sensibly and take it beyond the rather trite suggestion that 'design' is simply what designers do. All landscape architects for example, have an interest in raising aspirations for the environment, a passion to create quality places and make them available to all, not just those lucky enough to have the choice. What distinguishes us from other active interest groups concerned with the landscape is that we not only read and describe the landscape, understand its traditions and culture, but we also have a close knowledge of its potential and the skill to realise that potential. What is special, and absolutely undersold, is precisely this knowledge. As landscape designers, we have a unique perspective.

It doesn't matter if it's a technical or scientific report, criticism of a scheme, or the creation of a project for implementation, conservation or management. It makes no difference if we are concerned with the city centre, school playground, national parks, the urban realm or the seaside. Or what stage of the development process the project has reached, whether it is the feasibility, planning, strategic review, the detailed design or its long-term management. Each of these development stages requires different kinds of knowledge and skill, but essentially, they all involve design. It is a question of research and decision making. Designing is about making propositions, presenting a vision for the future. Central to the discipline is the forward thinking, the anticipatory and predictive nature of its practice. On this basis, anyone who has a responsibility for the landscape, whether they deal with words rather than drawings, a computer rather than a pencil, they are effecting, predicting or managing spatial change. It all has a visual dimension.

Focusing on content rather than process and acknowledging the importance of expertise, calls into question the current vogue for the public to be

involved at every level of decision making and thinking. In the swing from authoritarianism to public consultation, we can become so obsessed with process we ignore content, blithely adopting the attitude that the process will deliver whatever the process delivers. There is a genuine risk here that we are washing our hands of professional responsibility and we should know better. The outcomes of community planning and design in the 1970s were 'rarely exceptional' (Relph 1987: 234) and the same is true today. There are too many images of community-designed spaces that are just too dismal to show. If nothing else they prove that no matter how many people are consulted, no matter how many views are collected, someone has to synthesise the information and work out the spatial implications of it all and that takes specialist knowledge – expertise. Whatever form the consultation takes, it should not be seen as an alternative to the making of often difficult design decisions, because these decisions are the nuts and bolts of the process, an artistic rationale if you like. But like it or not, the lesson would appear to be that designing (on whatever scale) is not a democratic activity, any more than mending a broken arm, making a legal judgement or fixing the plumbing, one way or another, they all require expertise. If you want your boiler fixed, don't send for a chartered accountant.

Flagging up the extent to which professional responsibility seems to have been abandoned in the name of public participation is not to signal a return to an old-style autocracy, with high-handed 'experts' telling the populous what's good for them. This is to confuse arrogance with an attempt to define an appropriate process. Public participation should be a good investigative collaboration, a discussion about how best to develop a comprehensive brief. The pragmatic argument makes it easier to understand where to draw the line in that process.

Taking a holistic view also helps us avoid the fragmentation of the landscape that contributes to the woeful underestimation of its spatial and cultural value. It enables us to redefine nature and overcome the damaging dichotomy that has traditionally severed it from culture. Lending it an almost mystical status, it is one of the foremost reasons why landscape architecture continues to be associated with technology rather than ideas. Predictably, designers are often divided into two camps, the ecological (practical and scientific), and artistic (usually taken to be more personal

Kish Island, Iran.

What exactly do we mean by nature?

and idiosyncratic). But what exactly do we mean by nature? Why we do think 'nature' is good for us, if by nature we mean the green stuff, the things that grow? Ask your average urbanite what is meant by nature in the city for example, and he will mention trees, urban foxes and rats, not necessarily in that order and not all inherently good for our souls. Is our supposed fondness for nature something that we share culturally or even universally, as many would have us believe, its efficacy and value a matter of fact, beyond question or debate? Is it a matter of scientific necessity to find out all there is to know about it in order to save the planet? Should it be left to itself or tweaked and tampered with to suit our purpose? Neglect a garden and you get weeds, allow woodland to develop and you get bio-diversity. Nature is what we make of it. The problem is that in the city, nature, landscape, 'the green stuff', call it what you will, is an afterthought; the trees and shrubs to be imported and manicured once the architects have left the building.

Of course, there is always the whiff of a scientific basis to make it seem more respectable and substantial. Nature is part of a long and impressive list of concepts that will supposedly improve the quality of our lives, along with ecology, bio-diversity and sustainability, it offers a panacea for an ailing world. There is generally an optimistic presumption that we all know what we are talking about with regard to these things, what they do, how they work etc., that we all know what nature looks like, how it behaves and how it can impact on our lives. This is a cosy misconception. It is doubtful that a consensus could be reached about any of the aforementioned, let alone what nature actually is even within a group of landscape architects and that's without adding architects, engineers, planners, politicians and local communities into the mix.

The problem is that to be coldly objective and scientific or airily metaphysical about nature does considerable disservice to the very concept. Both views isolate it from the bigger picture, dislocating it from culture, cost, value and profit. Reducing nature to natural systems and the like gives the impression that it can simply be detached from strategic and spatial decision making. Easy to marginalise, it is left out of the frame, hard to justify, difficult to substantiate, compromised on after the event rather than considered from the start. And we've all seen the results. Relegated to hard won square metres of grass, trees, hedgerows

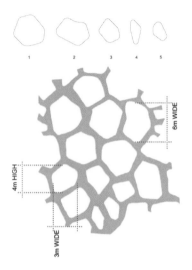

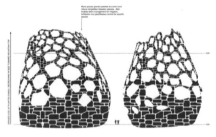

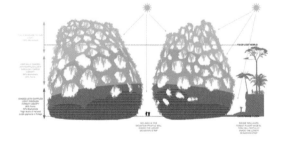

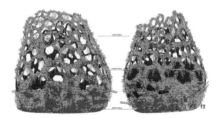

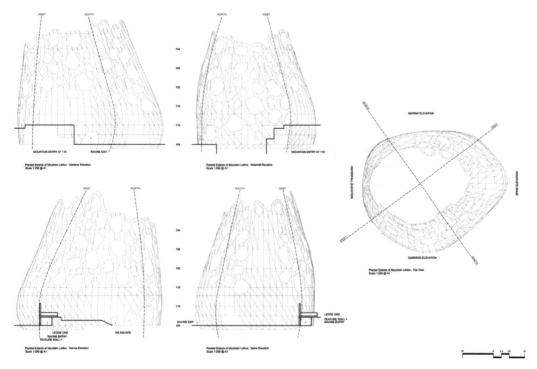

Enclosing the ravine walk and the canopy walk, the lattice weaves its way up around the mountain to create the Lost World Garden at the top of the structure, rising to the east to wrap around the giant extract duct that supports the cooling system.

The large air-conditioned cool moist conservatory in the Gardens by the Bay, Singapore, displays the essential elements of a tropical cloud forest environment found at heights of 800–2,500 m above sea level with a temperature range of 18–25 degrees Celsius and relative humidity of 80–100 per cent. At the heart of the conservatory is the highly abstract form of the 45 m high Mountain Lattice. Inspired by the Maiden's Veil Fungus (*Dictyophora duplicata*) (top left), it is designed to illustrate the enormous elevation range, it gives an impression of height and creates a cool cloudy atmosphere.

(left middle) The lattice wrapping the mountain interior is planted with tropical epiphytes. The shape and configuration of the apertures is taken directly from the natural geometries of the fungus.

(left) Working with the complexity of the form, the scale of the apertures nestled around the mountain and the constraints of light, temperature and inclined surfaces, the extent of the epiphytic coat covering the lattice decreases towards the mountaintop. To represent the range of species found at different altitudes and heights in the cloud forest, it transforms from the spine of silhouetted spiky forms to a dripping hairy base.

GRANT ASSOCIATES

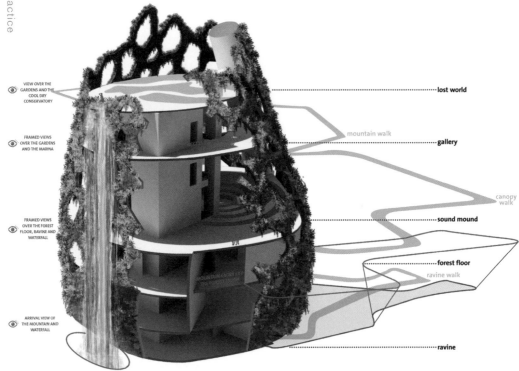

VIEW OVER THE
GARDENS AND THE
COOL DRY
CONSERVATORY

FRAMED VIEWS
OVER THE GARDENS
AND THE MARINA

FRAMED VIEWS
OVER THE FOREST
FLOOR, RAVINE AND
WATERFALL

ARRIVAL VIEW OF
THE MOUNTAIN AND
WATERFALL

lost world

mountain walk

gallery

canopy
walk

sound mound

forest floor

ravine walk

ravine

The mountain contains a theatre and various galleries. Visitors
arrive at the top of the mountain by lift, ascending by stairs to
the special lost world displays, then descend by steps and ramps
through and around the mountain, taking in the various layers of a
typical cloud forest …

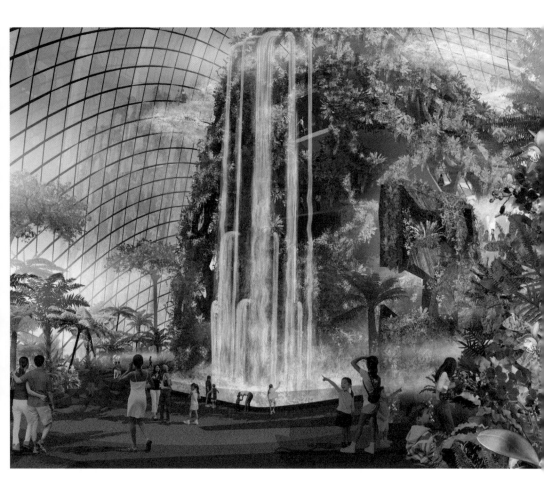

… until finally they arrive disorientated beside a 40 m high
waterfall in a ravine luxuriant with vegetation.

and ditches, 'nature' is levered in after the important neutrally objective economic decisions have been made, fitted neatly between settlements and roads, usually along the streams, rivers or corners of parks or 'informal green spaces', nothing more than living embroidery. Nature seen like this is often cynically assumed to be enough to address matters of quality and, furthermore, the justification needed for green space is looked at in terms of its benefit for wildlife. Nevermind the spatial structure of the constructed public realm, the ease of movement, the sense of belonging, the cultural identity of the place or the social and physical experience of the people who live and work in the places we design.

No matter how much spirituality hovers around the concept of nature, in reality we find it difficult not to associate it with technology. Consigning landscape architecture to an intellectual backwater, unable to justify its existence other than through the placement of trees and flower beds, sowing grass and a knowledge of what to plant where. Creating ecological habitats and providing professionals who are seen as little more than social facilitators, this is a technological bias that undermines the rich culture and tradition of the discipline. Disconnecting landscape design from the achievements of its early practitioners, undermines its credibility and profile at precisely the time when this kind of expertise is most needed.

To overcome the alienation perceived to exist between ecology and art, Johnson and Hill suggest that if the ecologists and the artists work together matters will improve and higher standards will be achieved (Johnson and Hill 2002: 7). But it doesn't end there. Just as it is no longer good enough to fragment consciousness into bite-size bits and pieces, it is critical in the wider arena to stop breaking things up into components, be they biological or cultural, of scientific or artistic concern. This means ditching both narrowly scientific and wildly subjective approaches to nature. Our relationship with nature is not reliant on the layering of symbols, myths and social conventions on to independent physical realities, we can only ever see, perceive or interpret it through a cultural lens. There is no way to see it in all innocence, naked, without reference or beyond reason.

Value and meaning are not inherent in nature itself anymore than in art or language. It is not a special case; in fact there are no special cases. Rather

than ideas versus nature we have ideas of nature. Instead of seeing nature as something separate, from culture, from ourselves, we must recognise that in the way we live our lives, with every intervention we make, we are expressing, consciously or not, an attitude towards the physical world. The choice is not whether we work with art or ecology, with nature or culture, but how considerately, imaginatively and responsibly we go about our business, because for every one of our actions, there is a reaction in the physical world. We impact on it every minute of every day of our lives. Where we decide to build new cities or expand old ones, place streets, squares, parks and gardens. How we do this, why we do this, reflects the value we place on the quality of our physical environment.

Nature is not a quasi-sacred maternal fountainhead, something to get back to or be at one with. It is actually an incredibly elastic, adaptable and underutilised medium, an extraordinary way to manipulate light and shade, views, evoke feelings and create moods, lift spirits and generate a proper respect for ecosystems. Nature in this sense, should be just as much a part of the furniture as the high-rises. It should be dyed into the fabric of our towns and cities. Working with the natural processes, given the global challenges we face, is an ecological imperative. We have no choice in the matter. But it is the whole thing, the ideas and values we hold and their expression in physical form, be it green, grey or blue that defines us. This is what frames the experience we all have of the places we live in and it is this experience that is a properly relevant definition of nature. After all, natural systems don't stop where the buildings start.

Fragmenting the landscape into components such as visual, cultural, ecological or heritage, dilutes its identity. After the initial burst of enthusiasm when the public realm is used to sell developments, recognition of its true social and economic value often fails to materialise into quality environments. There are many reasons why this happens; the landscape is not a solid object like a building or a road. It is unspecific, difficult to measure, commonplace and everyday. Unsurprising then, that it is something we tend to take for granted. Although it is of profound significance to everyone, residents, visitors and passers by, it seems to belong to all of us, but actually, to no one. It has no single champion, no obvious constituency. We don't pay for it directly as we pay tax for our homes, offices and schools. In the UK, the local authority usually

maintains the public realm and so the landscape is often seen as a drain on resources, a burden, rather than an investment opportunity. We hear plenty about subsidies going to farmers, but precious little about the value the landscape adds to the local and national economy, even though it was made dramatically evident by the disastrous impact it had on tourism in the foot-and-mouth crisis a few years ago and again more recently in the UK.

Illustrating the dangers of compartmentalising and central to the problem in the United Kingdom and I suspect, worldwide, is the fact that lots of departments have responsibility for little bits of the landscape. It is found in spatial and social planning, agriculture, economics, transport, engineering, culture and environment. Sometimes it even features in education and health policy. There can scarcely be a more compelling example of divide and rule. Even when the landscape is a prime concern, the way it is handled is fractured and diffuse. On a European level for example, there are a number of treaties and policies dealing with select aspects of the landscape such as agriculture, archaeology, wildlife and natural habitats, ecology and cultural heritage. Likewise in the UK there are national surveys and assessments that deal with landscape character, visual assessment and nature conservation. And a real problem with this is that in the various surveys, the visual dimension, where it is addressed, is often separated from character, dispensed with as a perceptual, experiential matter or 'visual amenity' which has an unmistakeably municipal ring to it. Clearly it is easier to split the landscape up rather than deal with it as a complex entity.

It makes it almost inevitable that detail is substituted for spatial design and technology for ideas. Policy, often made by well-intentioned people who don't have design expertise, is handed down to those who do, who then become responsible for ameliorating the consequences. In this way, landscape strategies devolve into technological appendices rather than setting out a clear strategic vision of its spatial structure. The checklists, procedures and design codes now at our disposal, reinforce this attitude, helping to evaluate and monitor the more easily quantifiable parts of the process. But don't mistake this for quality. Good design does not necessarily equate with the details of the sustainable technology, the number of miles of urban swales, green or brown roofs or whether we need

to plan for 35 or 40 dwellings per hectare. The design and specification of the details is hugely important of course, increasingly so with the demands of sustainable development, but it really does require a well-designed conceptual and spatial framework, something that cannot be provided by land use planning alone.

The Commission for Architecture and the Built Environment (CABE) and CABE Space in the UK have certainly helped us understand more about design quality. But listen to the growing chorus of criticism aimed at flagship projects such as the Thames Gateway and the difficulty of embedding this ambition within the planning and development process evidently hasn't gone away.

To achieve a strategic vision for the landscape that is so desperately needed, it is critical to look at the bigger picture, the context within which it might be possible to accommodate new settlements, expanded towns and villages, forestry or changes in agricultural practice. We have to have that overview, a geographic and landscape sensibility, to assess the impact of wind farms, new roads, power stations or extensions to the city periphery. To understand if and how these interventions might fit into the broader landscape, it needs to be assessed and designed, spatially, visually and conceptually, in detail and with rigour. As shown with the wall at Batavia Harbour, Markermeer, in the design for a new urban extension for Amsterdam at IJburg and other projects referred in this book, it won't happen by accident and we can no longer afford to leave it to chance.

This type of inclusive approach is supported by the Council of Europe in the form of the European Landscape Convention (ELC) (signed in February 2007 by the British Government), a new instrument devoted exclusively to the landscape of Europe. It is a huge step forward, acknowledging that landscape is an important economic concern which is now firmly on the mainstream political agenda. Giving considerable status and standing to the landscape, it is reflected in the UK by the fact that all of the major political parties currently have quality of life as a major political concern. The ELC is not simply about landscape as bio-diversity or ecology, concerned only with the countryside, the special, beautiful places, remote or unspoilt areas of the remarkable heritage we have. It takes a more holistic view, addressing the whole package, including the

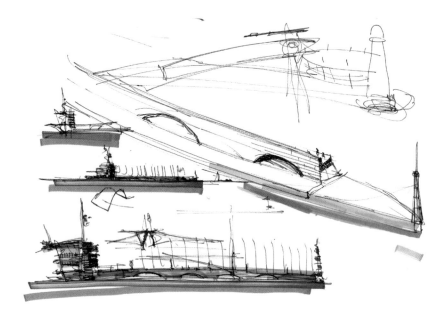

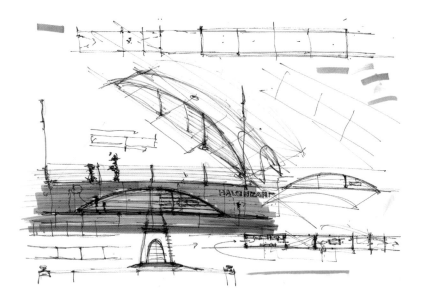

The large hollow wall at Batavia Harbour (above and right) acts as a
self-sustaining infrastructure, a pier, a berth, a home port, a ferry mooring place,
a dike and breakwater for the polder embankment, a windbreak, observation point
and promenade and can accommodate new functions in the structure.

VERBURG HOOGENDIJK ARCHITEKTEN VHA

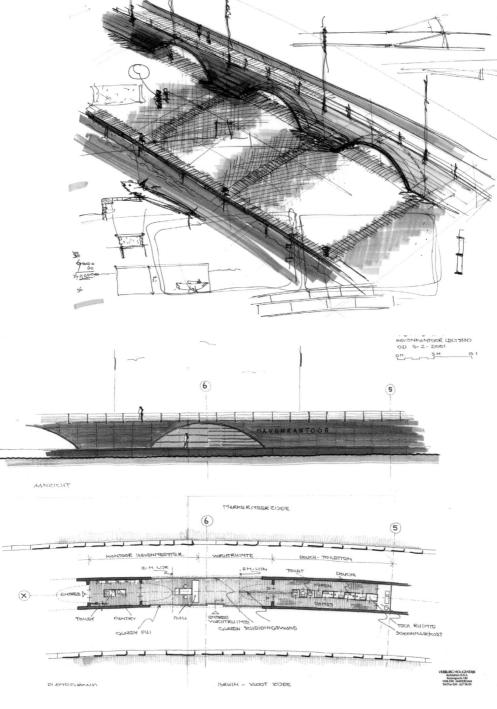

HAVENKANTOOR LELYSTAD
D.D. 5-2-2001
0 M 5 M 10 1

⑥ ⑤

HAVENKANTOOR

AANZICHT

MARKERMEERZIDDE

⑥ ⑤

KANTOOR HAVENMEESTER. WACHTRUIMTE DOUCH - TOILETTEN
 2-M LIDR 2M-LIJN TOILET DOUCHE

Ⓧ ENTREE HEREN
 DAMEN
 TOILET PANTRY BAU ENTREE TECH. RUIMTE
 WACHTRUIMTE SCHOONMAAKKOST
 GLAZEN PUI GLAZEN SCHEIDINGSWAND

PLATTEGROND BRUIN - VLOOT ZIDDE

VERBURG HOOGENDIJK
Architekten B.N.A.
Keizersgracht 169
1016 DW AMSTERDAM
Tel/Fax 020 - 627 96 05

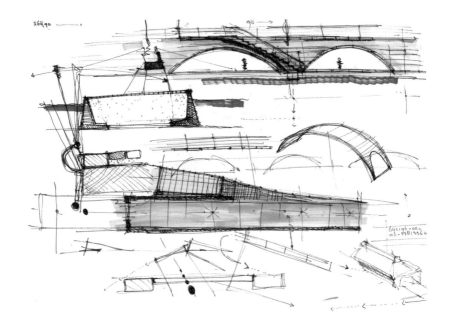

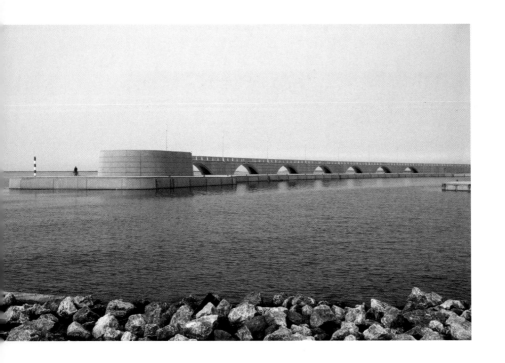

The wall acts as a beacon and reference point that gives scale and dimension
to the dam and has a clear identity to bind and guide future development.

VERBURG HOOGENDIJK ARCHITEKTEN VHA

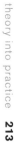

theory into practice

Describing the design process as 'discovering the creative error and deviating from the straight and narrow at exactly the right moment' Palmboom suggests 'there are no fixed patterns … just countless potentialities', and that it is 'only by discovering, selecting, using and interweaving from this vast range of possibilities does one – eventually – reach something self-evident which legitimises the design to the outside world' adding 'it requires a high degree of boldness as well as patience' (Palmboom, 2003: 72–77).

Palmboom and van den Bout Stedenbouwkundigen characterise themselves as surveyors who mark out lines and creating a framework that gives the urban environment its structure without predetermining its appearance. And so at IJburg, the new urban extension at Amsterdam consisting of 18,000 dwellings on the IJmeer Lake, they provide a robust spatial framework backed up by a number of clear rules for future development, to create the 'conditions in which the urban community can evolve as it sees fit' (Smets, 2003).

The plan consists of six islands of different sizes. The extensive interface between land and water enables building at a relatively high density as well as the opportunity to create new habitats such as shallows, transitional zones and lee areas. The city and the water work together as a whole; the buildings are treated as part of the landscape.

IJburg, Amsterdam

PALMBOOM AND VAN DEN BOUT STEDENBOUWKUNDIGEN

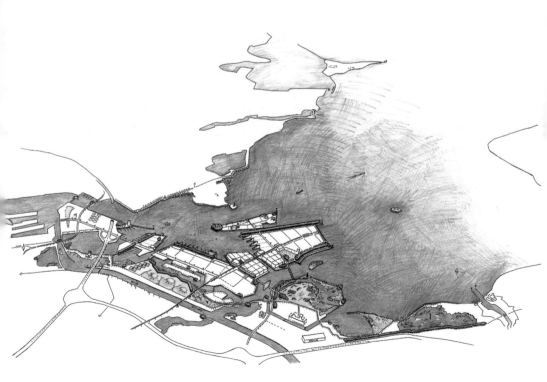

Two islands in the northeast act as a breakwater, creating the lee for the other islands and articulating the large water expanse. The gaps between the islands make the archipelago visually transparent.

The difference between the lee and the rough water surfaces brings about a differentiation in the contours of the shoreline, which ranges from tree-lined dykes in the north, to quays and bankside gardens in the south.

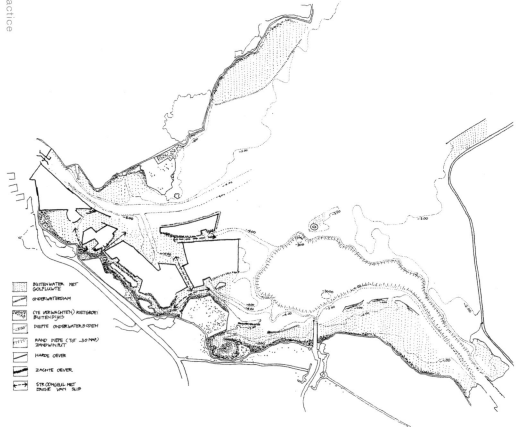

The configuration of land and water and the composition of shorelines, complemented
by the underwater design for various creeks, new shallows and underwater dams,
preceded the land use planning decisions.

IJburg, Amsterdam

PALMBOOM AND VAN DEN BOUT STEDENBOUWKUNDIGEN

The urban structure, determined by two main roads, a tramway and a metro line, provides orientation towards the Amsterdam city centre and the major hubs in the region.

While the composition of the archipelago as a whole is a bit whimsical – resembling drifting floes – the islands have a simple geometric main structure. Each island has its own character, and besides the residential and work areas, IJburg offers a number of programmatic assets that are important for the entire Amsterdam region including a marina, beach, transport exchange, cemetery and various new nature areas.

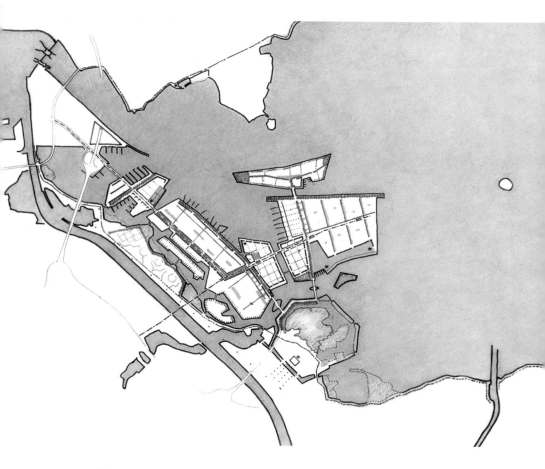

The plan does not impose a definitive architectural image but the
foundations for an occupational strategy. Within that strategy, each
project must not only create an individual or collective realm, but also
establish a relationship with the large scale of city and landscape. The
interface between realm and city has sometimes an explicit architectural
character (the façade along the boulevard) and sometimes an informal
and scenic one (the shoreline of a large watercourse).

IJburg, Amsterdam

PALMBOOM AND VAN DEN BOUT STEDENBOUWKUNDIGEN

urban and suburban, the cities and the towns, the ugly, non-descript and derelict areas in urgent need of regeneration. It is not just about asking governments to consider the landscape or to take it into account. The ELC gives the landscape its proper status, not as the bits left in between the buildings, developments, highways and town centres, or a vague blanket cover that will look after itself, but as the context upon and within which these dynamic processes take place. The landscape, with all of its potential, is regarded as the base layer, against which decisions about all future development need to be made.

The potential of working with ideas at a design-led strategic level is well illustrated by the masterplanning project devised for the Black Country Consortium urban research park in the West Midlands. The concept, based on broadening horizons, above, beyond and below, comes from an understanding of the region's topography, the history of mineral exploitation and landscape despoliation and the desire to radically change the identity of the region. When developing the concept for this project there was a feeling that rather than being a park study alongside other studies, it would end up as overarching those on transport, housing and town centre development. In fact the conceptual vision devised is so persuasive that it could act as a remarkable catalyst for physical and visual change in the region for the next 30, 60, even 90 years.

The ambitious brief is to turn the Black Country around, to rescue it from years of decline and depopulation and in its place create a high quality sustainable environment, an area that people will be happy to move to rather than away from. It was decided the whole place should be considered as a national urban research park, and three distinct, separate layers were identified to be designed and managed over the long term to complement, play off and spark against each other in order to forge a new identity. The aim is to create awareness of possible future scenarios that are nationally embedded but locally focused in terms of employment, health, education and commerce. It was proposed that the structure, quality and character of the region should be defined by a highly articulated urban topography based on an interpretation of different landscape characters, from the heath land to the north, orchards to the south, wheat fields to the east and mixed agriculture to the west, an accentuation and exaggeration of the range of habitats and conditions

found in low-lying wetlands and bogs, to the upland heaths and pine forests of the hilltops. Intensive industrial bio-agriculture and research for high-end value products such as jute, hemp, flax and research for urban agriculture and reclamation interspersed with traditional orchards, allotments and garden centres.

Infiltrating the urban structure, these typologies define the villages, creating a distinct visual identity for each centre. The massing and density of the urban architecture creates a strong spatial structure in conjunction with the hills and plains, horizons and views. A network of international reference points contributes to cultural exchange, demonstrating local, regional and international connections.

This is an embryonic idea, the result of a short intensive study. There's still a long way to go, plenty of arguments to be had to demonstrate its potential, but people, and not just those inside the profession, are talking about it. The exciting thing is that the Black Country project is about planning, not just for growth, but to put right in an imaginative way, what is currently a piecemeal hotch-potch.

This brings us back to ideas, aesthetics and understanding the meaning of place. The profound advantage of being explicit about the conceptual basis of a project goes way beyond the formal implications discussed in the previous chapter. Something of the persuasive power of ideas was made dramatically clear whilst selecting the shortlist for the City Park competition in Birmingham, UK. It was evident that the teams fell into two categories. There were those you knew could do a steady job, would deliver on time; in other words, the project would be in relatively safe hands. The park would be adequate, fit for purpose, but it might not set pulses racing. Then there were the teams who could also deliver (how else would they get past the procurement officers?), but the difference in approach was telling, these people were dealing explicitly with ideas. They talked about the importance of the concept not only as a way of starting the project, but also as a way to take everyone through the difficult process of getting something built, as a critical means of dealing with the things that can so easily knock a scheme off course.

A quantity surveyor who was actually working with two separate teams, demonstrated brilliantly the value of a good idea. With the first team he said little or nothing; he was neutral and detached. But when he appeared with the next team, the difference was palpable. He was passionate and animated, fully engaged with and committed to the work and clearly enjoying himself. It wasn't difficult to work out which project he preferred and it was his enthusiasm as much as anything that sold the team's ideas to the judges. It was a clear affirmation of the creative approach.

Like many projects already mentioned, the reclamation of Vall d'en Joan cuts across the artistic/ecological divide. The extraordinary idea is to work with the engineer's technological requirements to create dams and platforms, but transform them into terraces and fields and use technical, agricultural solutions to re-create the romance of long-lost agricultural landscapes. Working with ecological processes and traditional agricultural practices, it has engaged the imagination of the population and is now an integral part of the city. But what made people buy into it was not the idea of a park *per se*, but the engaging quality of the idea *behind* the park. This is what made all the difference, it was a talking point as well as an explanation and this empowered the clients, the community and the various professions to get the project started. Ideas can be cohesive, they bind all manner of things together; argument, opinion, values. There can be no better way to capture the hearts and minds of everyone involved than a great idea.

It is hard to overstate the importance of language in all of this. At present, the constructed public realm is dismally misrepresented as public open space, recreational space, green space, grey space, etc. The paucity of official planning jargon inevitably leads to an ignorance in policy and often in practice, of the rich complexity and subtlety of the physical context, thereby seriously underestimating the impact it has on the quality of life. To address the problem, therefore, we must look to change the habitual descriptions and references. A more differentiated vocabulary, making explicit the quality and character of places, one that elucidates the multitude of uses and functions of space from the highly symbolic to the everyday is needed to make the physical fabric of our lives more tangible. To effect real change, an evocative, expressive way of speaking

FLOOR PLAN OF GENERAL PROJECT

A waste dump opened in 1974, up to 80 m deep in some points, covers 70 hectares in the limestone massif of El Garraf. The terraces are determined by the need to contain rubble to ensure the stability of the great mass of accumulated waste. Retaining walls 10 m high create the terraces, which are formed by importing material rather than excavation. The basic structure of the terraces, filling the space between retaining walls, is inert subsoil. A fertile layer of soil is imported for vegetation. Between the two are layers of sand, geo-textile, and a waterproof lining. A layer of sand separates the waste dump from the new soil.

Rows of oaks and pine trees line the drainage channels, and paths and species native to the El Garraf stabilise the slopes. Crop rotation is based on leguminous plants to improve soil fertility, and agricultural species.

Vall d'en Joan, Barcelona

TERESA GALI AND BATTLE I ROIG ARQUITECTES

Manure is applied to specific planted areas. The landscape is managed using traditional farming techniques with the aim to encourage the colonisation of native species, whether by planting, irrigation or weeding or creating conditions for natural propagation.

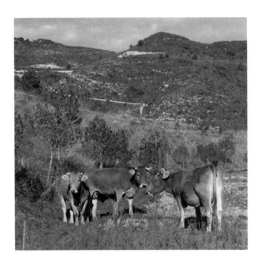

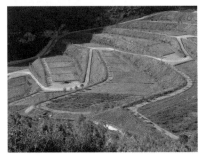

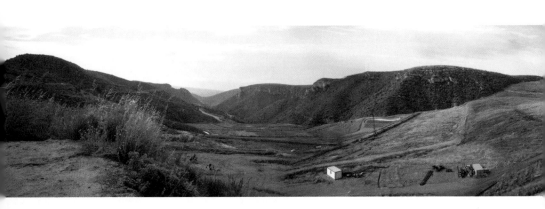

Detail of the methane chimneys.

Vall d'en Joan, Barcelona

TERESA GALI + BATLLE I ROIG ARQUITECTES

that accurately reflects the way we live our lives has to permeate official documents and guidelines, become accepted and then expected in project and competition briefs, etc. If we really want to fully articulate the way we experience the world, there can be no room for the dry bureaucratic talk that squeezes the life out of any debate about place and space. It is not as though we are stuck for ideas. There is a wealth of literature and research, evidence scientific, academic and anecdotal, imaginative narratives to inspire and show us things we hadn't noticed in the world. The real skill of a designer is in using the information to capture these narratives and/or create new ones through good investigative digging and then explicate the work in such a way that it fires the imagination.

Obviously, it is not just about language and language alone. The narratives, the words, must be made real, supported by a demonstration of their spatial implications. When dealing with the transformation of a place it is not only the understanding of new ideas that enables us to adjust to new circumstances and possibilities but the convincing and appropriate evidence of their expression in physical form. If we steer clear of the safe options we can begin to fill the conceptual void by talking seriously about ideas and their function in quality design.

Essentially, design is about raising aspirations, making it crystal clear what is possible and what can be achieved. The very least we can do as advisors, teachers and practitioners is to let people know what they can and should expect. If an essentially run down, demoralised city like post-Franco Barcelona can be transformed in 20 years into a world class city with an unparalleled urban infrastructure then why not envisage the Black Country as a sustainable collection of villages that will match the cultural diversity and excitement of any metropolitan area in Europe, but without the associated sprawl and grime? Or think that nearby Aston, an area shredded by the Spaghetti Junction's intervention could become renowned for its international, locally sourced cuisine and food markets, rather than as a shabby, unloved urban 'badland'. This is what raising aspirations means; encouraging, demonstrating and ultimately providing a persuasive and imaginative view of the future.

Recognising the value of quality environments would mean that if the Principality of Wales ever again has the opportunity to build something

As for example, philosophical and poetic references rooted in Welsh culture and rich
vocabulary of landscape typologies informing the ethos and spatial sensibility of the
invited competition entry for the Walled Garden, the National Botanical Garden, Wales,
by Camlin Lonsdale.

The National Botanic Garden is found in a landscape of low, undulating hills. Human
modification of this topography is typically minimal. Where it does occur, organic forms tend
to result. By virtue of its existing form, the Walled Garden offers an opportunity to fashion the
land for an altogether different purpose and to make conscious, even bold, interventions into
its naturally occurring, parent landform.

Three axes traverse the garden and create the geometry and proportion of its composition
and the pattern for movement through the garden. The Middleton square axis emerges from
the new square. Parallel to the short axis of the Great Glasshouse, it establishes a connection
with the geometry of the park and forms the principal line of movement into the garden.

The North Gate axis is a visual connection along which the elements of the garden are
placed; the threshold, water channel, doorway, bridge and gatehouse. The Moorland stream
axis draws the influence of turbulent water and high land into and through the garden.

NATIONAL BOTANIC GARDEN OF WALES WALLED GARDEN

Masterplan March 1999

0 10 20 30

Masterplan

A Pump
B Aqueduct
C Cistern
D Experimental enclosures
E Moorland stream & path
F Kitchen garden
G Peach house
H Peach house terrace
I Peach house pavement
J Carp pool
K Bridge
L Testing beds
M Gatehouse
N Gelli cnau
O Gallery
P Classroom
Q Classroom courtyard
R Terraces/vineyard/orchard
S Herbarium
T East slip garden – open cloister
U West slip garden – covered cloister
 & fernery
V North gate
W South window gate
X West window gate
Y East gate
Z Moorland gate

CAMLIN LONSDALE
LANDSCAPE ARCHITECTS
PARC BACH LLANGADFAN POWYS SY21 0PL
Telephone 01938 820 492 Fax 01938 820 525

Views into the slip gardens are available from elsewhere in the garden and from the outer wall, but visitors only gain access from the inner garden by means of gated openings. To the west the rocky, shallow soiled fernery is shaded by overhanging boscage while the eastern slip, bathed in sunlight becomes a sumptuous herbaceous-bordered ambulatory or cloister.

Hard fruits, hops or vines occupying the northwest terraced slopes of the garden have the maze-like qualities of orchards and vineyards.

The testing beds provide a living archive to engage the visitor in first hand experience of the challenges of cultivating the earth's surface.

Medicinal and culinary plants are to be found on the drier north-eastern slopes, with more familiar kitchen garden plants, cold frames, cloches and support frames.

In response to a concept of 'gardens within gardens' a sequence of spaces
introduces the opportunity for events, installations and experiment. Despite their
separation and their connection with the terraces to the west, the enclosures possess
a rhythmic quality commencing within the stable courtyard.

Water is drawn from a pump at the southeastern extremity of the site and
transported by aqueduct to the open cistern at a high point in the garden. The cistern
provides a seven-day water store during dry weather. Water drawn from the cistern
flows by gravity through open channels in the experimental enclosures to the carp
pool at the low point of the garden. The carp pool is a reservoir, receiving water
from the cistern and replenished from the moorland stream as it enters and passes
through the Walled Garden. In normal rainfall conditions, the recycling system will be
'closed' with the pump drawing water from a chamber contained within or adjacent
to the carp pool. During dry weather when flows from the moorland stream are low,
water may be sourced from the assumed existing supply to the pump house.

The Walled Garden contains a collection of structures. A partially enclosed gallery houses exhibition material and information relating to current activities in the experimental enclosures and testing beds. Immediately adjacent to the gallery and connected to it by a 'green corridor', the classroom and courtyard occupy the northeastern corner of the inner garden.

CAMLIN LONSDALE

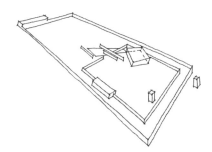

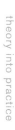

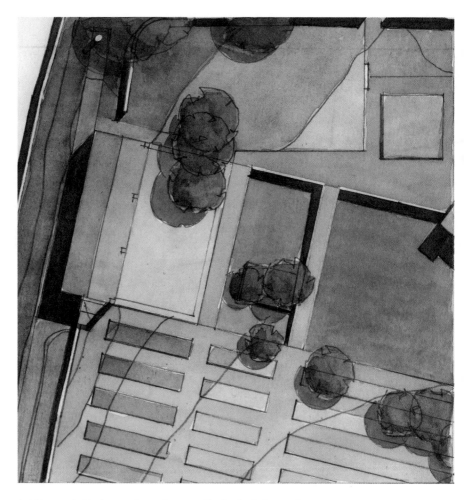

A platform carrying the classroom hovers above ground level and projects across the carp
pool, providing cool, shaded water for the fish below. By penetrating the line of the wall,
the gallery and classroom together form a threshold between the inner and outer gardens.
The peach house offers exotic fruit and the opportunity to linger on its open terrace.

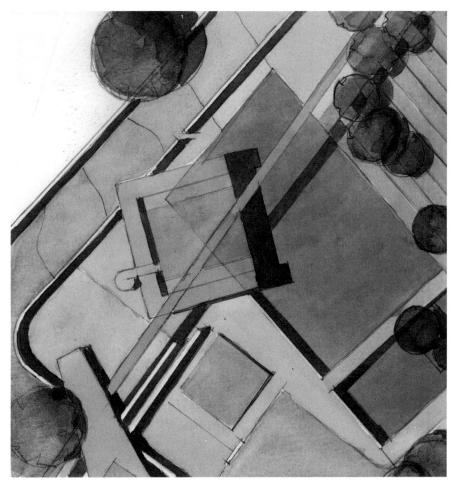

A gatehouse sits astride the inner garden wall offering shelter to those entering by
the south gate and a restful prospect for those who have completed their exploration
of the garden.
CAMLIN LONSDALE

like Zaha Hadid's opera house, it would be utterly inconceivable to turn it down, it would be a matter of national pride and confidence to endorse and rubber stamp it, because the long-term social and economic benefits are so blindingly obvious. Rather than worry about the cost, people would worry about the cost of another lost opportunity.

Increasingly, hard-nosed economic proof is accumulating that demonstrates the impact and value of thoughtfully designed landscapes. The National Trust are actively measuring it and have all manner of statistics regarding the benefits of good-looking places. In the mid-nineteenth century, the improvement bill for Birkenhead Park for example, with its 'extensive provision for a municipal park and high quality housing' (Elliot *et al.*, 2008: 53), increased the value of the land sevenfold. In Barcelona, the chance to create a park, preferably before the houses are built, is seen as an unmissable opportunity for developers to increase return on their investment. As far as some economists are concerned, the case is already proven, the evidence is impossible to ignore. And to estate agents, it's a statement of the obvious. It is straightforward economics, recognising the value of context and when it comes down to it, the benefit of a good view.

The numbers of jobs created or homes built cannot be our only measure of success. Safety, a sense of pride and involvement, the value of making people feel good about themselves and their surroundings, these ideas may not be as easily quantifiable, but they are not just airy utopian conceits. They are real indicators of the success or otherwise of a place. But despite all good intentions and considerable political posturing, it is still not easy to force these new criteria on to the agenda; on to the bottom lines that influence developers, the public and the key decision makers, despite alarming evidence of the huge economic cost of thoughtlessly conceived environments in our towns and cities (see CABE 2006).

As individuals and representatives who have responsibility for the built environment, we have to raise our game. For too long now money spent on the landscape in the UK has been embarrassingly small beer in comparison to the rest of Europe, for instance in Nou Barris, Barcelona, 214 million euros were spent on a new park to help change the socio-economic profile of an area. The park in Poble Nou opened in 2008, costing

141 million euros. All of this represents proper, serious investment in the public realm and that's exactly what it is, an investment. As we are now finding in the UK, the social cost of a casual abuse, misuse or neglect of the built environment is huge and possibly irreparable.

The economic argument is always the most influential, persuading the treasury, the civil servants and the funding agencies, the applicants and developers. Even so, when the political battles are won and the stakeholders are on board, there is still the tortuous process of getting things built. There are countless examples of potentially exhilarating projects being knocked off course, hamstrung and compromised by the fiscal constraints of the here and now rather than driven by the economics of possibility. The key here is to convince everyone, the politicos, the mandarins, big business, that a high quality built environment is central to sustainable economic growth and the real measure of how we define ourselves as a nation. That's when we'll see proper investment.

The deeply flawed conception at the heart of epistemology and theories of perception has consistently deflected us from developing effective strategies to teach the arts, having serious discussions about quality and ultimately from achieving the measure of design expertise needed to match society's aspirations to create well imagined and properly sustainable environments.

Ditching the metaphysical baggage enables us to articulate the art of design, teach the generation of form, connect spatial strategies to real places and develop ways of working that not only encourage but also demand the expression of ideas, the ideas that are fundamental to the design process. The proof of good education is in the value of its application. Demystifying the art of design represents the best chance we have of consistently achieving design excellence, which is the ability to create good-looking places, because the quality of our environment is directly proportional to the quality of our lives. It's an equation as simple as it is compelling.

Arnheim, R. (1986) *New Essays on the Psychology of Art*, Berkeley and Los Angeles, CA: University of California Press.

Barkow, J. H., Cosmides, L. and Tooby, J. (eds) (1995/1992) *The Adapted Mind: Evolutionary Psychology and the Generation of Culture*, New York and Oxford: Oxford University Press.

Best, D. (1992) *The Rationality of Feeling,* London: The Falmer Press.

Boden, M. (1990) *The Creative Mind, Myths and Mechanisms*, London: Weidenfeld and Nicolson.

Borden, I. and Rendell, J. (2000) *InterSections: Architectural Histories and Critical Theories,* London: Routledge.

Bragg, M. (2005) 'Beauty', *In Our Time*, United Kingdom, BBC Radio 4, 45 minutes.

Broadbent, G. (1988/1975) *Design in Architecture: Architecture and the Human Sciences*, Letchworth: David Fulton Publishers Ltd.

Bryson, N. (1983) *Vision and Painting: The Logic of the Gaze*, Basingstoke: Palgrave.

Bryson, N. (1990) *Looking at the Overlooked: Four Essays on Still Life Painting*, London: Reaktion Books Ltd.

Bryson, N. (2001/1999) 'The Natural Attitude' in J. E. S. Hall (ed.), *Visual Culture: The Reader*, London: Sage Publications in association with The Open University.

Burns, C. J. and Kahn, A. (eds) (2005) *Site Matters: Design Concepts, Histories, and Strategies*, New York and London: Routledge.

CABE (2006) *The Cost of Bad Design*, London: Commission for Architecture and the Built Environment.

Corner, J. (1992) 'Representation and the Landscape: Drawing and Making in the Landscape Medium', *Word & Image* 8 (3, July–September): 243–75.

Corner, J. (2002/1999) 'The Agency of Mapping: Speculation, Critique and Invention' in D. Cosgrove (ed.), *Mappings*, London: Reaktion Books Ltd.

Costall, A. (1995) 'The Myth of the Sensory Core: The Traditional Versus the Ecological Approach to Children's Drawings', in V. G. Thomas and C. Lange-Kuttner (eds), *Drawing and Looking: The Developing Body and Mind*, Hemel Hempstead: Harvester Wheatsheaf, pp. 16–26.

Davey, N. (1999) 'The Hermeneutics of Seeing' in I. Heywood and B. Sandywell (eds) *Interpreting Visual Culture Explorations in the Hermeneutics of the Visual*, London and New York: Routledge, pp. 3–29

Day, C. (2002) *Spirit & Place*, Oxford: Architectural Press.

de Sausmarez, M. (1961) 'A Visual Grammar of Form', *Motif* 8: 3–25.

Dewey, J. (1958) *Experience and Nature*, New York: Dover Publications Inc.

Dewey, J. (1980/1934) *Art as Experience*, New York: The Berkley Publishing Group.

Dewey, J. (1991/1910) *How we Think*, Amherst, NY: Prometheus Books.

Dewey, J. (1997a/1916 in *Democracy and Education*), 'Theories of Knowledge', in L. Menand (ed.) *Pragmatism: A Reader*. New York: Vintage Books, pp. 205–209.

Dewey, J. (1997b/1925) 'Experience and Nature' in L. Menand (ed.) *Pragmatism: A Reader*, Vintage Books: New York: Random House, pp. 233–64.

Dilnot, C. (1989) *The State of Design History: Part II in Design Discourse*, Chicago, IL: The University of Chicago Press.

Dutton, T. A. (1991) 'Introduction: Architectural Education, Postmodernism, and Critical Pedagogy' in T. Dutton (ed.), *Voices in Architectural Education, Cultural Politics and Pedagogy*, New York: Bergin & Garvey.

Eagleton, T. (1983) *Literary Theory: An Introduction*. Minneapolis, M. N: University of Minnesota Press.

Eagleton, T. (1990) *The Ideology of the Aesthetic*, Oxford: Blackwell Publishing.

Eagleton, T. (2003) *After Theory*, London: Allen Lane an imprint of Penguin Books.

Easterling, K. (1999) *Organization Space: Landscapes, Highways and Houses in America*, Cambridge, MA: MIT Press.

Edwards, B. (1989/1979) *Drawing on the Right Side of the Brain*, Glasgow: Fontana Collins.

Edwards, B. (1990/1987) *Drawing on the Artist Within: How to Release your Hidden Creativity*. Glasgow, William Collins and Sons.

Eisner, E. (1972) *Educating Artistic Vision*, New York: Macmillan.

Eisner, E. (2002) *The Arts and the Creation of Mind*, Harrisonburg, VA: Yale University Press.

Elkins, J. (2001) *Why Art Cannot be Taught*, Urbana and Chicago, IL: University of Illinois Press.

Elliot, P., Daniels, S. and Watkins, C. (2008) 'The Nottingham Arboretum (1852): The Natural History, Leisure and Public Culture in a Victorian Regional Centre', *Urban History*, 35(1): 48–71.

Evans, R. (1995) *The Projective Cast: Architecture and Its Three Geometries*, Cambridge, MA: MIT Press.

Evans, R. (2000) 'In Front of Lines That Leave Nothing Behind' first published in *AA Files 6* (May 1984) in K. Michael Hays (ed.) *Architecture Theory since 1968*, Cambridge, MA: MIT Press, pp. 482–9.

Everett, D. (2008) *Don't Sleep, There are Snakes: Life and Language in the Amazonian jungle*, London: Profile Books.

Fish, S. (1989) *Doing What Comes Naturally: Change, Rhetoric and the Practice of Theory in Literary and Legal Studies*, Oxford: Durham, NC University Press.

Foster, H. (1996) *The Return of the Real*, Cambridge, MA: MIT Press.

Gadamer, H.-G. (1992/1960) *Truth and Method*, 2nd edn, New York: Crossroad.

Gallagher, S. (1992) *Hermeneutics and Education*, Albany, NY: State University of New York Press.

Goldschmidt, G. (1994) 'On Visual Design Thinking: The Vis Kids of Architecture', *Design Studies* 15 (2 April): 158–174.

Goleman, D. (1996) *Emotional Intelligence*, London: Bloomsbury.

Hale, J. (1994) *The Old Way of Seeing*, Boston and New York, Houghton Mifflin Company.

Hansen, R. (1992) 'The Sketch: Speculative Tool for the Art of Making', CELA (the Council for Educators in Landscape Architecture), *CELA: Design and Values*, Proceedings, 1992, Conference held at University of Virginia. Published in 1993, Landscape Architecture Foundation/ CELA (Washington).

Hill, R. (1999) *Designs and their consequences: Architecture and Aesthetics*, New Haven, CT, and London: Yale University Press.

Holl, S., Pallasmaa, S. and Perez-Gomez, A. (1994) 'Questions of Perception, Phenomenology of Architecture', *Architecture and Urbanism*, July (Special Issue).

Hudson, L. (1976/1972) *The Cult of the Fact*, London: Jonathan Cape.

Ingold, T. (2000) *The Perception of the Environment*, London and New York: Routledge.

James, W. (1977/1884) *Psychological Foundations. The Writings of William James: A Comprehensive Edition*, ed. J. J. McDermott, Chicago, IL: The University of Chicago Press.

James, W. (1907) 'What pragmatism Means' in L. Menand (ed.), *Pragmatism: A Reader*, New York: Vintage, pp. 93–111.

James, W. (1981/1907) *Pragmatism*, Indianapolis, N: Hackett Publishing Company.

Jay, M. (1994) *Downcast Eyes: The Denigration of Vision in Twentieth-Century French Thought*, Berkely and Los Angeles: University of California Press.

Jellicoe, G. A. (1993) Interview. K. Moore. London.

Jellicoe, G. A. (1996) *Studies in Landscape Design: The Studies of a Landscape Designer over 80 Years*, Woodbridge: Garden Art Press.

Johnson, B. R. and Hill, K. (eds) (2002) *Ecology and Design: Frameworks for Learning*, Washington, Covelo, London: Island Press.

Johnson, P.-A. (1994) *The Theory of Architecture: Concepts, Themes and Practices*, New York: Van Nostrand Reinhold.

Kandinsky, W. (1979/1947) *Point and Line to Plane*, New York: Dover Publications.

Kemnitzer, R. (2003) 'Editorial', *Tracey Contemporary Drawing Research* www.lboro.ac.uk/departments/ac/tracey/comm/ (Contemporary issues in drawing), published by Loughborough University, Communication (July 2003).

Kemp, M. (ed.) (1989) *Leonardo on Painting: An Anthology of Writings by Leonardo da Vinci with a Selection of Documents Relating to his Career as an Artist*, New Haven and London: Yale University Press.

Kepes, G. (1994/1944) *Language of Vision*, New York: Dover Publications.

Koestler, A. (1964) *The Act of Creation*, London: Hutchinson & Co. (Publishers) Ltd.

Langer, S. K. (1994/1953) *Feeling and Form: A Theory of Art*, in S. D. Ross (ed.). *Art and Its Significance, An Anthology of Aesthetic Theory*, Albany, NY: State University of New York Press.

Lawson, B. (1993) 'The Art of the Process', *The Art of the Process, Architectural Design in Practice*, Oxford: The Builder Group.

Lawson, B. (1994) *Design in Mind*, Oxford: Butterworth-Heinemann Ltd.

Menand, L. (ed.) (1997) *Pragmatism: A Reader*, New York: Vintage Books.

Meyer, H. (2003) 'Mobilising the Landscape'. *Transformations of the Urbanised Landscape, The Work of Palmboom & van den Bout Stedenbouwkundigen*. H. Meyer. Amsterdam, Teksten Uitgeverij SUN: 5–8.

Meyer, H. (ed.) (2003) *Transformations of the Urbanised Landscape, The work of Palmboom & van den Bout Stedenbouwkundigen*. Amsterdam, Teksten Uitgeverij SUN.

Midgley, M. (2001) *Science and Poetry*, London and New York: Routledge.

Pallasmaa, J. (1994) 'An Architecture of the Seven Senses', in S. Holl, J. Pallasmaa and A. Perez-Gomez (eds), *Questions of Perception, Architecture and Urbanism*, July, Special Issue, Tokyo.

Pallasmaa, J. (2005) *The Eyes of the Skin: Architecture and the Senses*, Chichester: Wiley Academy.

Palmboom, F. (2003) 'Urban Design: Game and Free Play versus Aversion and Necessity'. *Transformations of the Urbanised Landscape, The Work of Palmboom & van den Bout Stedenbouwkundigen*. H. Meyer. Amsterdam, Teksten Uitgeverij SUN: 72–77.

Parsons, M. J. (1987) *How We Understand Art: A Cognitive Developmental Account of Aesthetic Experience*, Cambridge: Cambridge University Press.

Parsons, M. J. (1995) 'Visual and Verbal Learning in Art: The Consequences of Developments in Aesthetics for Art Education and the Psychology of Art', *Art and Fact: Learning Effects of Arts Education*, Utrecht: LOKV, Netherlands Institute for Arts Education.

Potteiger, M. and Purinton, J. (1998) *Landscape Narratives: Design Practices for Telling Stories*, New York and Chichester: John Wiley & Sons.

Prosser, M. and Trigwell, K. (1999) *Understanding Learning and Teaching: The Experience in Higher Education*, Buckingham: SRHE and Open University Press.

Putnam, H. (1999) *The Threefold Cord: Mind, Body and World*, New York: Colombia University Press.

Putnam, H. (2002) *The Collapse of the Fact/Value Dichotomy and Other Essays*, Cambridge, MA: Harvard University Press.

QAA (Quality Assurance Authority) (2001) *Subject Benchmark Statement for Art and Design*, Consultation Document (third draft) May 2001, Quality Assurance Authority.

Raney, K. (1999) 'Visual Literacy and the Art Curriculum', *International Journal of Art and Design Education*, 18, 1, by the National Society for Education in Art and Design.

Relph, E. (1987) *The Modern Urban Landscape*, Baltimore, MD: Johns Hopkins University Press.

Robinson, D. G., Laurie, I. C., Wager, J. F. and Trail A. L. (1976) *Landscape Evaluation*, Manchester: University of Manchester.

Rorty, R. (1980) *Philosophy and the Mirror of Nature*, Oxford: Blackwell.

Rorty, R. (1982) *Consequences of Pragmatism*, Minneapolis, MN: University of Minnesota Press.

Rorty, R. (1992) 'The Pragmatist's Progress', in S. Collini (ed.), *Umberto Eco: Interpretation and over interpretation*, Cambridge: Cambridge University Press.

Rorty, R. (1999/1998) *Achieving our Country: Leftist Thought in Twentieth-Century America*, Cambridge, MA: Harvard University Press.

Rorty, R. (1999) *Philosophy and Social Hope*, London: Penguin.

Rorty, R. (2001) 'Response to Richard Shusterman', in M. Festenstein and S. Thompson (eds), *Richard Rorty: Critical Dialogues*, Cambridge: Polity Press.

Rykwert, J. (1989) *The Idea of a Town*, Cambridge, MA: MIT Press.

Ryle, G. (1990/1949) *The Concept of Mind*, London: Penguin Books.

Schon, D. A. (1991) *Educating the Reflective Practitioner*, San Francisco, CA, and Oxford: Jossey-Bass Publishers.

Schuman, T. (1991) 'Forms of Resistance: Politics, Culture and Architecture', in T. Dutton (ed.), *Voices in Architectural Education, Cultural Politics and Pedagogy,* New York: Bergin & Garvey, pp. 3–27.

Schwartz, M. (1997) 'Interview with Martha Schwartz', in H. Landecker (ed.), *Transfiguration of the Commonplace*, Washington, DC, and Cambridge, MA: Spacemaker Press.

Shusterman, R. (2000) *Pragmatist Aesthetics, Living Beauty, Rethinking Art*, 2nd edn, Lanham, MD: Rowman and Littlefield Publishers, Inc.

Shusterman, R. (2001) 'Reason and Aesthetics: Habermas and Rorty', in M. Festenstein and S. Thompson (eds), *Richard Rorty: Critical Dialogues*, Cambridge: Polity Press.

Smets, M. (2003) 'In Search of Appropriate Coalitions'. *Transformations of the Urbanised Landscape, The Work of Palmboom & van den Bout Stedenbouwkundigen*. Amsterdam, Teksten Uitgeverij SUN: 9–13.

Snodgrass, A. and Coyne, R. (2006) *Interpretation in Architecture: Design as A Way of Thinking,* Abingdon and New York: Routledge.

Stafford, B. M. (1997) *Good Looking Essays on the Virtue of Images,* Cambridge, MA: MIT Press.

Staniszewski, M. A. (1995) *Believing is Seeing: Creating the Culture of Art,* Harmondsworth: Penguin.

Tagliabue, B. and Zaragoza, I. (2001) Arquitectura dibujada/Architecture drawn, The project of Miralles/Tagliabue for Diagonal Mar. Barcelona, ACTAR.

Taylor, R. (1992) *The Visual Arts in Education,* London: Falmer Press.

Thomas, G. V. (1995) 'The Role of Drawing Strategies and Skills', *Drawing and Looking: The Developing Body and Mind,* in V. G. Thomas and C. Lange Kuttner (eds), Hemel Hempstead: Harvester Wheatsheaf, pp. 107–122.

Thompson, I. H. (2000) *Ecology, Community and Delight: Sources of Value in Landscape Architecture,* London and New York: E & FN Spon.

Turner, T. (1996) *City as Landscape: A Post-postmodern View of Design and Planning,* London: E & FN Spon.

Walker, D. (1982) *The Architecture and Planning Of Milton Keynes,* London: The Architectural Press.

Walker, P. and Simo, M. (1994) *Invisible Gardens,* Cambridge, MA: MIT Press.

Weston, R. (2002) *Utzon,* Hellerup, Denmark: Edition Blondal.

Whitely, N. (1999) 'Readers of the Lost Art: Visuality and Particularity in Art Criticism', in I. Heywood and B. Sandywell (eds) *Interpreting Visual Culture: Explorations in the Hermeneutics of the Visual,* London: Routledge.

subject index

image credits

The author and publisher would like to thank the following individuals and institutions for giving permission to reproduce illustrations. We have made every effort to contact copyright holders, but if any errors have been made we would be happy to correct them at a later printing. All numbers refer to pages.